Faraway
childhoods

A little girl

Facing the door of the
Temple is another door.
There dwells a little girl
with white cheeks
and ruby lips.

People die for love of her,
so gracefully she walks.

Anonymous poet of Ancient China

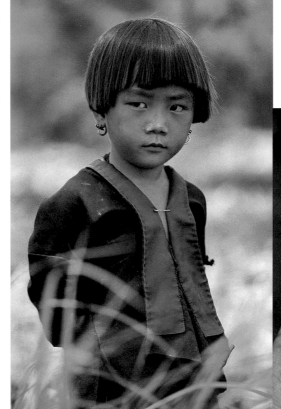

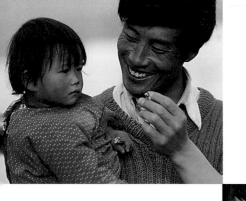

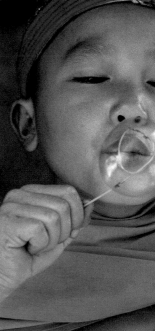

To Rebecca and Harvey, Anna and
Eli, Marie and Eugène, Marie-Louise
and Auguste-Hadrien, their children,
and all children everywhere.

Chapter I Babies and Toddlers 6

Chapter II Growing Up 48

Chapter III Play 98

Chapter IV Apprenticeship 126

Chapter V Family portraits 166

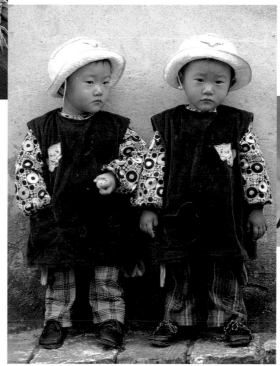

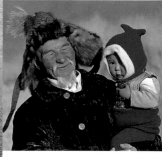

Faraway
childhoods

PHOTOGRAPHY KEVIN KLING

Text in collaboration with Bernard Dupaigne

HACHETTE
Illustrated

Babies
and Toddlers

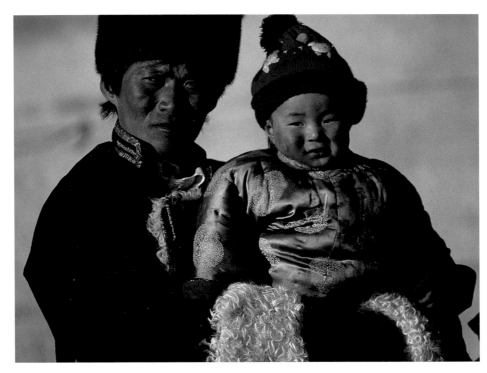

Society cannot exist without children. Nothing gives everybody

more pleasure than the birth of these tiny creatures, who will grow

up to form the next generation and carry on its traditions.

In many cultures, being childless is a mark of shame for the individual,

as well as spelling the extinction of the family line and the group.

Children represent hope, there must be children. And when they

finally arrive, nothing is too much trouble – precautions, rites or taboos –

to ensure their survival.

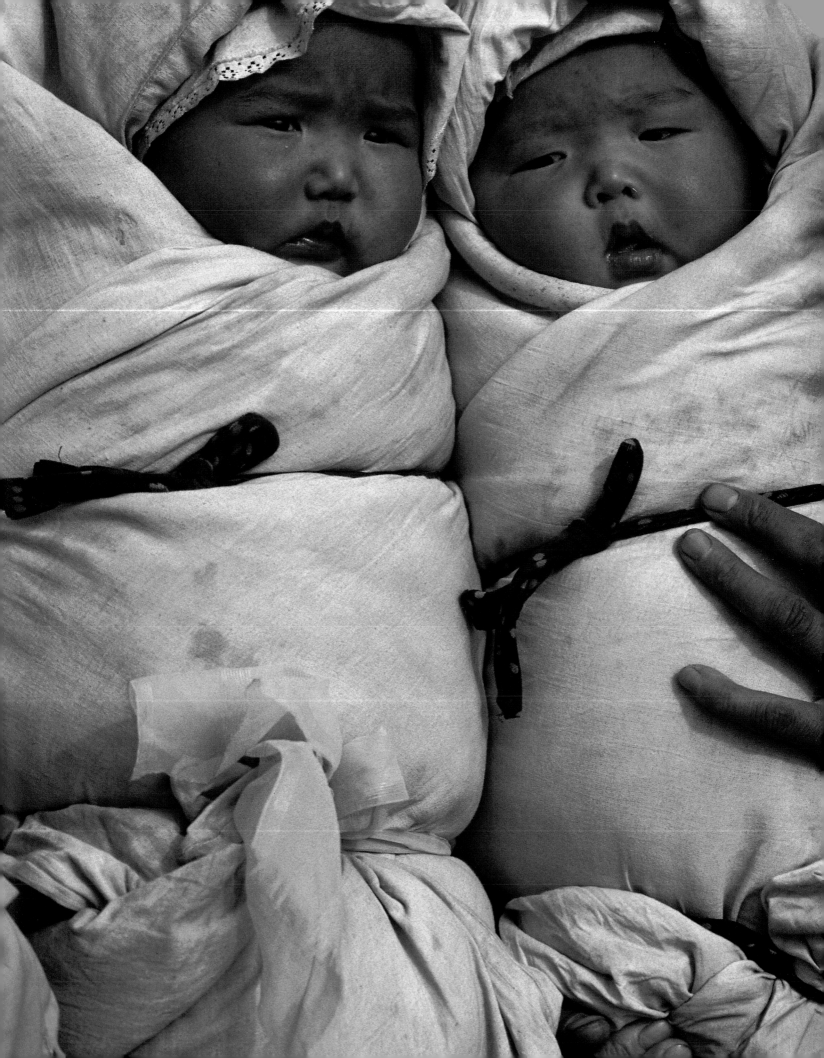

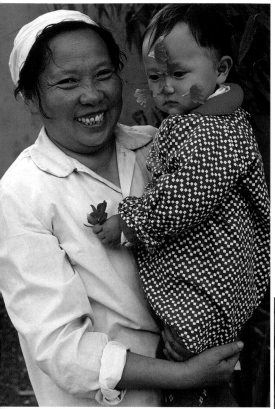

A child does not belong merely to its own family; it is the collective property of the group protecting it and guaranteeing its education and development. The biological parents do not have full and exclusive rights over the child; the extended family, the clan and society, in general, keep an eye on its treatment and rearing, imposing their customs and laws, and exercising constant control over the mother and father. From the moment the baby leaves the womb, it is a member of society and it needs to be taught the rules of the group into which it has been born. There is no distinction, therefore, between the care lavished on the new arrival by its mother or close relatives and the responsibility of the group for its upbringing. The child belongs to everyone: it represents the promise of their future.

Giving birth

Giving birth is a momentous undertaking for a woman, and full of danger. In non-industrialised societies, where qualified doctors are in short supply, there is a high rate of infant mortality. Worse still, many women die during childbirth because of the lack of proper care. The birth of the first child – a boy is the preference almost everywhere – is the true consummation of a marriage. It is only after the first birth that the young wife will be accepted as a full member of her new family, with the right to speak out and voice her opinions. Until then, she is merely tolerated, and regarded with suspicion by the other women in her husband's family. There is no female solidarity here. The womenfolk expect only one thing from the new clan member: to work and produce children, and males if possible. Childbirth conjures up mystery and peril, with the implication of forces beyond our control; it also involves the effusion of blood, the sight of which is always terrifying. This primal act is always accomplished away from everyday life, sometimes in special huts outside the village.

ABOVE:
Petals to welcome the
spring. Xishan, China.

RIGHT:
An afternoon of torrid
heat. Chengdu, China.

OPPOSITE PAGE:
Convalescence.
Gansu, China.

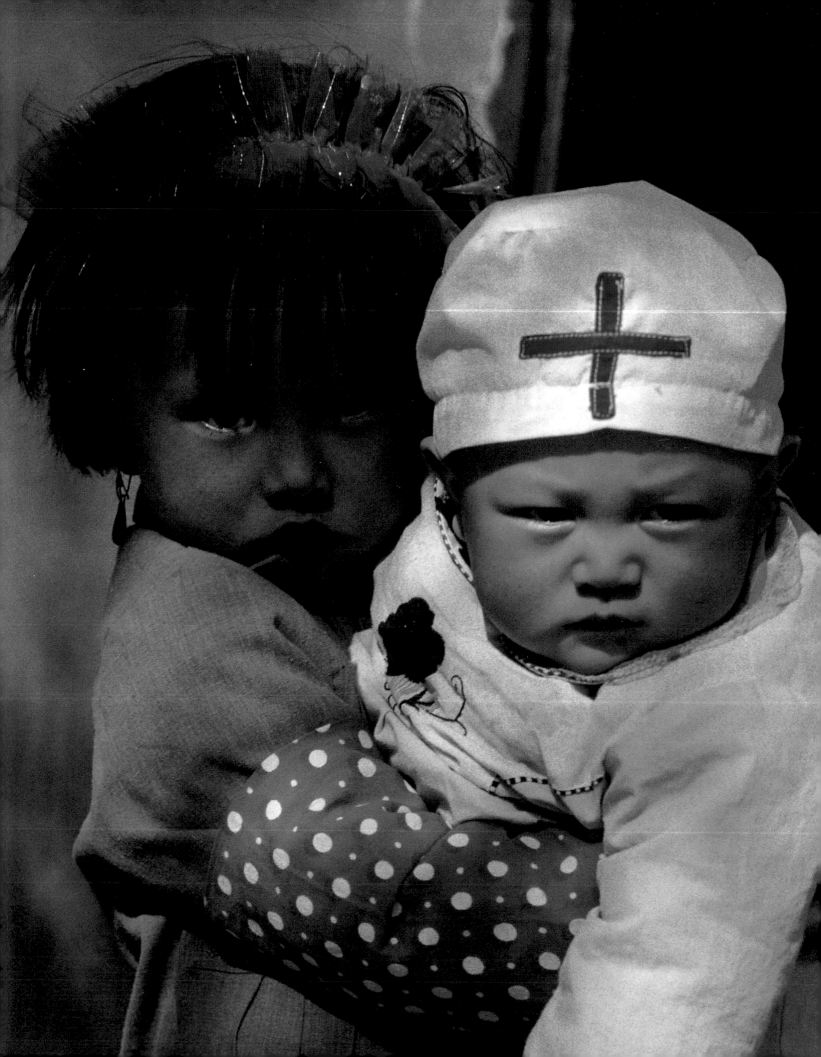

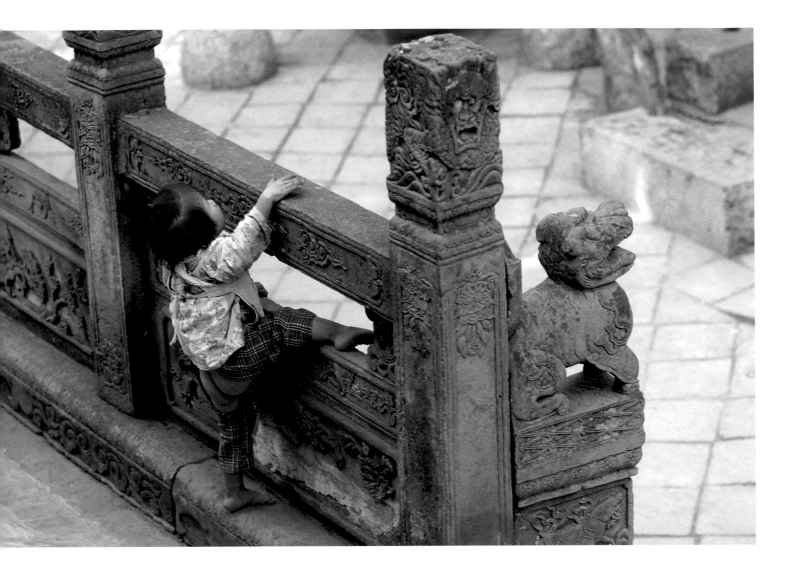

Warding off the evil eye

Tackling a balustrade. In China, slit culottes are the fashion. Beijing.

The new-born child is delicate, vulnerable to the influence of the evil eye or spells that any jealous person can cast; for this reason, no one is allowed in the mother's room. The parents must obey numerous rules and taboos, designed to protect the child during its first years. The infant receives magical protection in the form of charms and amulets; in the Islamic world, the newly born child is surrounded by such items. All around its cot are suspended charms and little bells, blue stones, crystals of alum, miniature horns (symbolising strength), which are to ward off malicious spirits jealous of the mother's good fortune.

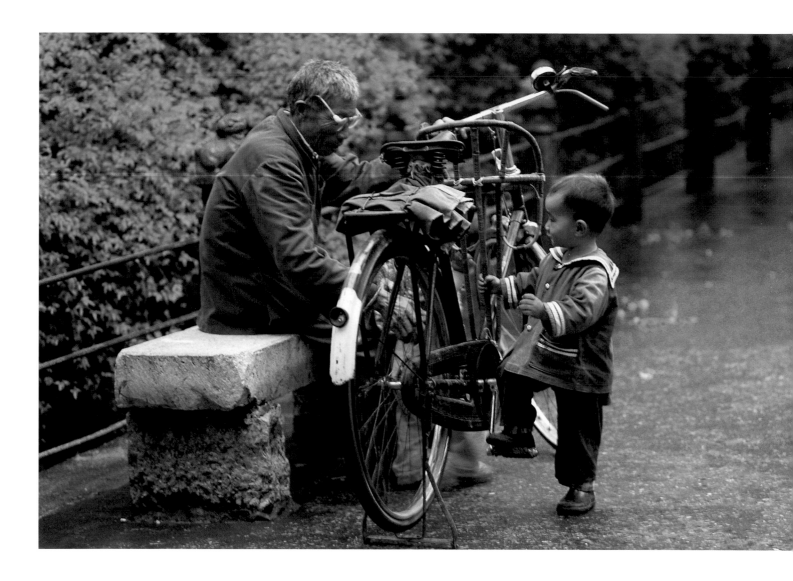

First bicycle
ride with
grandpa.
Guilin, China.

Envy and jealousy, evil spirits and ill luck hover about the new-born child. Here again, things are different from the Western tradition where people go into raptures over the little one, fondling and kissing it, congratulating and complimenting its mother. In Africa, any overt signs of interest in the infant risk being interpreted as envy, giving rise to fears of some act of sorcery designed to punish the parents for having such a beautiful child. It is not considered acceptable to sing the child's praises or discuss it with its mother. In the same way that a woman is not spoken about directly, the child is mentioned only by allusion. No one asks the parents how many children they have, no one offers compliments.

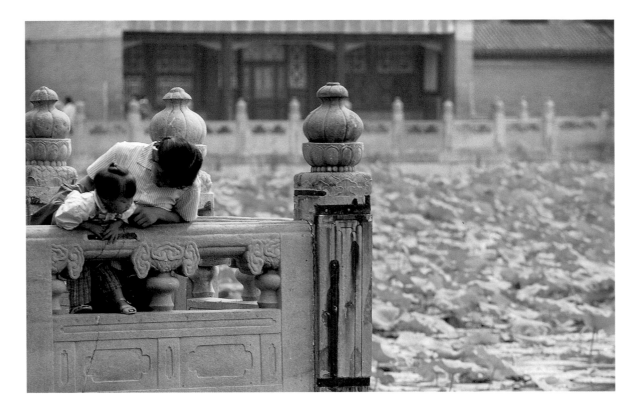

ABOVE:

Discovering floating lotuses with mother. Summer Palace, Beijing, China.

OPPOSITE PAGE:

Young Uighur and son. The best refuge from the desert sun is under the poplars. Mausoleum of Abakh Hodja, Kashgar, Xinjiang, China.

The "purification" of women

In Africa, the mother is required to observe a forty-day quarantine before making her reappearance in the world. After this, if her own mother has been unable to be present at the birth, the young woman rejoins her in her village to present the child, taking the opportunity for a short rest there. The ceremony of "purification" – the return of the young mother to normal life after the birth period, a time of danger and traditionally of defilement – takes place in Vietnam after twenty, thirty, fifty or a hundred days. A large feast is prepared, to which relatives, friends and neighbours are all invited.[1] Among the ancient Aztecs, as described by Jacques Soustelle, the "midwife" who had supervised the delivery would bid the child welcome, at the same time warning it of the uncertainties and vicissitudes of life: "Thou hast entered this world where thy parents dwell amid sorrow and weariness, where the cold and the wind and excessive heat hold sway. We know not whether thou wilt live long among us, we know not what fate is reserved thee".[2]

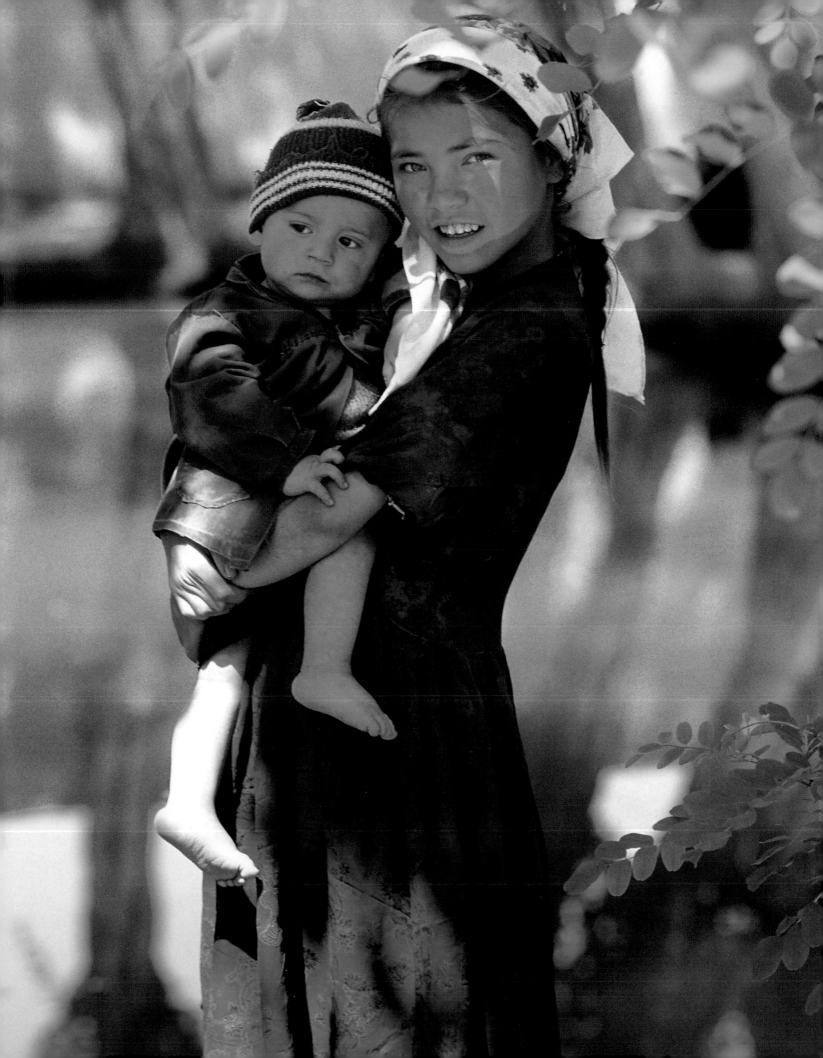

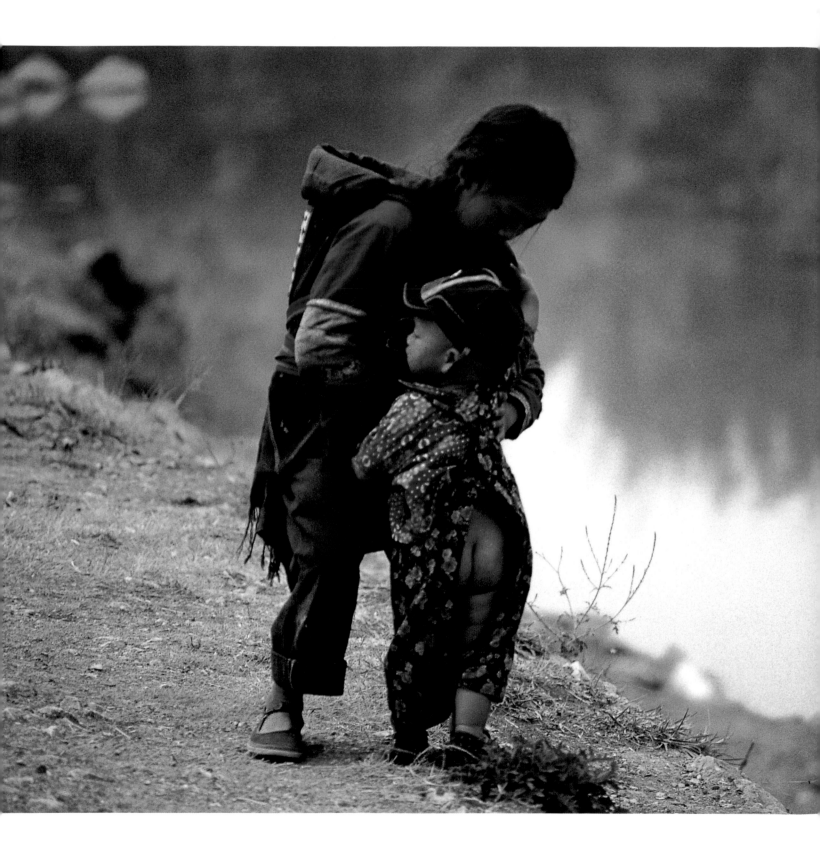

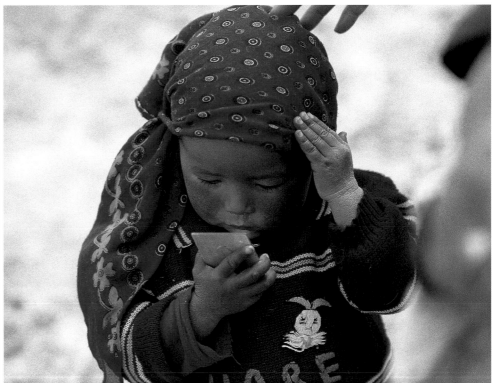

LEFT:
Sani brother
and sister.
Shilin, Yunnan,
China.

ABOVE:
Even among the
nomadic Kyrgyz,
appearances matter
from a very early age.
Kara-Kul, Pamir
Mountains, China.

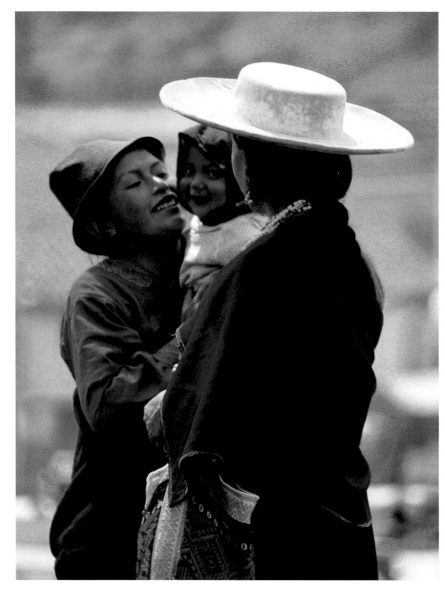

"The best smell is
that of bread; the best
taste, that of salt; the
best kind of love is
the love of a child".
(Spanish proverb)

LEFT:
Forging that special
relationship with
granny. Saraguro,
Ecuador.

RIGHT:
The Puruha Indians
carry their infants on
their backs wrapped
in scarlet or fuchsia
ponchos. Riobamba,
Chimborazo, Ecuador.

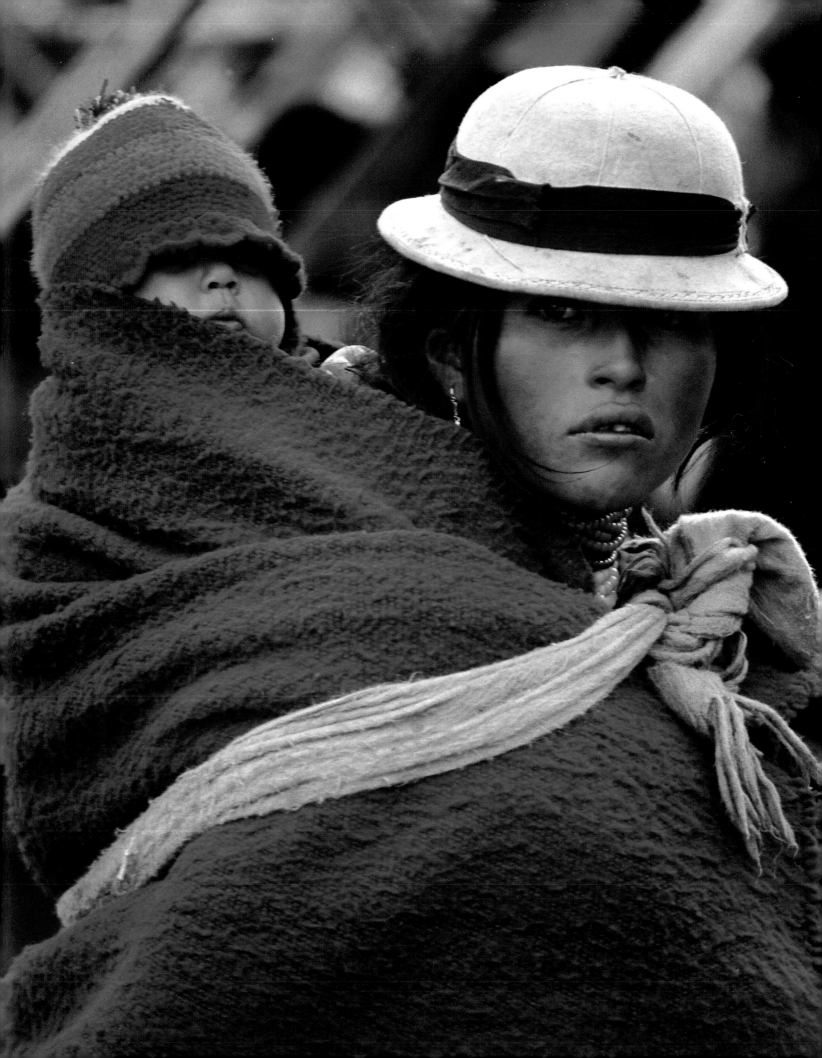

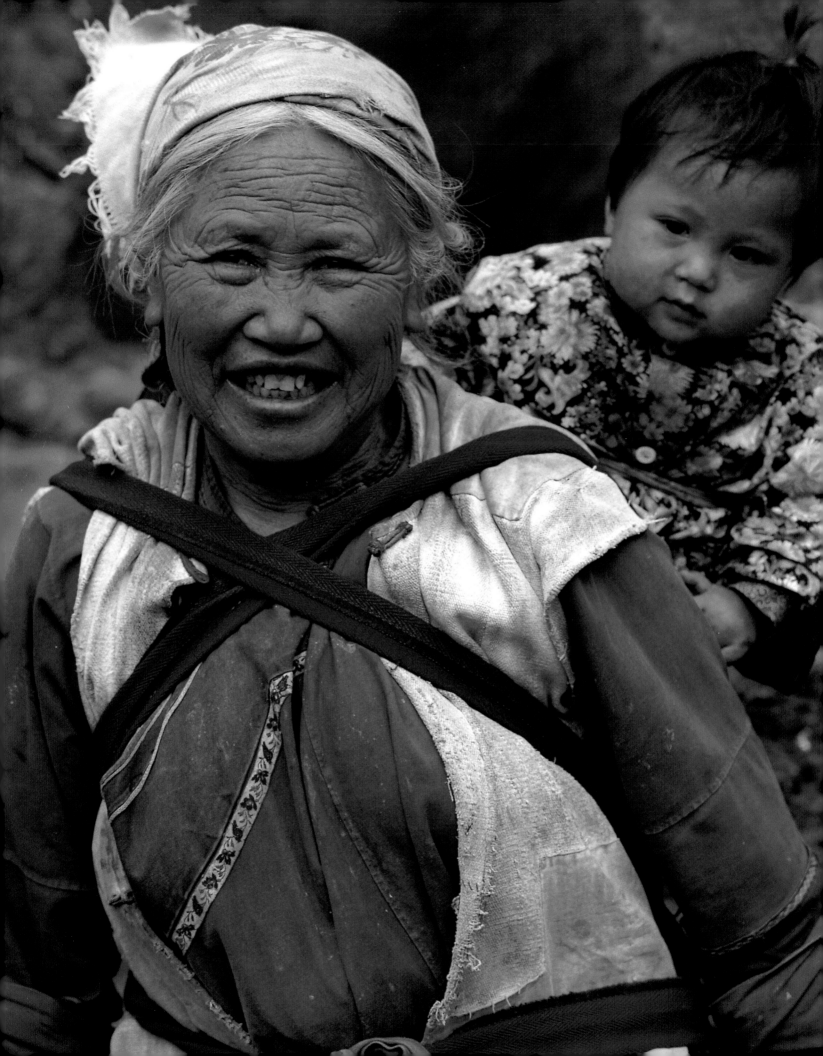

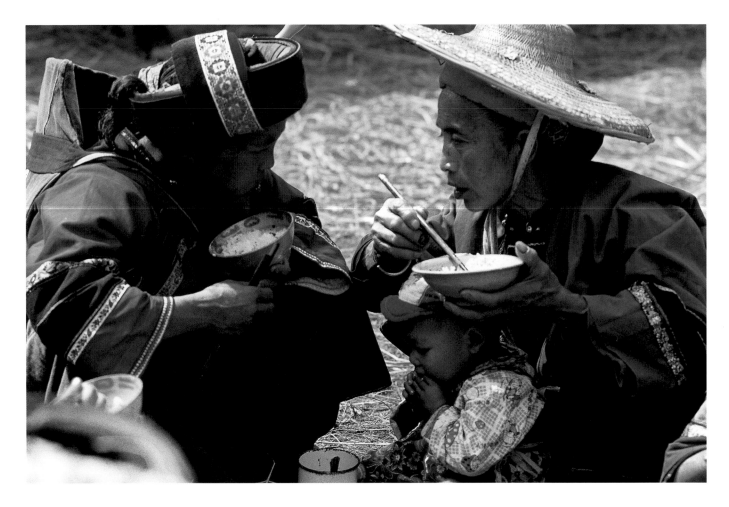

The first nourishment the African infant receives is bitter, to initiate it from birth into the pangs that will pursue it for the rest of its life. Among the Kissi of Upper Guinea, "the midwife rubs the child's lips with a juice made from peppers and cola nuts; the same remedy will be applied in due course to the child who refuses to suckle".[3]

The mother then bathes the infant in a gourd filled with water, rubbing its tiny body all over: "Every morning, the child will be washed, and massaged with shea butter. The baby will also undergo certain prescribed physical procedures. It is taken by the arm or leg, and its natural orifices are scraped and cleaned. For the Malinke, a human being does not just emerge and develop at will. When the infant is born it is still an unfinished being. The midwives, the smith (a woman) and the mother's sister, first wash the child with black soap. They open its mouth to examine it and check whether there are any teeth – the sign of a special individual – and study its width, a sign of beauty.

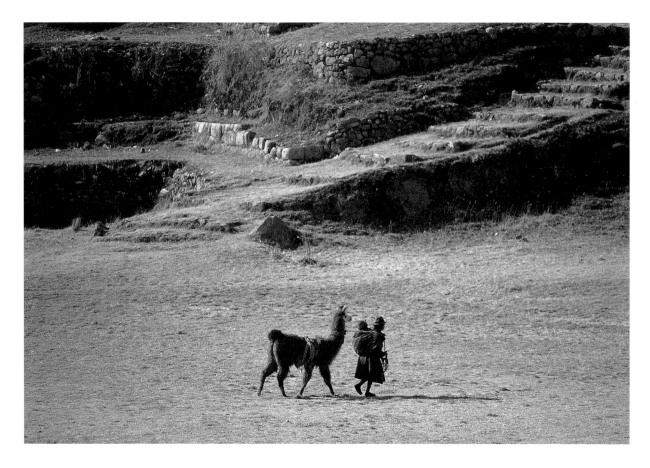

Next the eyes are examined to see how the lids open and the size of the sockets. Finally, the head is scrutinised so that any malformation of the skull can be rectified. The amount of hair is also important. A baby who arrives without hair symbolises the return of a former family member: a grandfather or ancestor".[4]

The naming of children

African children do not receive a name before they are seven days old in case evil spirits discover their whereabouts and steal them. The mother reappears for the first time in public to present the infant to the men of her father's family; by giving it a name they accept the child's presence and allow it to assume its place in the family line. The baby leaves its original home – the placenta – to enter the house of its father. The name given is, in fact, according to our conceptions, a forename, as the family name remains the same from one generation to another.

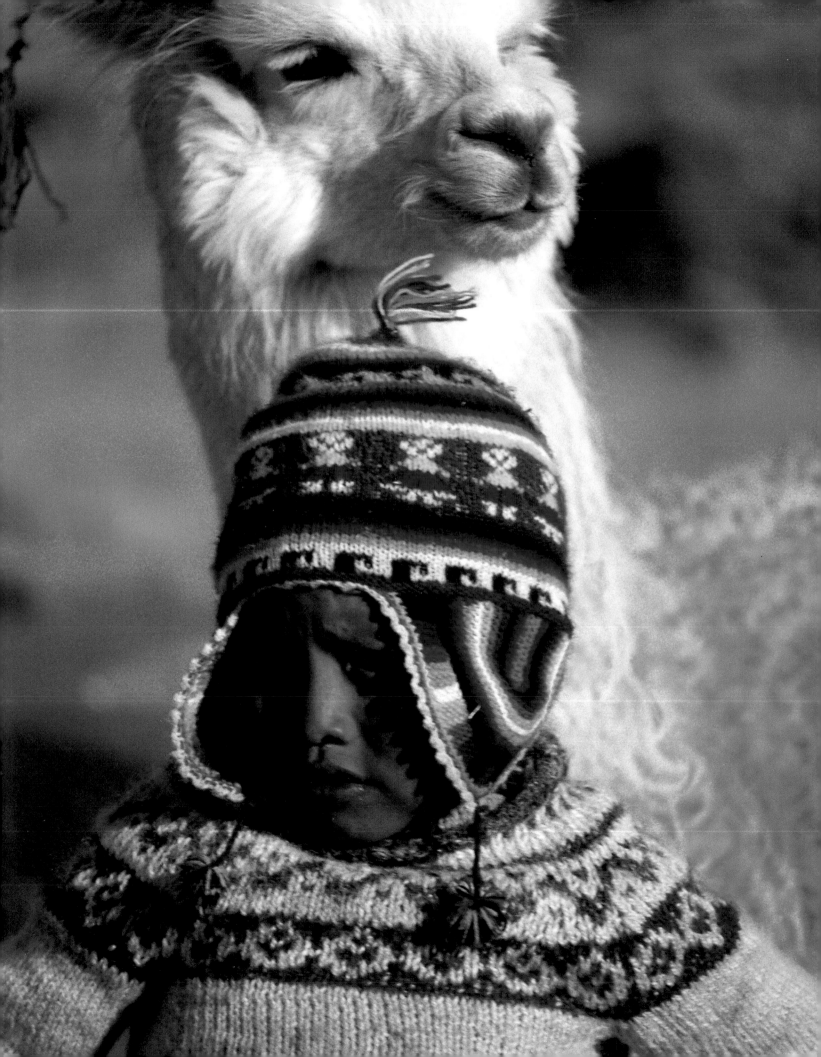

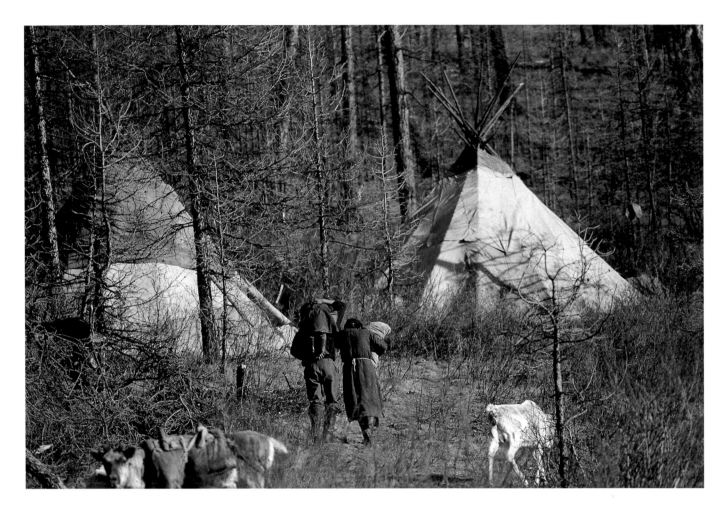

Returning to the "tepee" for the night. The Tsatang, who breed reindeer, are the only Mongolian nomads not to live in round "yurts" made of felt. Hovsogol Aymag, Mongolia.

In times gone by, a new-born child in the West was immediately washed and clothed. "In the nineteenth century, infants were baptised within hours, or at the most three days, after birth"; this allowed them to enter Paradise in their state of innocence if they failed to survive. Further, the child was made to wear a bonnet protecting its head; because this came into contact with the holy oil during the sacrament of baptism, "the bonnet acquired a sacred character".[5]

Among the Brahmins of India, the naming ceremony takes place about twelve days after birth, on a favourable day of the lunar period, an even-numbered day for girls and uneven for boys. According to Margaret Sinclair Stevenson,[6] if a mother has lost more than one child, the infant will not be named for six months or a year. If the family has suffered a death or some ceremonial defilement, the christening will be deferred to a more propitious moment.

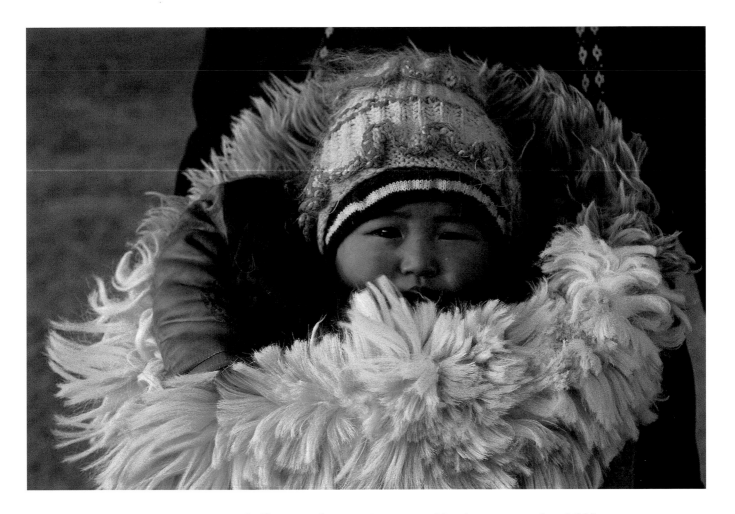

During the freezing winters (−40°F/−40°C), children are wrapped up and transported in baby-carriers lined with sheep's wool hung from their parents' necks. Hovsogol Aymag, Mongolia.

In Vietnam, the most important thing is to protect the child from the attentions of evil spirits. "If a child is not given a personal name before it reaches four or five months – and sometimes four or five years – it is in the hope that, being anonymous, it will be more likely to be overlooked by the dark and dangerous forces".[7]

The Javanese child at birth "receives one or more names, chosen in principle by the maternal and paternal grandparents. An individual may change these over many years: a child who is frequently or seriously ill, for instance, is given a new name. On marriage, it is possible to adopt a more meaningful name. A couple can agree to create a completely new name composed of elements of existing names from the two families".[8]

Among the Amazonian Indians, children are often not named for two or three years: the parents will only then come to believe they will survive.

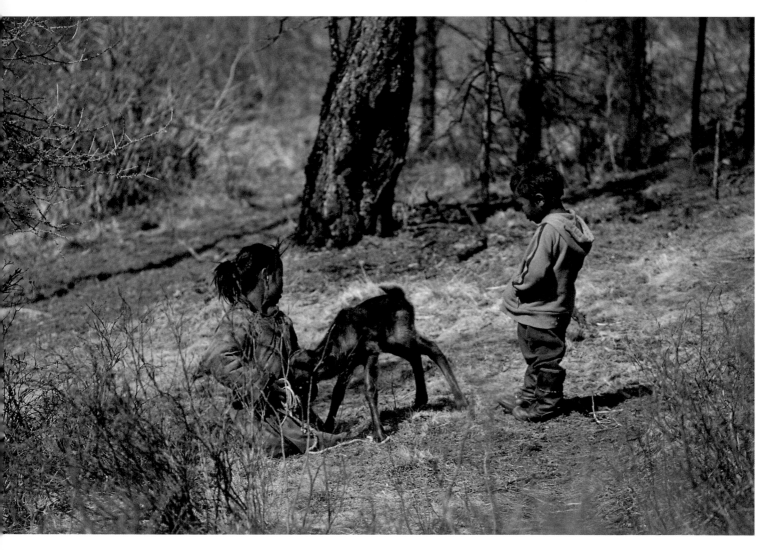

Tsatang children
tending a week-old
baby reindeer.
Breeders believe
a reindeer should
not be touched
until three days
after birth.
Hovsogol Aymag,
Mongolia.

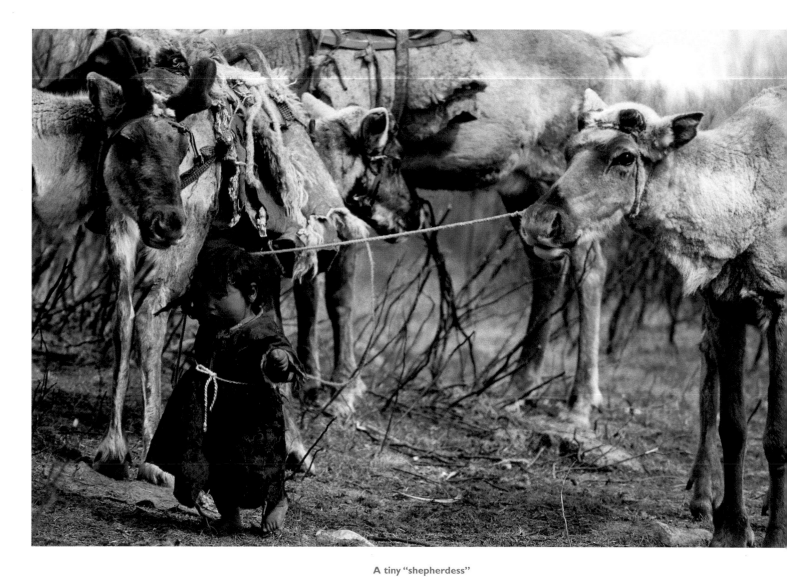

A tiny "shepherdess"
struggles to return
her reindeer to
their enclosure.
Hovsogol Aymag,
Mongolia.

Adoption

ABOVE:

This infant has been placed in a basket normally used to collect yak dung. Tsangpo Valley, Tibet.

RIGHT:

The tearful face of a child lost in the milling and dusty throng at a Sunday market. Kashgar, oasis of Western China, on the borders of Kyrgyzstan, Tadzhikistan, Afghanistan and Pakistan.

Children are expected to bring wealth to their families or, at the very least, comfort to their parents in their old age. A child who is lost must therefore be rapidly replaced. This is why many societies have evolved mechanisms for adoption, to consolidate or restore the unity of the group by introducing a child born in a different family.

In Vietnam, "the adoption of a younger son or daughter is quite simple; there are no formalities, and all that is required is the consent of the original parents (or at least of the father). In general, it is through charitable intent that a well-to-do family undertakes to bring up a child from a poorer one among its own offspring. Sometimes a sum of money changes hands: the mother receives two or three piastres for a child between eighteen months and five years old, whom she cannot feed and is not anxious to contact again. Almost always the adoptive parents remain on friendly terms with the true mother and father, and the child is expected to show due respect and obedience to both groups of adults".

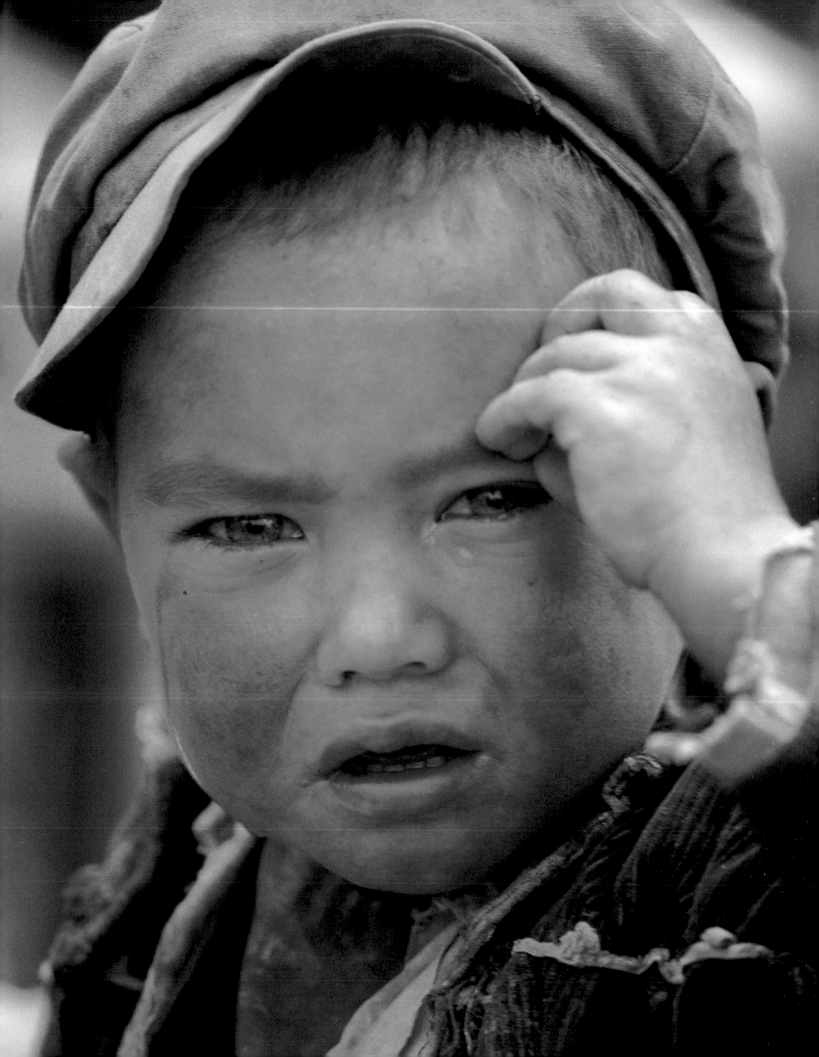

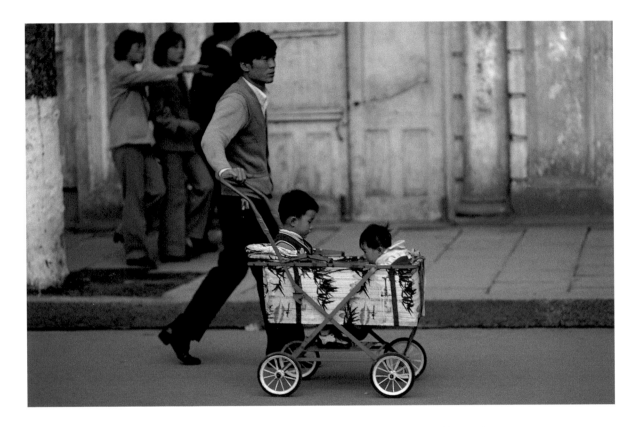

ABOVE:
Pushchair for two,
rare in China.
Shanghai

RIGHT:
Han twins.
Tonghai, China.

The natural parents have little reason to refuse adoption: it offers the child a privileged position in the new family without tearing it away from its real mother and father. "While they live, they will expect the child's respect and obedience; after death, its prayers and veneration. The child will take part in memorial rites in their honour conducted by its elder brother in the way it would have done itself, had it not been obliged to celebrate the ancestral cult of another branch of its family".[9]

Among the Algonquins, who live round the Great Lakes of North America, the death of a child could be compensated by the ritual adoption of another. "Upon the death of a child, a similar child was put into his place. This similarity was determined in all sorts of ways: often a captive from a raid was taken into the family in the full sense and given all the privileges and tenderness that had originally been given to the dead child. Or quite as often it was the child's closest playmate, or a child from another related settlement who resembled the dead child in height and features".[10]

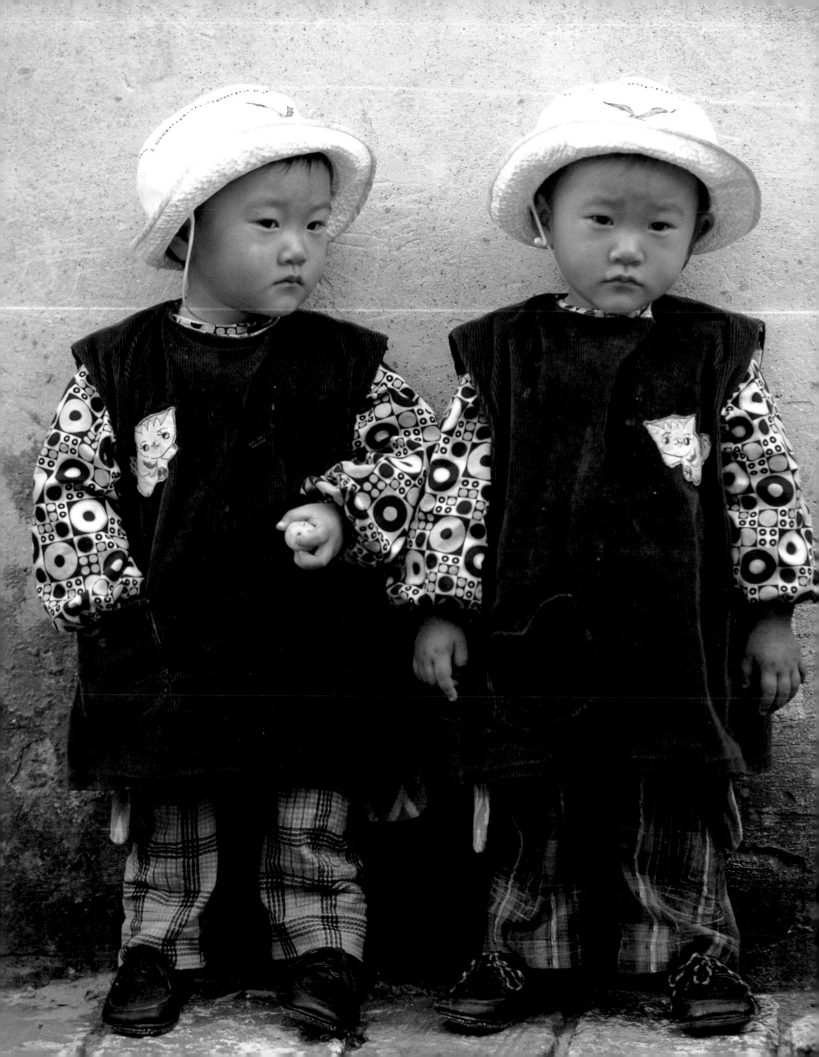

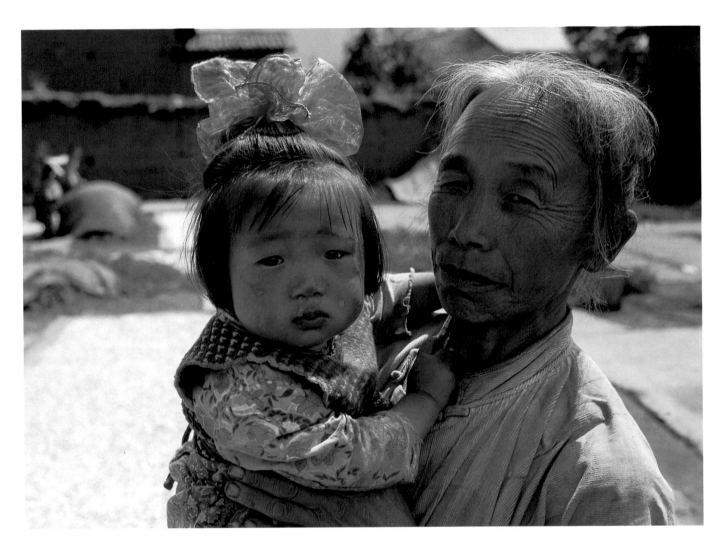

ABOVE:

Granny is often the
one who dries
the tears ...
Yunnan, China.

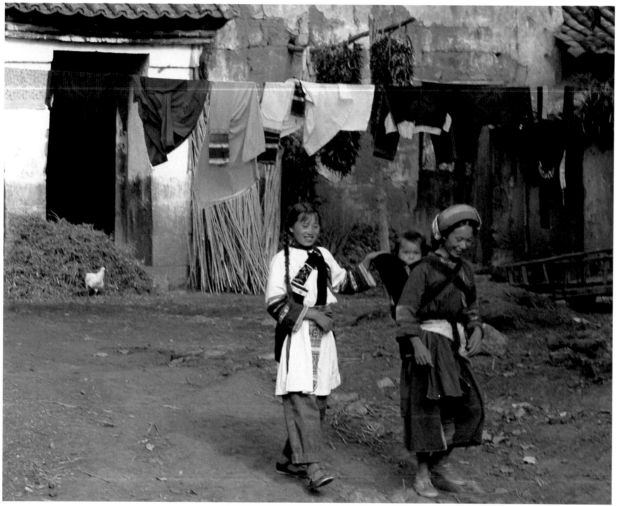

ABOVE:
Mother with baby
on her back; she
has just set her fresh
red peppers to dry.
Yunnan, China.

RIGHT:
New-born Uighur
children are tied to
their wooden cradles
in the hope that the
back of their skulls
will grow flat – a
mark of beauty.
Turfan, Xinjiang, China.

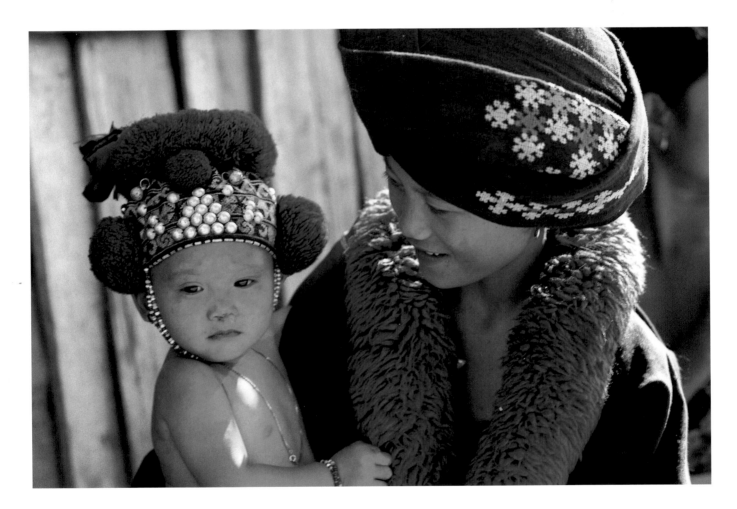

This Yao baby has shed
everything else – but
not that bonnet with
its pompoms and
silver pearls! Golden
Triangle, Thailand.

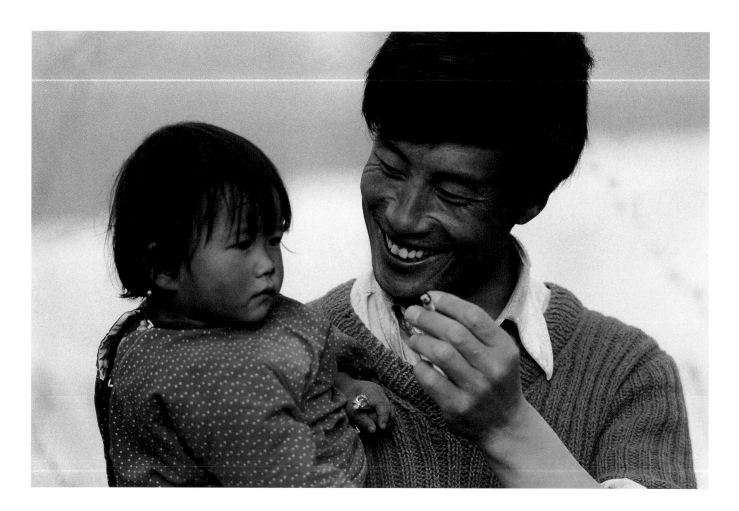

Proud father with
his only child.
Gansu, China.

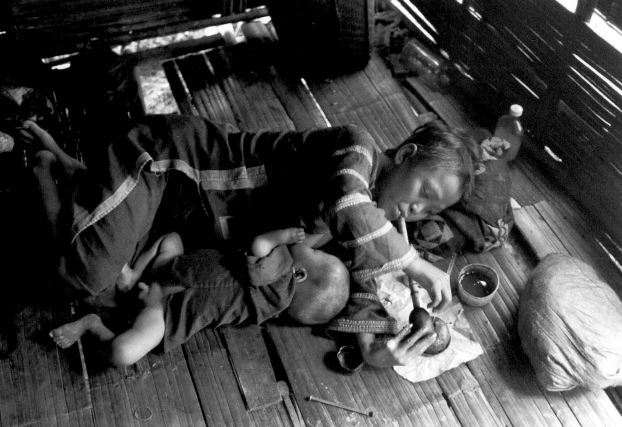

ABOVE:
"Sweet dreams ..."
Lisu baby sleeping.
Thailand.

LEFT:
A mother suckles
her baby while
smoking opium.
Members of the
black Lahu race of
Northern Thailand.

OPPOSITE PAGE:
As always, the older
children look after
the younger. These
are Lisu, from
Northern Thailand.

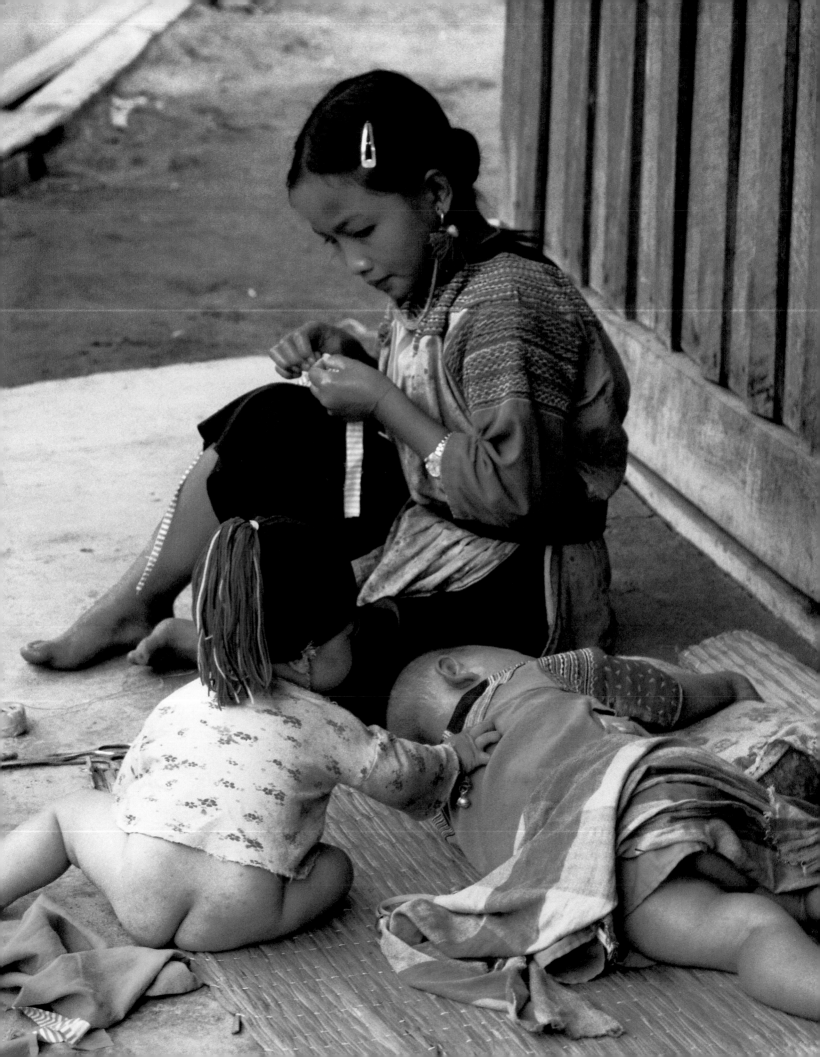

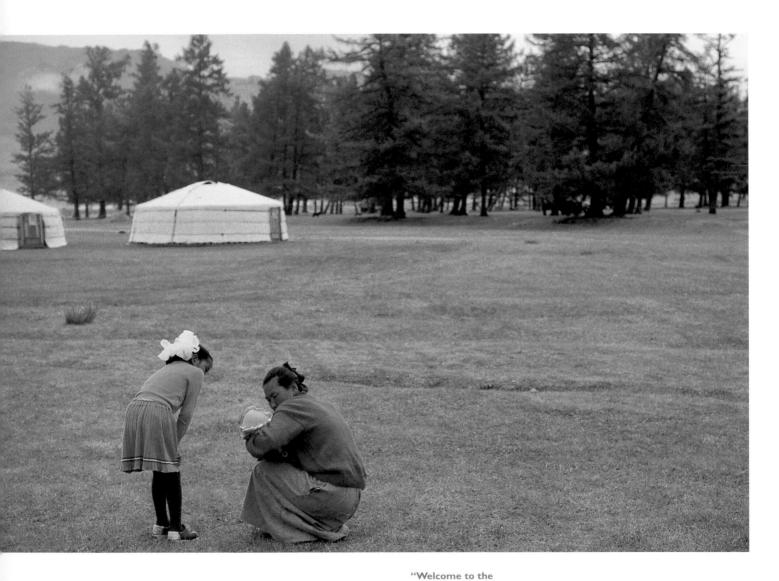

"Welcome to the
steppe in summer".
Zahvan Aymag,
Mongolia.

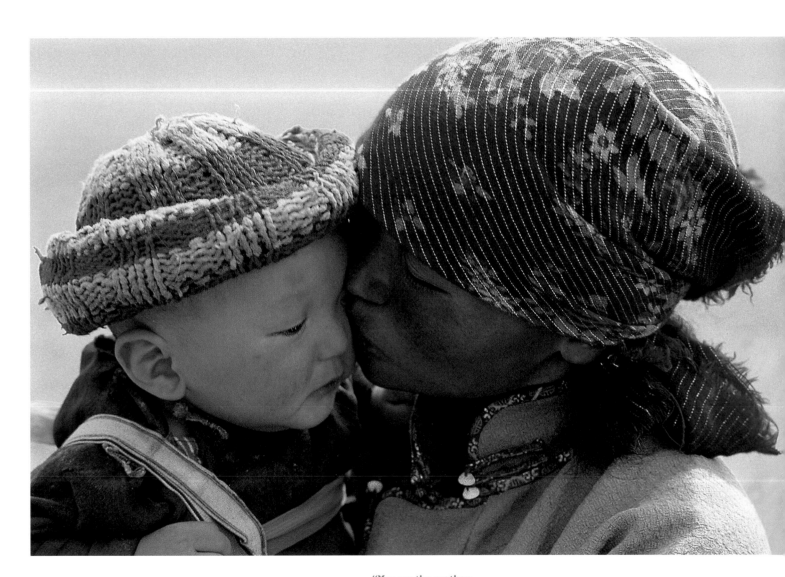

"You are the mother
of love – the mother
of all things".
(Sahara Sunday Spain,
nine-year-old poet.)
Gobi, Mongolia.

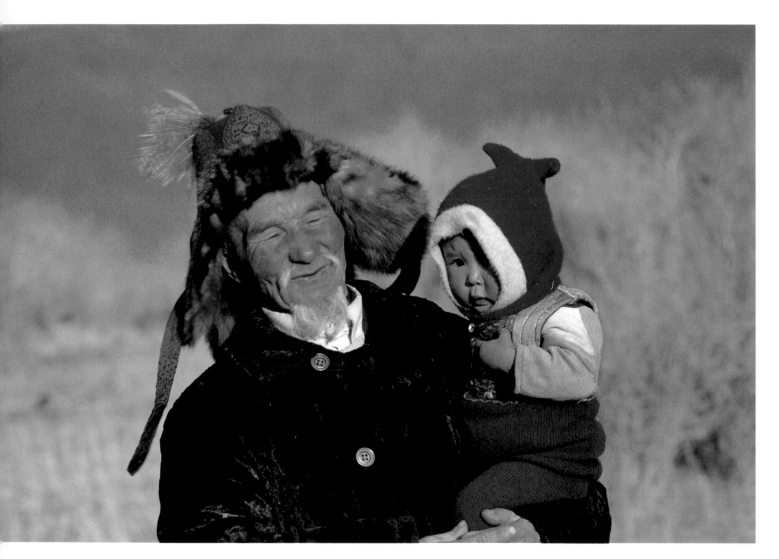

Kazakh nomad and grandson. One day the boy will learn to tend the Bactrian camels and decorate his bonnet with lucky owl feathers, like the old man. Altai Mountains, Mongolia.

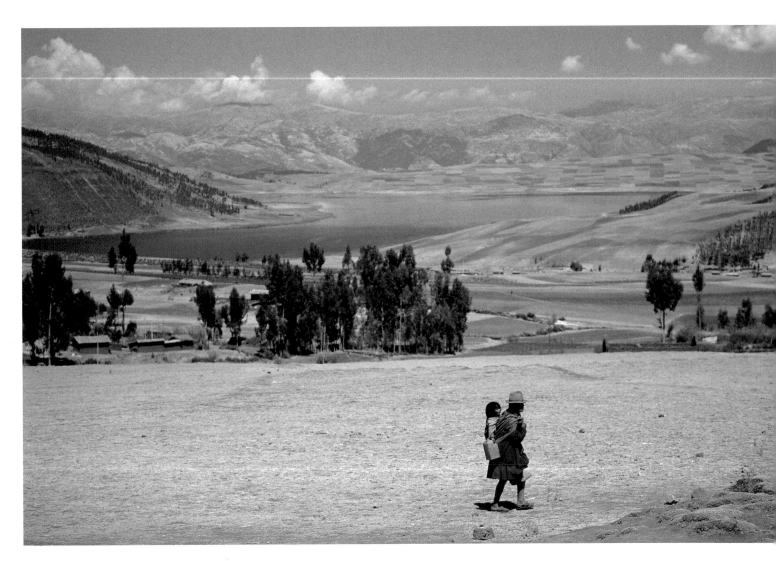

During their earliest years, all the children of the Altiplano are carried on their mothers' backs, firmly attached, and snugly pouched in woollen ponchos. Andes, Peru

Most of the world's
infants are carried on
the back, often wrapped
in some sort of
material, a shawl or
a poncho – or placed
in a home-made
baby-carrier.

ABOVE AND LEFT:
Mother and baby of
the Yuanyang minority,
China.

OPPOSITE PAGE:
Women of the minority
races of Southern China
expend considerable
labour embellishing
their baby-carriers
with masterpieces
of embroidery.
Aliao Shan, China.

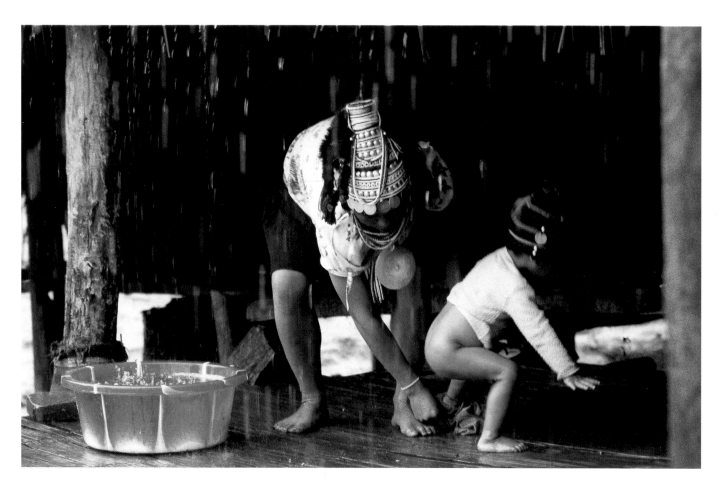

ABOVE:
Bath water falls from heaven! The monsoon brings abundant rain, normally so rare. The rest of the year, water has to be carried home in pots from wells or springs, often for miles, through the jungle. Akha of the Golden Triangle, Thailand.

RIGHT:
The innocent smile of a small Yao girl as she clutches the emaciated hand of her father. Thailand.

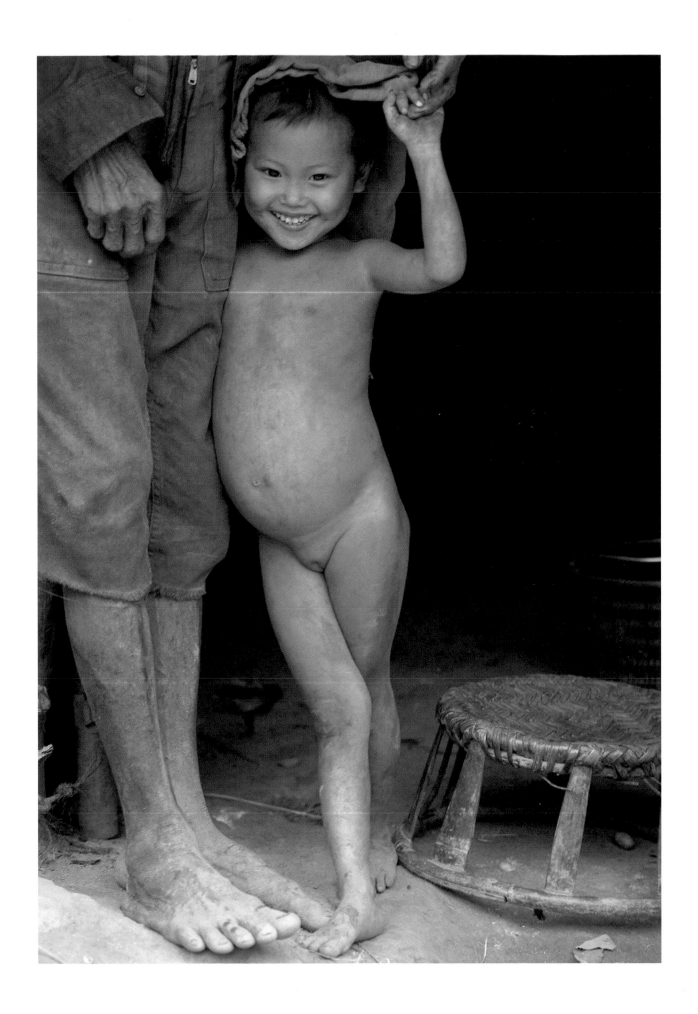

ABOVE:
Bonga mother
suckling infant in
a coffee plantation.
Babaka, Ethiopia.

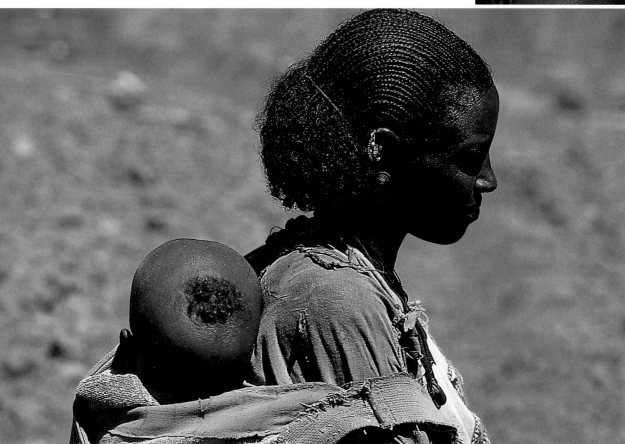

ABOVE:
A mother hoes a
stubborn, parched
field; her baby is
carried in a pouch
made of leather
and fabric.

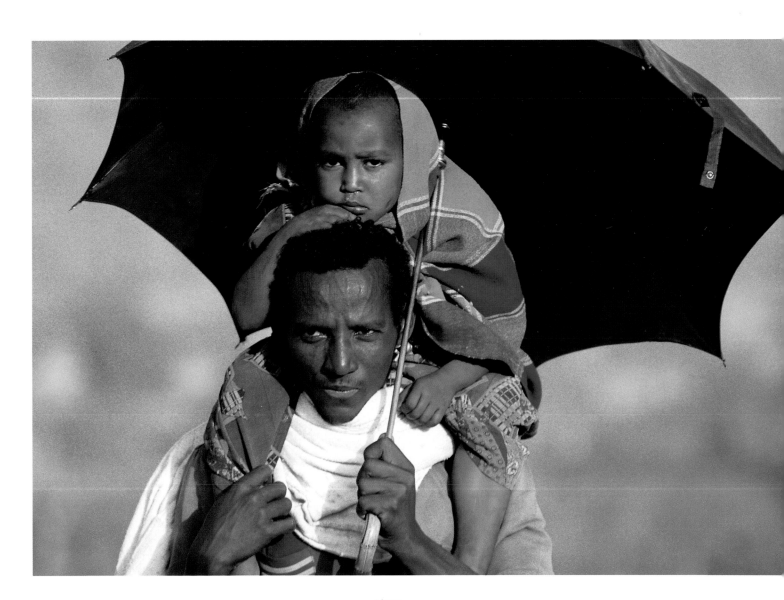

ABOVE:
Nearly 10,000 feet (3,000 m)
up, on the "roof" of Africa,
the sun's rays are so
powerful that parasols are
needed.
Godjam, Ethiopia.

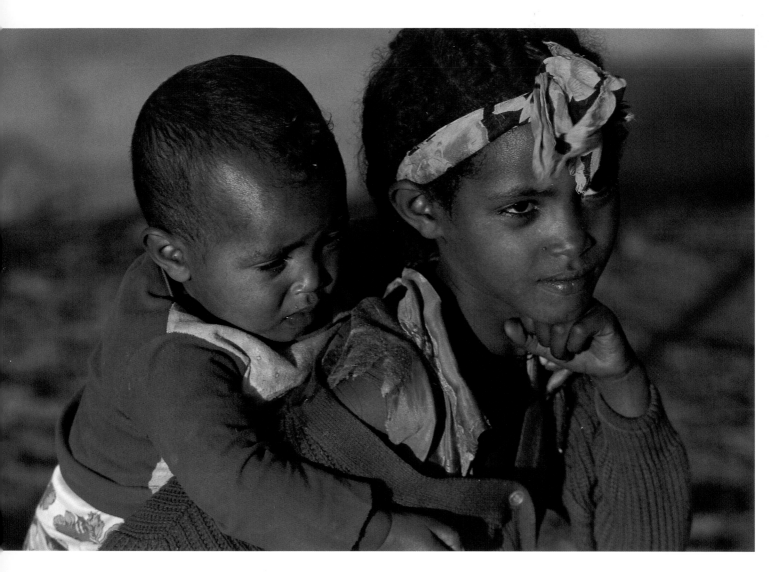

Happy to look after the younger ones while her parents work the fields or guard the flocks. Lalibela, Ethiopia.

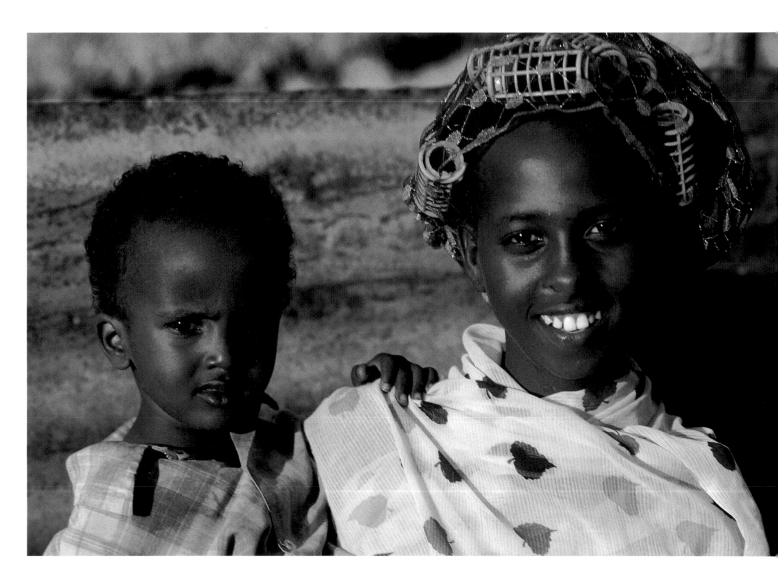

Pink curlers.

Beledweyne, Somalia.

Growing Up

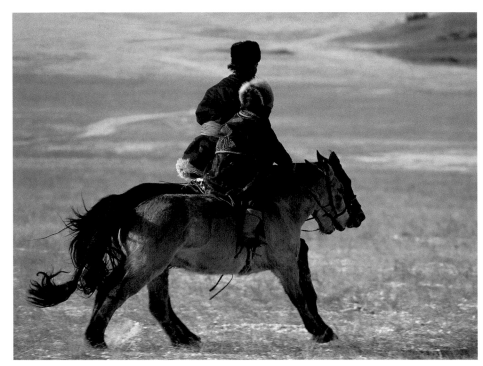

Childhood is a privileged time, but it is all too brief. Until a boy or girl
reaches the age when it is able to reason, every child
belongs to its mother. She is the one who brings the infant into the
world and rears it. At the age of around seven, a boy's education
will be taken further, under the guidance of his
father or a paternal uncle.

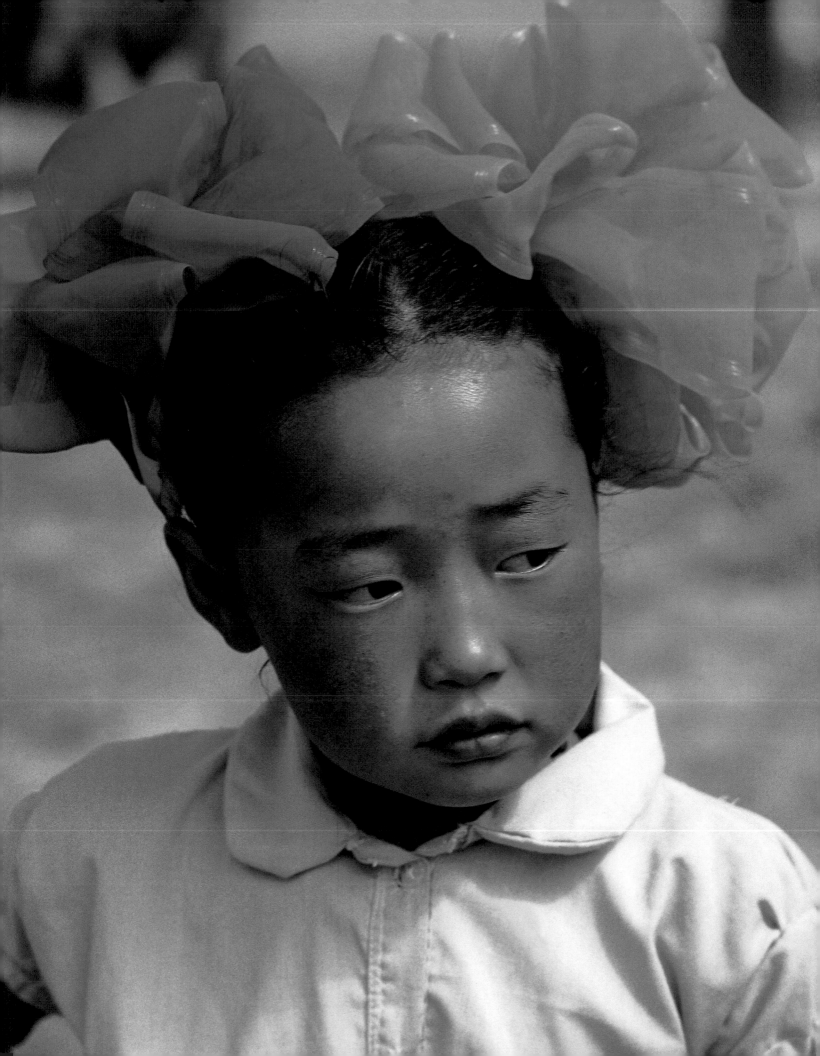

In general, mothers pamper their toddlers. "Cham children in Vietnam are frequently spoiled by their parents, who let them have their own way. To please the benevolent deities, mothers often smear the cherubic faces of their small children with a mixture of flour and saffron. As saffron is yellow in colour, the sight of it can hardly fail to awake pleasurable sensations in the bodies of the gods who, according to legend, have golden faces.

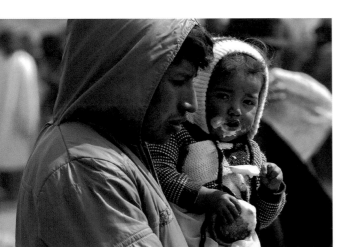

On the other hand, if the toddler has a nightmare, its mother may sometimes daub it with soot to repel the jealous attentions of evil spirits".[1]

Among other minority races in Vietnam, "the education of the young does not imply any kind of authoritarianism. No one ever smacks a very small child. (Things are different with the true Vietnamese: both father and mother make use of their right, recognised by law, to inflict corporal punishment on their children.) The mother carries her infant on her hip or her arm, watches its every antic as it crawls

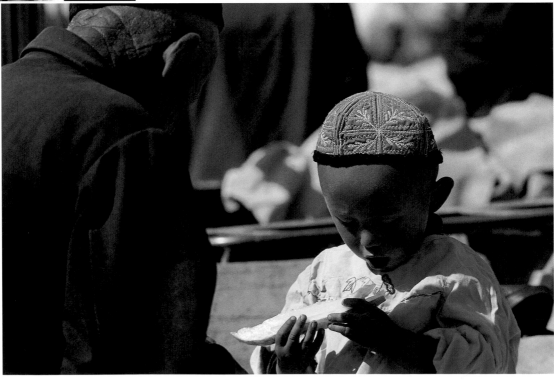

ABOVE:
A child with a face like an angel, smeared with ice cream. Saquisili, Ecuador.

RIGHT:
Nothing quenches thirst like a juicy melon from Hami, an oasis on the Silk Route beside the Taklamakan Desert. Xinjiang, China.

OPPOSITE PAGE:
Twins with water-ices. Turfan, China.

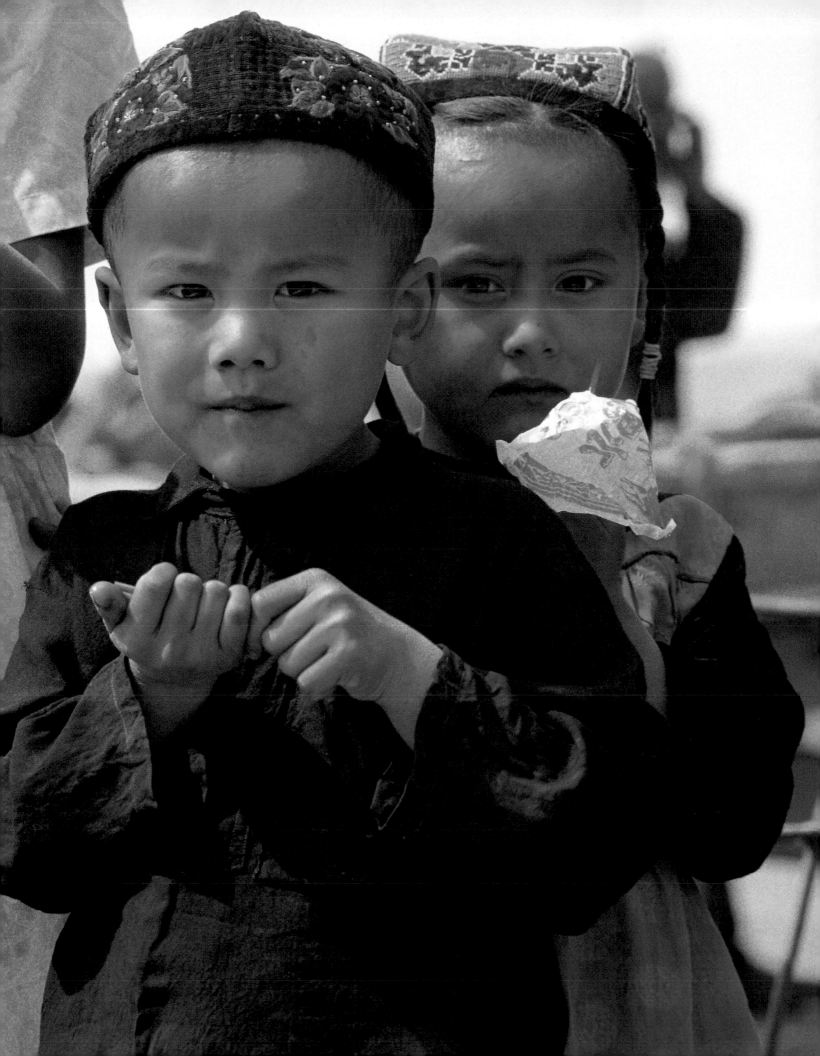

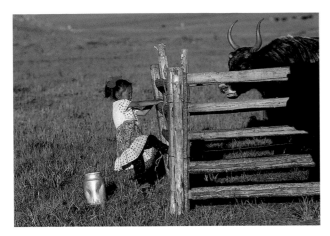

beside her, guides its first walking steps, cuddles and hugs it, seemingly ready to indulge its every whim".[2]

Mothers are never reluctant to carry their children in their arms or hold them close. "In the whole of the Far East, kissing is replaced by a sort of sniffing conducted at the base of the neck and near the ear. Children especially seem to adore this demonstration of maternal affection, laughing wildly each time it happens".[3] The same custom is found among the Mongolians: "When the nomads wish to show affection for their children, they do not kiss them, but sniff their heads".[4]

Children of Vietnamese minorities "do not bother with clothes before they are five. They merely wear a metal disc, suspended from a cord, over the genital area. Sometimes the child will wear an iron anklet (with a small, spherical bell attached) riveted round its leg by the local blacksmith. This is a mark of servitude. From that moment, the infant is dedicated to the spirits, who take it under their powerful protection".[5]

ABOVE:
Face to face: little girl and yak. Arhangai Aymag, Mongolia.

BELOW:
Yellow-ribboned girl approaching a couple of yurts. Steppe in summer, Arhangai Aymag, Mongolia.

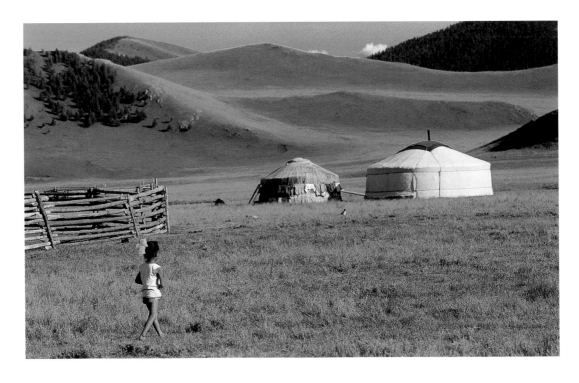

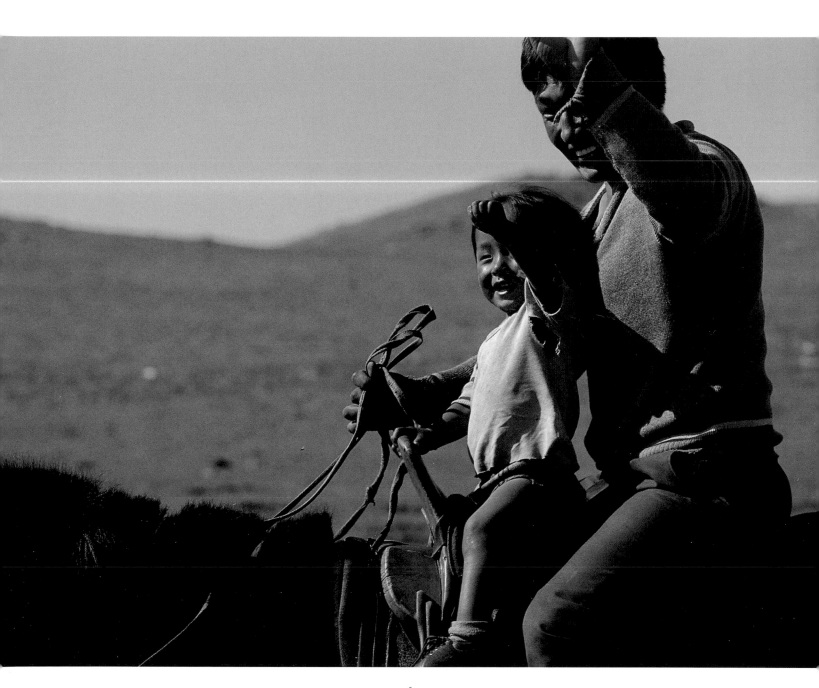

ABOVE:
They say that
Mongolian children
can ride before they
walk. Zavhan Aymag,
Mongolia.

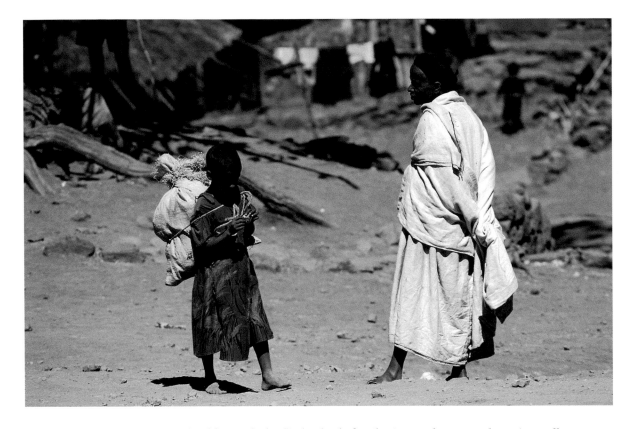

ABOVE:
Opening one's heart
to grandma.
Lalibela, Ethiopia.

OPPOSITE PAGE:
A coffee-planter's
son, enveloped
in the traditional
white shawl.
Kefa Province, Ethopia.

An African baby "is looked after by its mother, on whom it totally depends until it is weaned. During the day the baby sleeps on her back, moving to the rhythm of her pestle as she pounds grain; at night, it sleeps by her side. Morning and night she washes her infant in warm water, sometimes rubbing it with palm oil. Babies are breast-fed until about one year old; from then on they are given rice gruel, and their diet begins to resemble an adult one. Weaning is progressive; frequently a child of three or four is seen at its mother's breast, but this now serves only to provide comfort rather than nourishment. An old woman looking after a baby in the mother's absence will offer the child the teat of a completely flaccid breast, rather like a rubber comforter. During the first three or four years, children are cosseted; the father dandles them when they throw tantrums and yields to their caprices. Until the age of five or six, the infant belongs to its mother, from whom it rarely receives anything but affection and indulgence. It enjoys almost unbridled freedom".[6] For the mother, this period of infancy represents "the loveliest part of her life; she will want to keep it pure and beautiful as long as she lives.

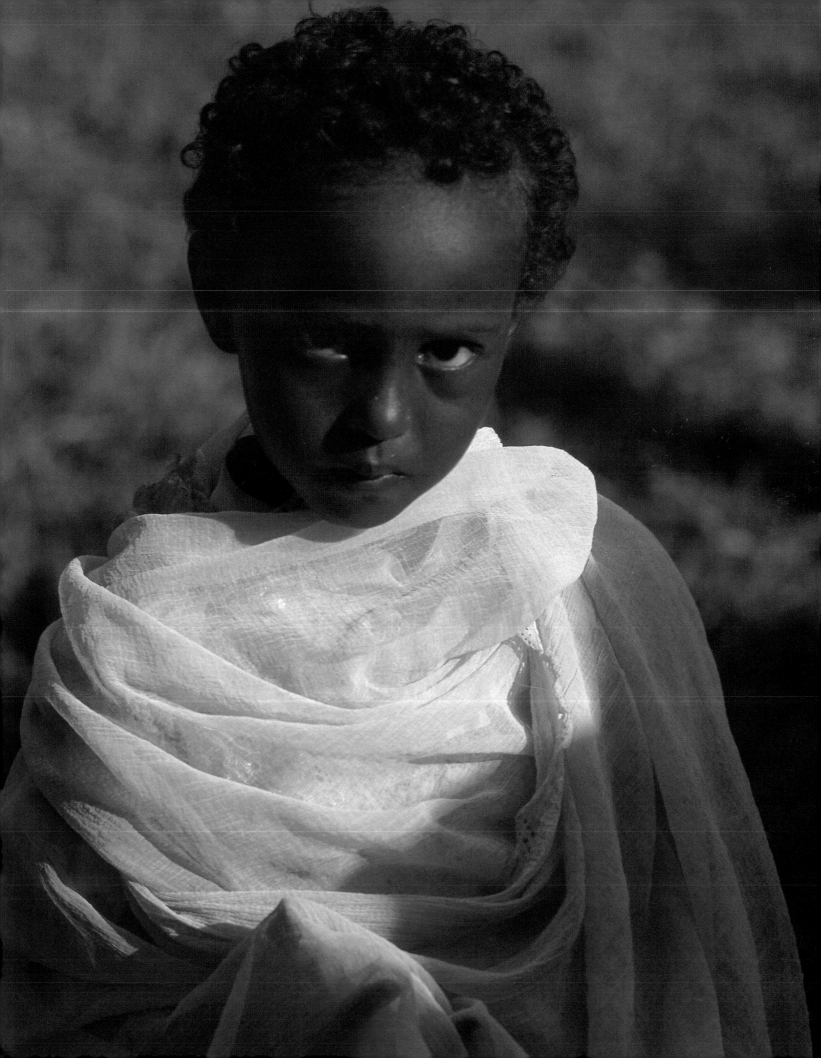

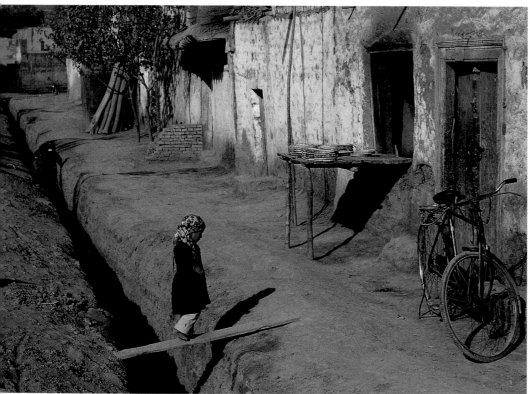

ABOVE:

First haircut. Sunday
market at Kashgar,
Xinjiang, China.

LEFT:

Little girl crossing
an irrigation ditch
on a narrow plank.
Kashgar, China.

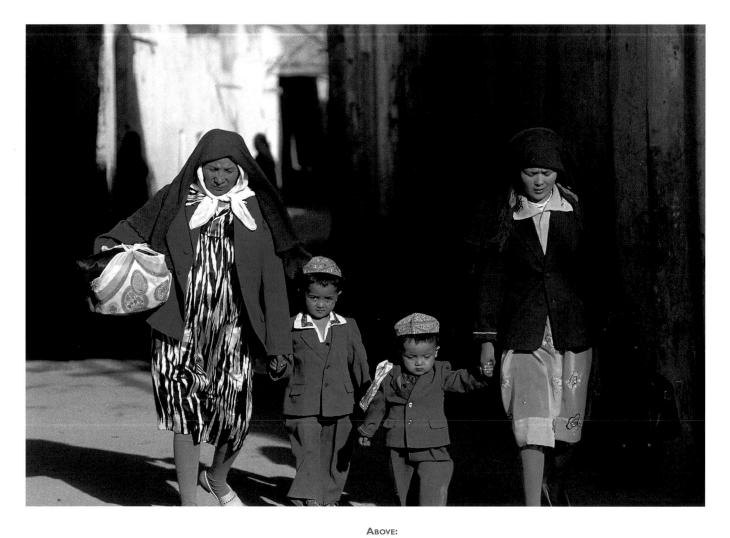

ABOVE:
Sporting their "Friday
best", a group sets
off for prayers at the
Grand Id Kar mosque.
Old quarters of
Kashgar.

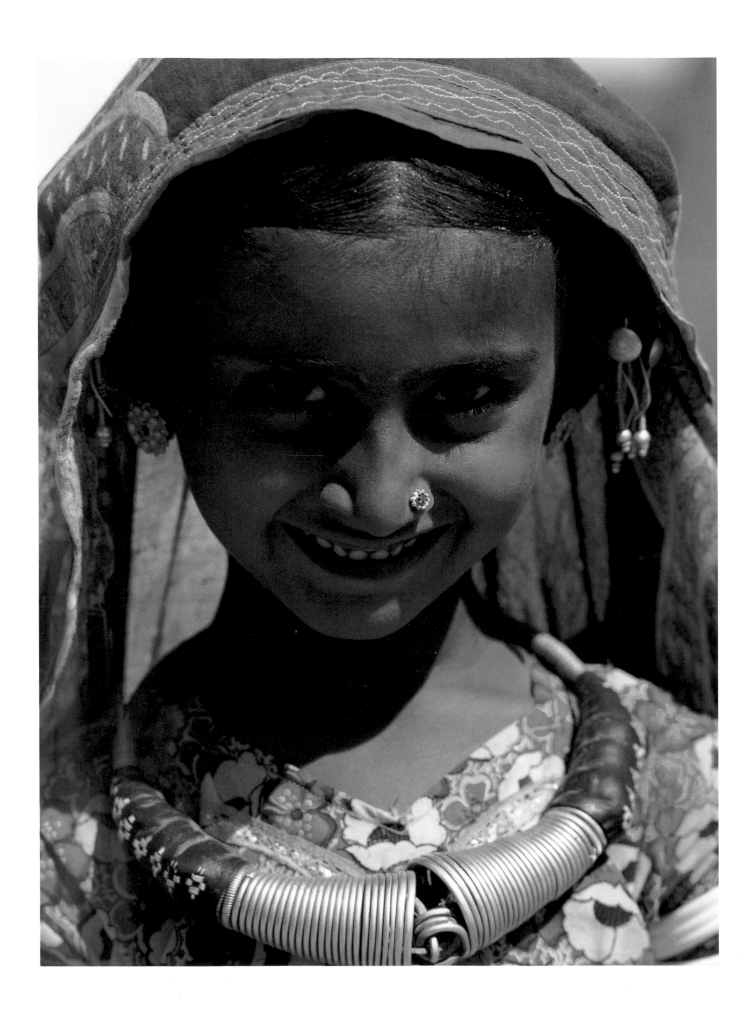

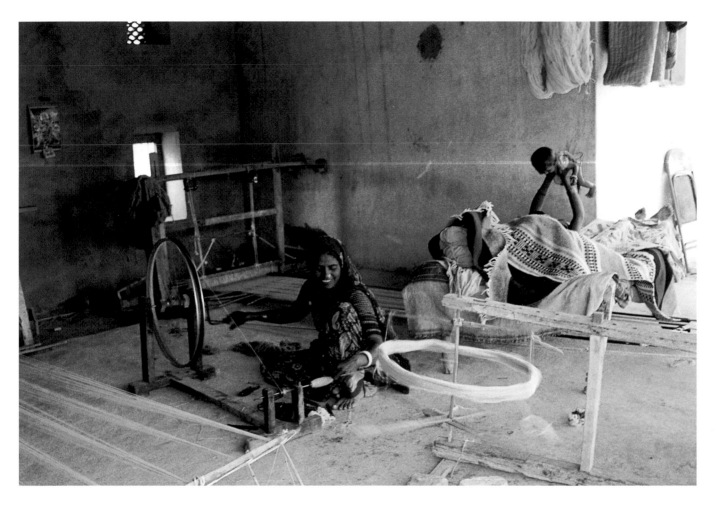

OPPOSITE PAGE:
Portrait of a
young Banni girl.
Great Rann of
Kutch, India.

ABOVE:
Gandhi's dream
lives on: families
continue to spin
cotton at home.
Great Rann of Kutch,
India.

'He is the apple of her eye', people used to say, referring to me and my mother. Everything in the world she did was for my happiness". The child cannot disobey its mother. "She was my mother, with all the respect and gratitude that entailed".[7]

In Africa, the first seven years are a carefree time. The child remains with its mother or a relative; it learns the language and the elementary rules of society. The adults are patient, full of kind words; they strive to show the youngster the way ahead and develop its mind. They tell it educational stories, fairy tales and riddles to increase its understanding and explain how the world works.

At seven, when it has begun to reason for itself, the child is taken in hand by its father, who will provide a more formal education.

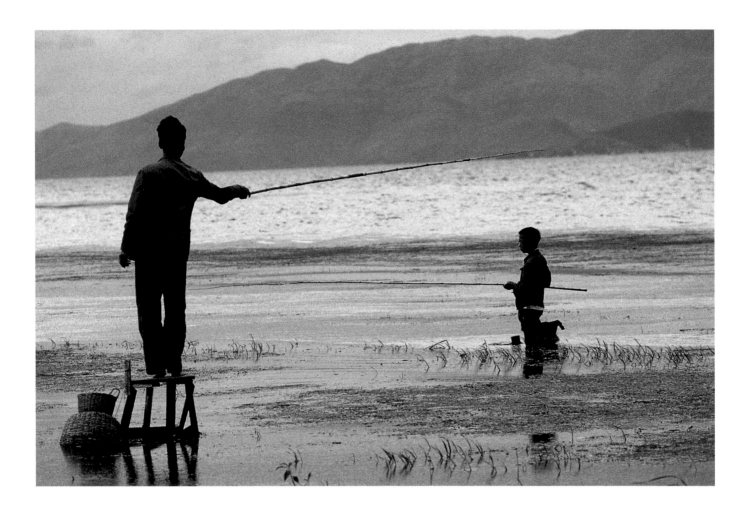

Taking after father: fishing in Lake Er Hai, Yunnan, China.

After this age, the African boy leaves his mother and maternal uncle – who have hitherto acted as his tutors – to be guided by his father and father's brothers. The carefree years of infancy are over; it is time for the boy to learn to socialise, in preparation for entering the real adult world. Young boys are admitted into the company of the adults whom they are expected to observe and imitate.

African parents "seldom exert their authority before a child is seven or eight. Punishments appear less frequent: at the age when the child would deserve a smacking it has most often already accepted the need to obey its elders".[8] Nevertheless, children are expected to make a sudden break from over-dependence on their mothers. The family takes turns to bring children up to respect the rules of the community, preventing them from becoming too attached to their biological parents.

Her first catch.

Guangxi Province,

China.

In Black Africa, boys are taken from their mothers, whether they like it or not, to be reared by the men. "In traditional society, the education of children is based wholly on the principle of seniority, each age-group having to submit to the authority of those above it, while acting as teachers to those below; this does not prevent the father, uncle or some other such relative having a privileged place in the child's upbringing".[9] It is the uncle, rather than the father (often absent) or the mother (too close and too indulgent), who tends to mould the character of the African child.

Children learn from their mothers by observation and imitation rather than by any formal instruction. In Africa, as in other regions of the world, the child is usually brought up by its grandparents rather than its parents, the latter being busy all day working in the fields. It is the grandparents, therefore, who teach their grandchildren the rules of polite behaviour.

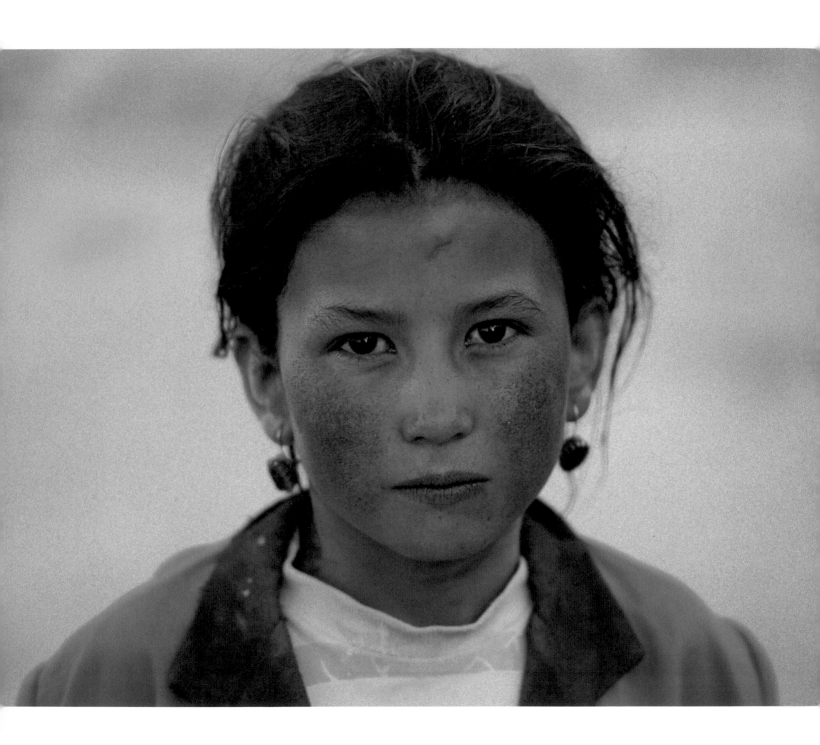

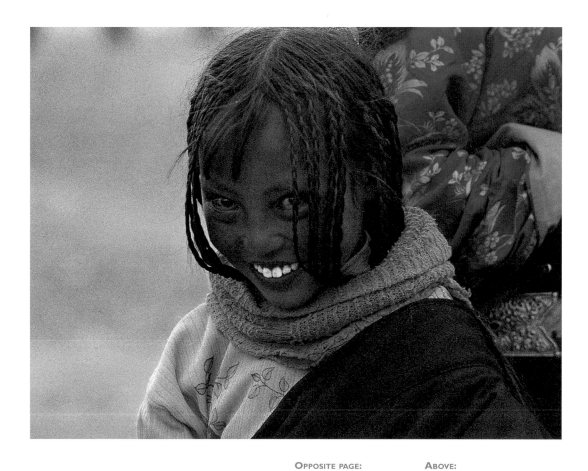

OPPOSITE PAGE:
Enigmatic expression,
cheeks reddened by
the sun, ruby glass
pendants: a young
Uighur beauty.
Kalamulak Oasis,
Dokuzdavan, China.

ABOVE:
Laughing eyes. Young
Nomad girl at a feast
in honour of a
rimpoche – a high
Buddhist dignitary
from Lhasa. Khampa
women wear their hair
in a large number of
slender braids. Kham
Province, Tibet.

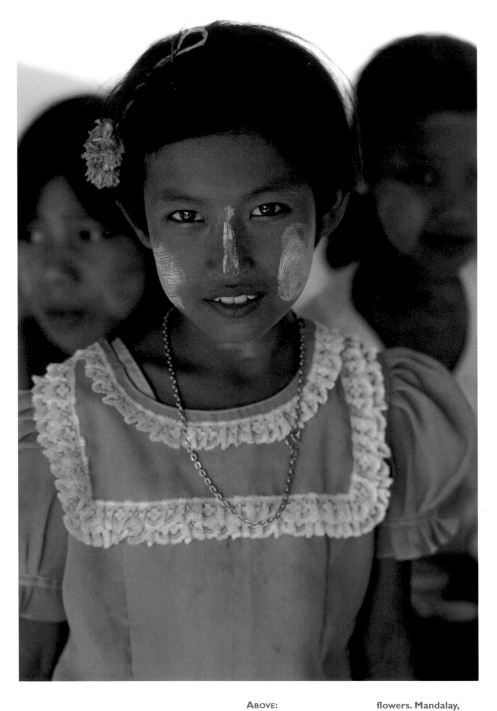

ABOVE:
Shan women apply a
kind of yellow "blusher"
to their cheeks and
noses – blended pistils
and petals of crushed
flowers. Mandalay,
Burma.
OPPOSITE PAGE:
Draining yoghurt.
Lake Dal, Kashmir,
India.

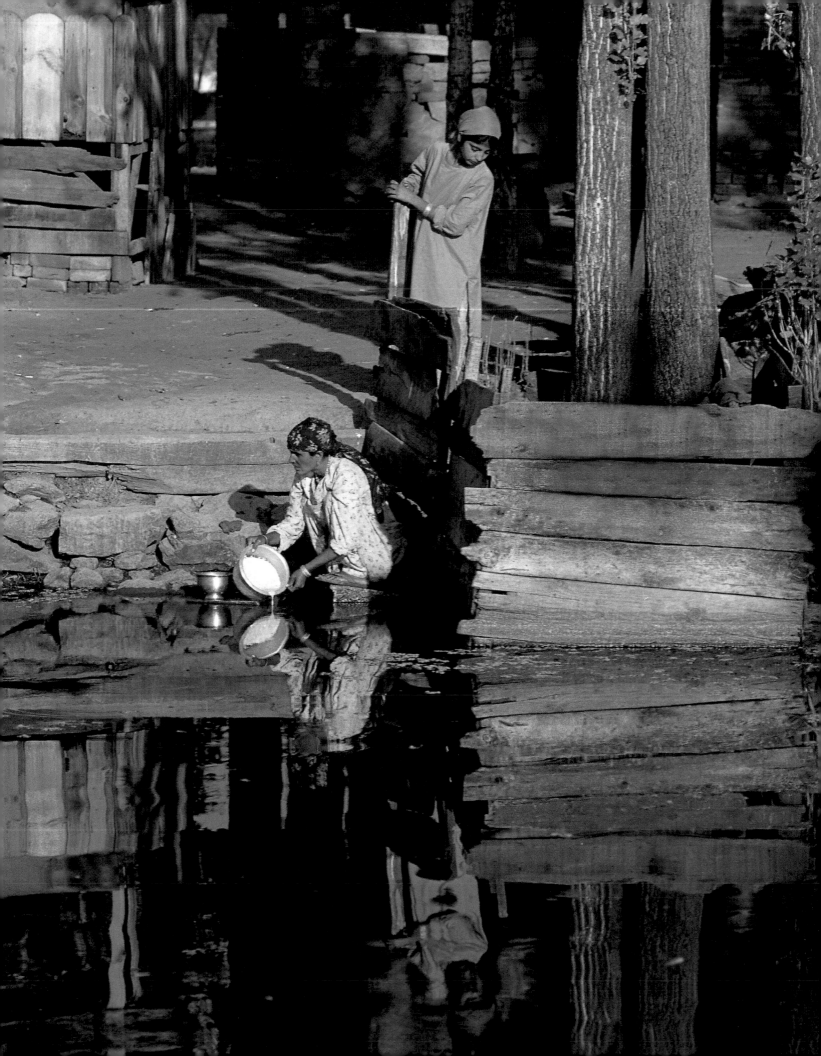

"From the earliest age, moral principles are inculcated through proverbs, riddles and stories told when all the family are gathered together between the evening meal and bedtime".[10] Legends and fairy tales, performances of traditional drama and songs play an equally determining role in children's upbringing. "In Vietnam, as in virtually all the Far East, a little girl is considered well brought-up when she can recite the endless rules of etiquette and protocol, which would amuse our European children. It is, for instance, improper to laugh in public to show one's happiness, but yawning with boredom is very elegant. When harvesting hemp, it is good taste to imitate the drunkenness that the plant can induce: this conserves its intoxicating properties. Should a household object crack, a cooking pot, for example, it is courting ill luck to throw it away. Politeness and courtesy should be given to inanimate objects as well as to people, so the cooking pot must be treated like a revered servant and must be hung under the piles of the hut or left respectfully to drift away on the current".[11]

The child, brought up by its mother for the first few years, will then be reared by its uncles and the group in general; they oversee the

BELOW AND OPPOSITE PAGE: Afternoon on the dunes: a bath in sand with curative properties. Tarim Desert, Xinjiang, China.

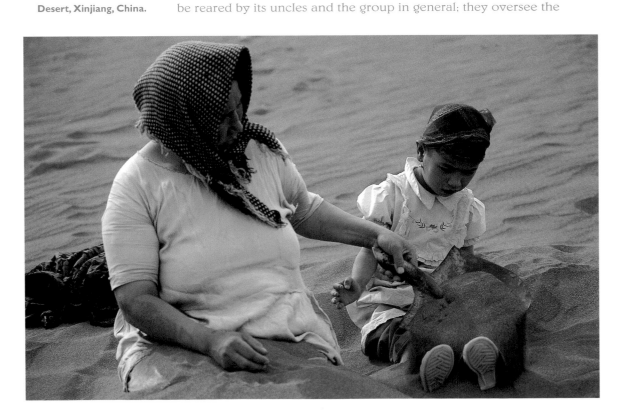

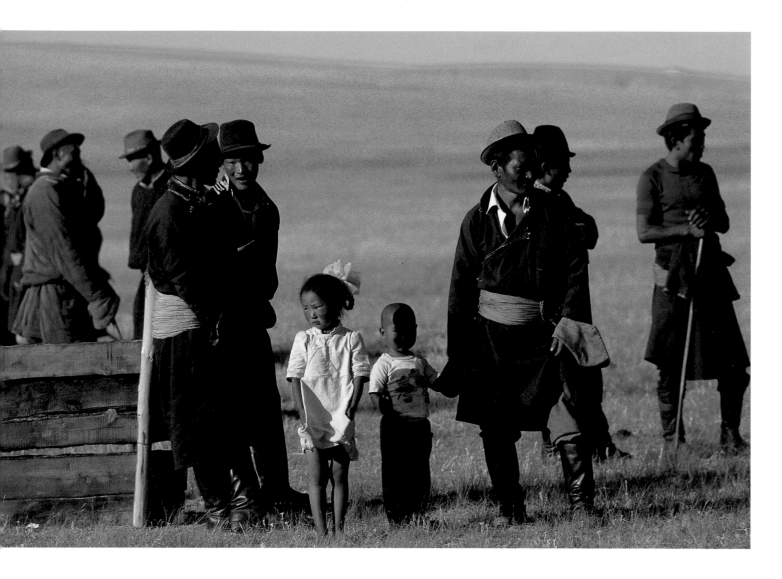

Summer on the steppe: fathers gather to teach their children the art of the *urga*, a large lasso fixed to a pole and used to capture wild horses. Near River Orkhon, Mongolia.

socialisation process, teaching the youngster how to behave in the community and to respect the rules. Everything is designed to transform the ignorant and callow youth progressively into a responsible adult who will maintain his place in society and play a role in its prosperity and renewal. So the boy must leave the tender, secure world of his mother's arms to prove himself in the world of adult males where his future development lies. It is precisely the inability to leave the mother that Dominique Fernandez[12] regards as the major failing of the Mediterranean system of child-raising; the men, spoiled beyond all reason during childhood by the womenfolk of the family, then behave like tyrants, first to their sisters, then to their wives.

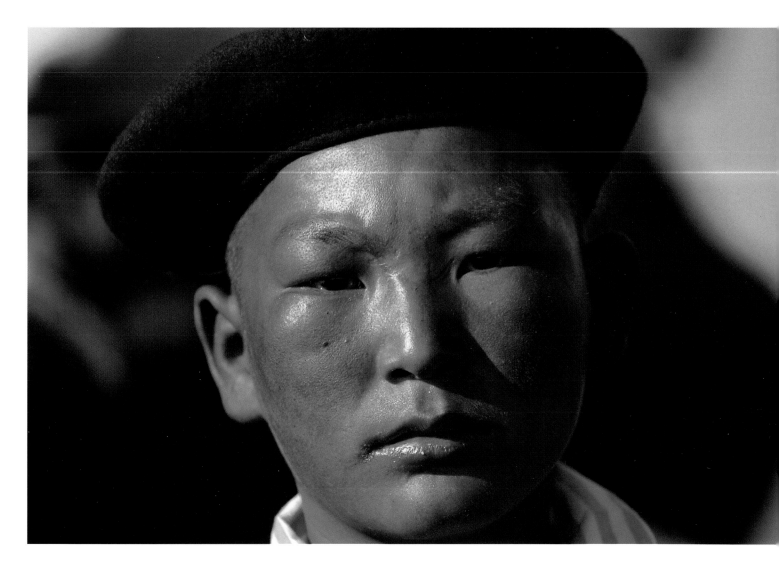

Young nomad wearing a beret. Karakoram region, Mongolia.

Respecting one's elders

In Africa and Asia, tradition teaches blind respect for the father, older relations (including brothers) and anyone of similar age. Although permitted to have fun with other children, the child must learn to be serious and reserved in front of its father, eat in silence in his presence, and never exhibit the slightest sign of emotion. Every story tends to reinforce this respect for the father and the elders. In South-East Asia, the *Vessantara Jataka*, the tale of the penultimate incarnation of the Buddha-to-be, tells how the prince offered his two children to the Brahmin Jujaka, who demanded he surrender them to prove his true detachment from earthly possessions.

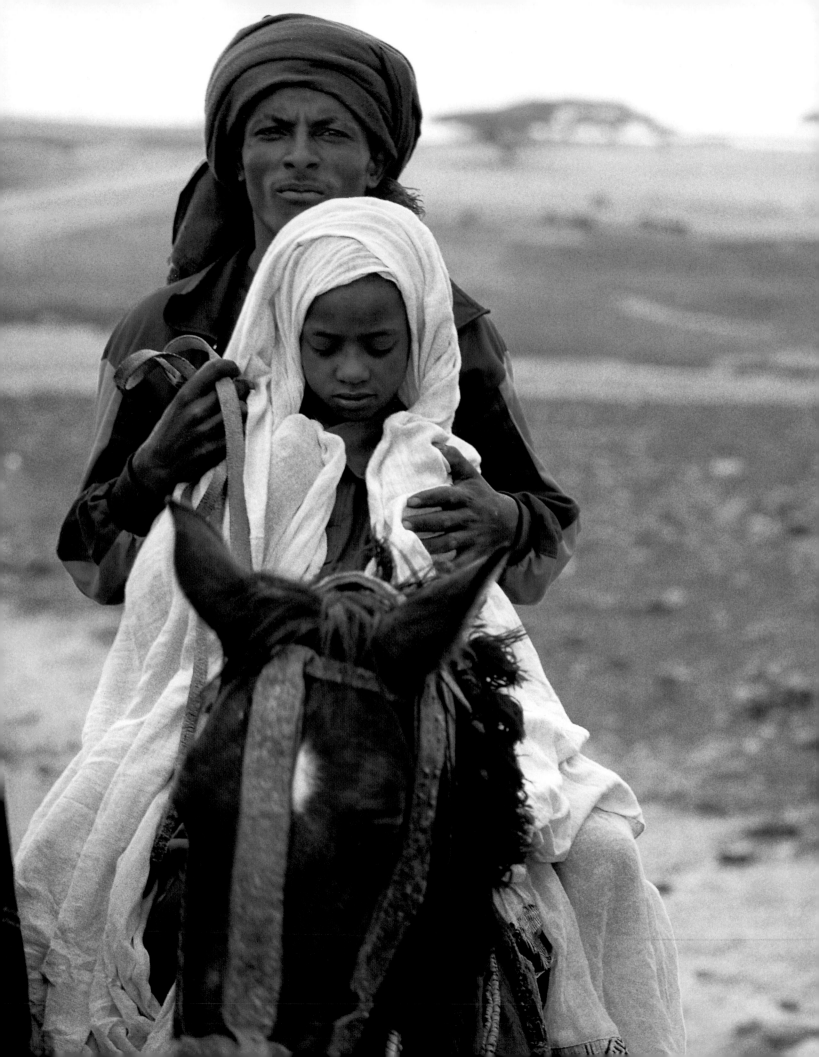

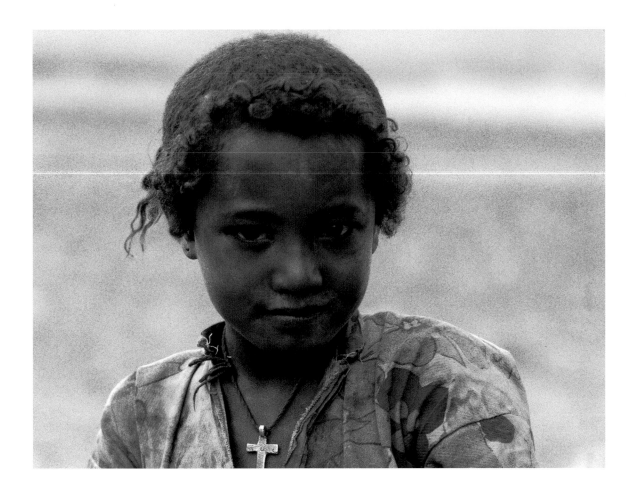

OPPOSITE PAGE: Nine-year-old girl being taken by her father to the house of her intended, where she will be married. In the Amhara tradition, the marriage will not be consummated until she finishes puberty. Simien Mountains, Ethiopia.

ABOVE: Amhara child wearing a Coptic cross from Lalibela. Gondar region, Ethiopia.

In the presence of relatives, especially a child's father and brothers, "African children were subject at meal times to a rigorous form of discipline. Those who broke the rules were punished, according to the gravity of their misdemeanour, with a severe look, a flip on the head with a fan, a slap, or quite simply sent away without food until the next meal".[13] Children must learn to behave in a restrained and serious manner with adults. They must show respect, which means thinking before speaking and never voicing private feelings or problems. Personal issues are discussed only with children of the same age, never with grown-ups. The idea of respect is fundamental; the child's conduct must prove its consideration for its elders and their status. Education teaches the child to behave appropriately, thereby winning respect. The opposite of the well brought-up person is someone who is deemed disrespectful: "not honouring his or her elders, with no sense of shame, who does not know his or her place, and rebels against the social order".[14]

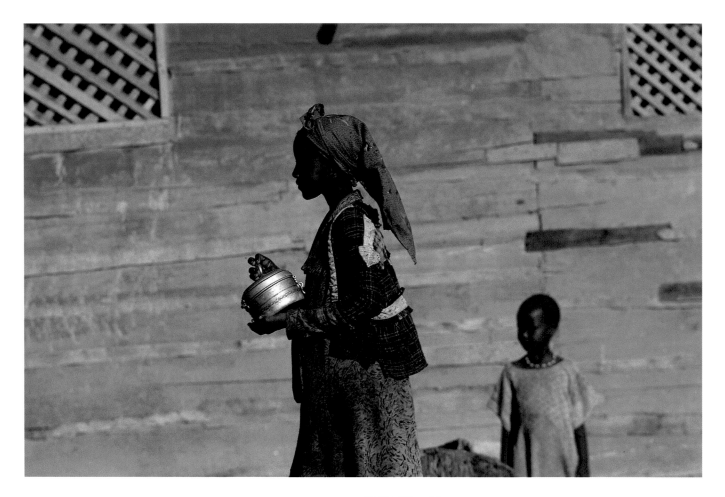

ABOVE: Elder sister
carrying the kettle.
Brava, Somalia.

OPPOSITE PAGE:
Afar girls of
marriageable age sport
scars, pearl necklaces
and fine tresses to set
off their beauty. Awash
Valley, Ethopia.

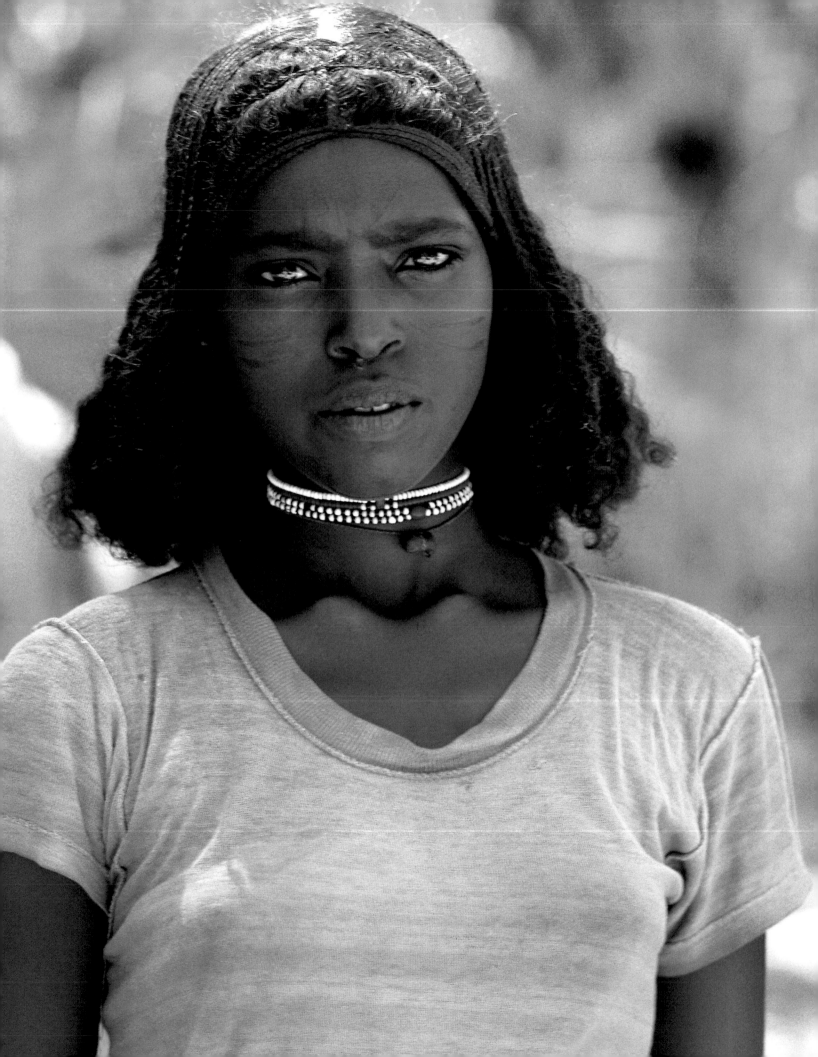

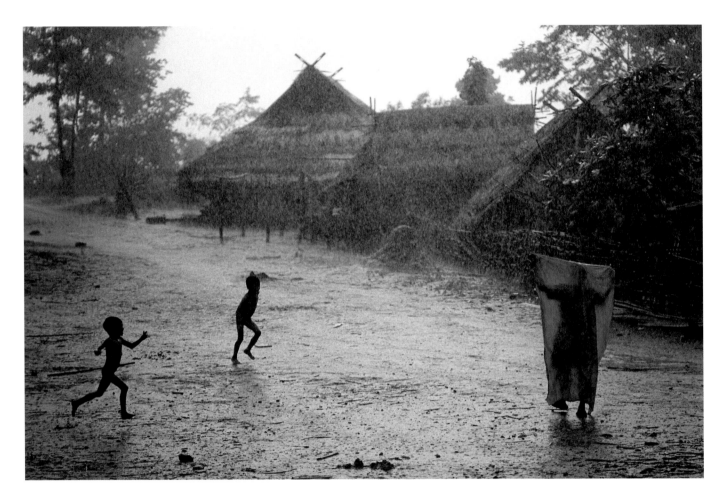

ABOVE:
Akha children enjoying
the arrival of the
monsoon. Near
Burmese frontier,
Thailand.

OPPOSITE PAGE:
A shy but radiant smile
on the "Roof of the
World". Nyemo, Tibet.

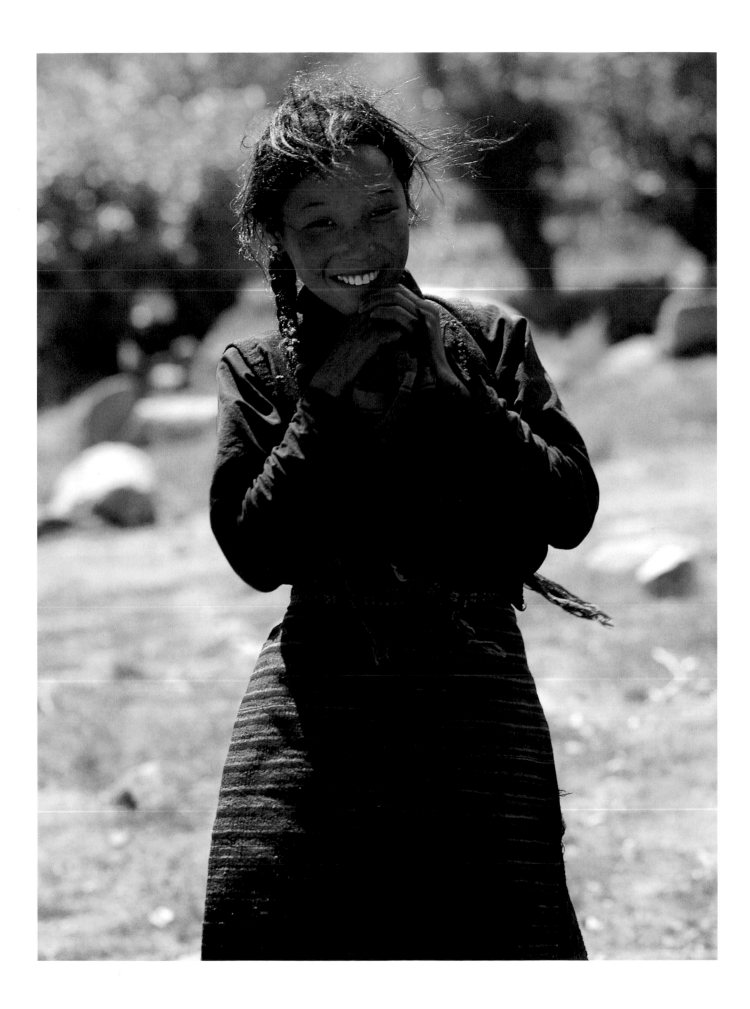

School

From the age of seven, Muslim children are sent to the local Koranic school run by mullahs who have studied the Koran, the Sacred Book, written in Arabic, which transcribes the word of the Prophet. As in India, ceaseless repetition is the only teaching method. Children all sit together in the same room or in the open air repeating the daily lesson, rocking backwards and forwards to the rhythm of the verses. Muslim children are expected to learn the Koran by heart. Traditionally, the length of their studies was seven years, seven months and seven days, except for exceptionally gifted pupils who could memorise the sacred texts in a shorter period. "In this manner, young people managed to write and recite the entire text of the holy book, without a single error, though understanding nothing of the sense; only those who, at a later stage, studied Arabic, would succeed in unravelling its meaning".[15]

ABOVE AND RIGHT:
Back to school.
In China, education
is compulsory, for girls
as well as boys.
Xinjiang, China.

OPPOSITE PAGE:
Swapping course-books
after school.
Kashgar, Chine.

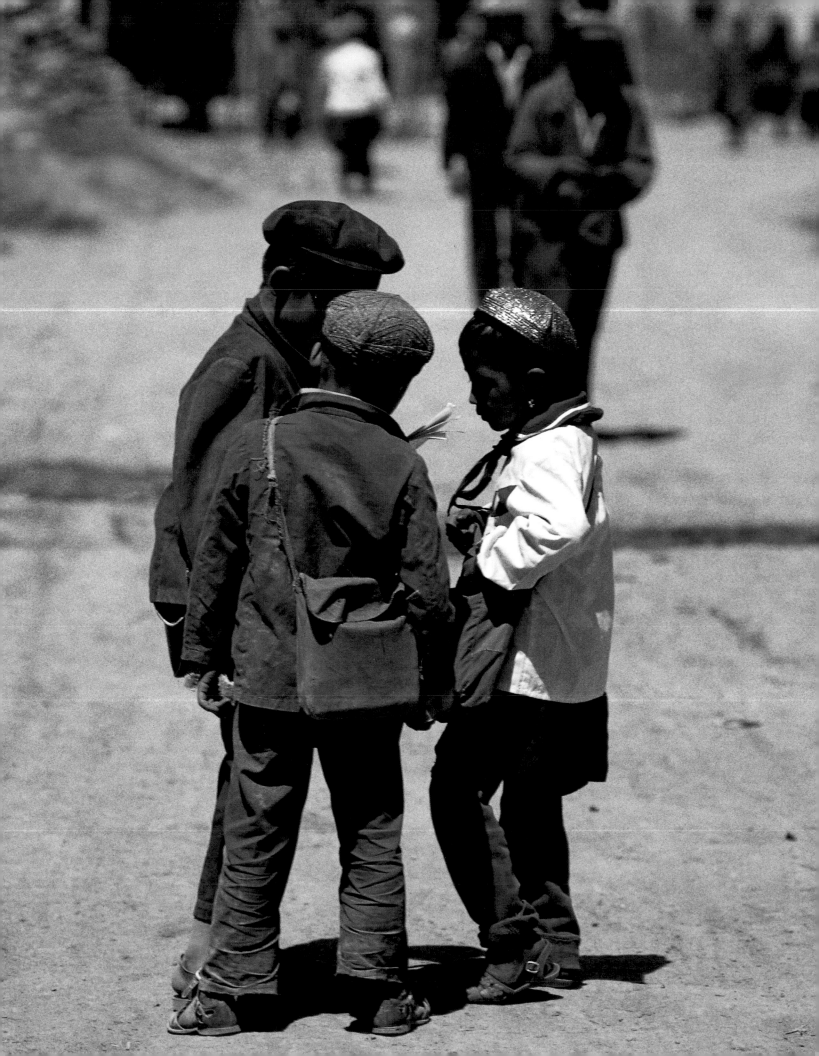

In Cambodia, "when a little boy could touch his left ear with
his right hand by passing his arm over his head – traditionally
in his seventh year – he was sent to board at the pagoda,
where he received instruction in the sacred texts and learnt
to read. Little girls could not attend the pagoda school:
theirs was a practical and moral instruction acquired through
helping their mothers. Their training was at its most intense
during the month-long retreat they were obliged to undergo,
at the first signs of puberty, away from the sunny world
outside, learning the most advanced women's skills, such
as weaving and embroidery, as well as the traditional rules
of morality".[16]

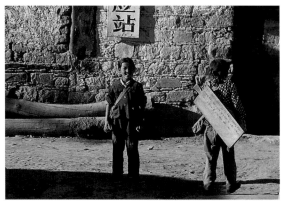

Modern schooling is a powerful factor in enforcing
the uniformity of the dominant urban environment
and in undermining village traditions. It represents
a radical break with the child's original world; it takes
the individual and moulds it. At school, it is forbidden
to speak one's native dialect or wear regional
costume. Compulsory uniform removes any visible
differences of origin, class and social conditions.

**ABOVE AND
OPPOSITE PAGE:
Small "blackboards",
written on in chalk,
replace desks and
exercise books.
Lhasa, Tibet.**

**RIGHT:
Two brothers on the
way to the Koranic
school at the Grand Id
Kar mosque,
accompanied by their
grandfather. Kashgar,
Xinjiang, China.**

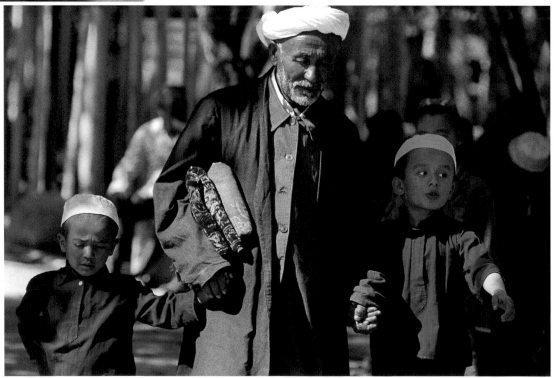

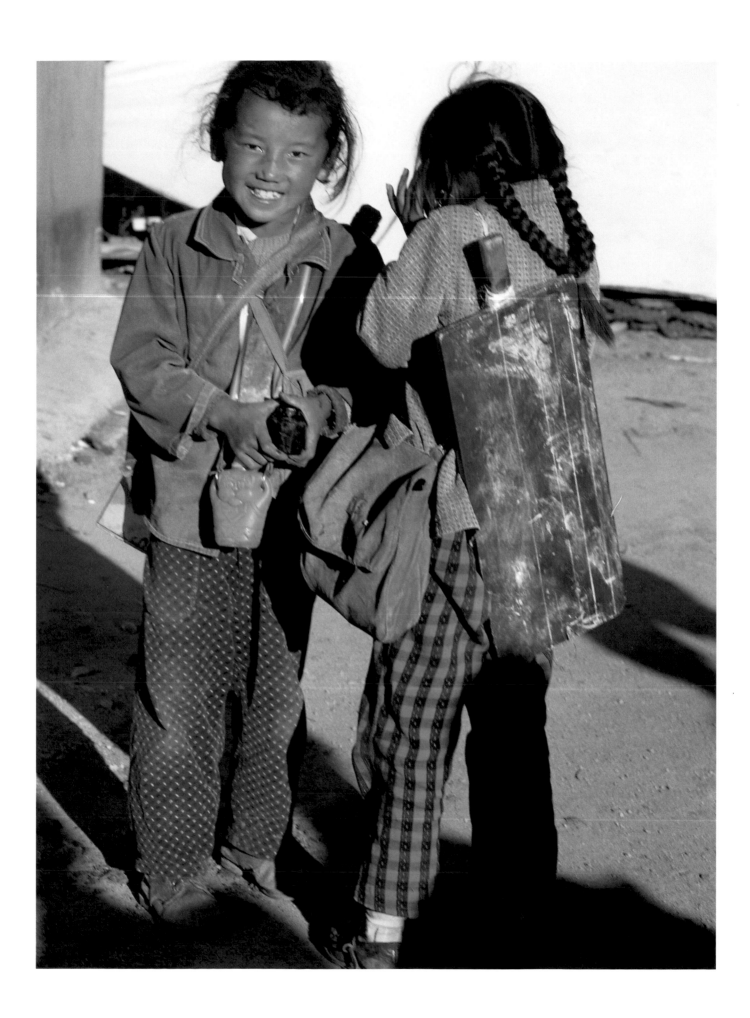

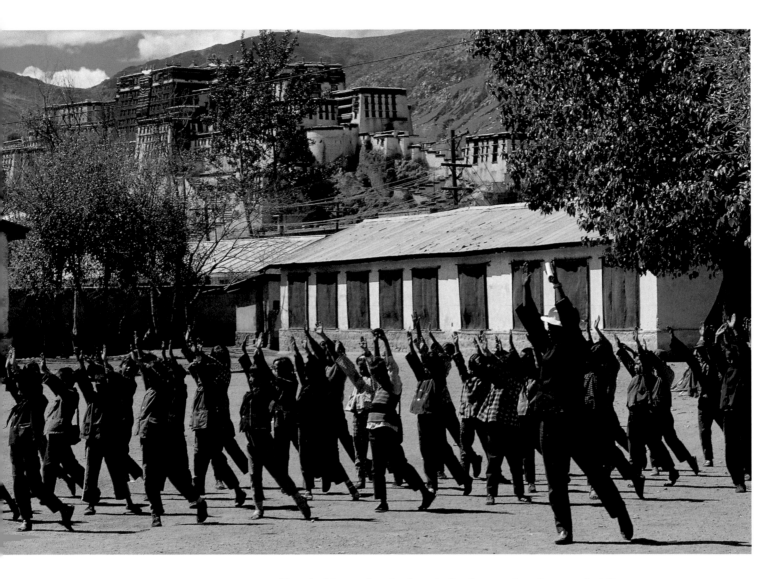

Gym class in front of the Potala, former residence of the Dalai Lamas. Lhasa, Tibet

New habits and a single set of rules are thus imposed at the expense of traditions and regional idiosyncrasies.

Today's education system throws a very effective spanner in the works of tradition, which was once considered immutable. This is especially true as regards the respect owed to parents and elders. School is a place of tensions, "provoked by the passage from one type of culture to another – from tribal structures to those of the West".[17]

School has an ambiguous function. Certainly, it represents the path to knowledge, personal fulfilment and integration with the modern world. Yet it also involves a violent break with family, tradition and the closed world of the village – a departure towards the unknown.

Crocodile of school "pioneers". Lhasa, Tibet

School gives children a modern education, but in contrast to the traditional form of upbringing, which observes the customs of the group, it becomes a place where social heritage is destroyed. Designed to open the minds of young villagers toward the outside world – the world of strangers to their group – the school is run by teachers who are themselves strangers, brought in from outside and inculcating values different from those traditionally handed down by the elders. School, run by the State, is an institution that removes children from their parents to educate them in a new way and provide them with Western-style knowledge. It entails a forced separation from the original culture, leading to rejection of traditions and local customs.

Schoolchildren (aged four to ten) celebrate the end of a long day's work. Brick by brick, they are building a new school, guided by their three teachers. Kalamulak, Altyn Tagh, China.

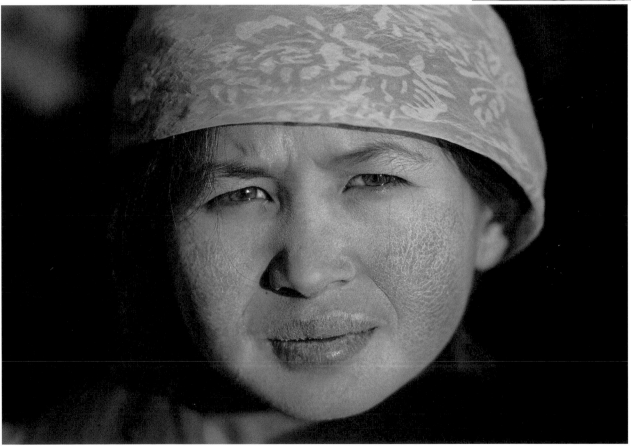

The winds blow the tiniest particles of sand – nicknamed "frozen flour" – from the Tarim desert as far as Beijing. This rain of yellowish-grey sediment (loess), present everywhere in spring and summer, dries and cracks the skin of both children and adults. Kalamulak Oasis, Altyn Tagh, China.

The child who has studied in an urban secondary school will not return to live in the village and so will not help its parents in the fields. Even if the child wanted to do this, its new status makes it impossible.

The educated child will leave the village and attempt to integrate into the external, urban way of life. The whole community will suffer loss if, as is often the case, the child never returns to repay its debt. Education can create disoriented, ambivalent individuals, torn between tradition and the brand-new world of strangers. The Communist countries of the East knew only too well how to exploit the possibilities of social rupture inherent in education. Government officials displaced the children of villagers and nomads by force: by tearing these youngsters away from old traditions, they aimed to create a new world with a new mentality.

ABOVE:
Children greet their teacher. Tibet.

RIGHT:
In the extreme west of China, children must study their native language as well as Chinese. This little girl is learning to write Uighur with the help of a book in Arabic characters. Xinjiang, China.

OPPOSITE PAGE: The shortage of schools means children of all ages study together. Chiang Mai, Thailand.

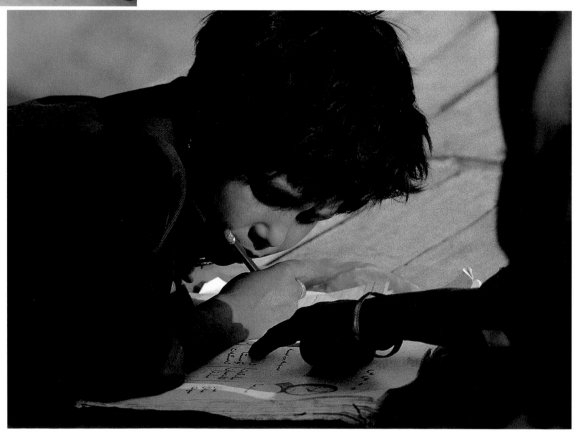

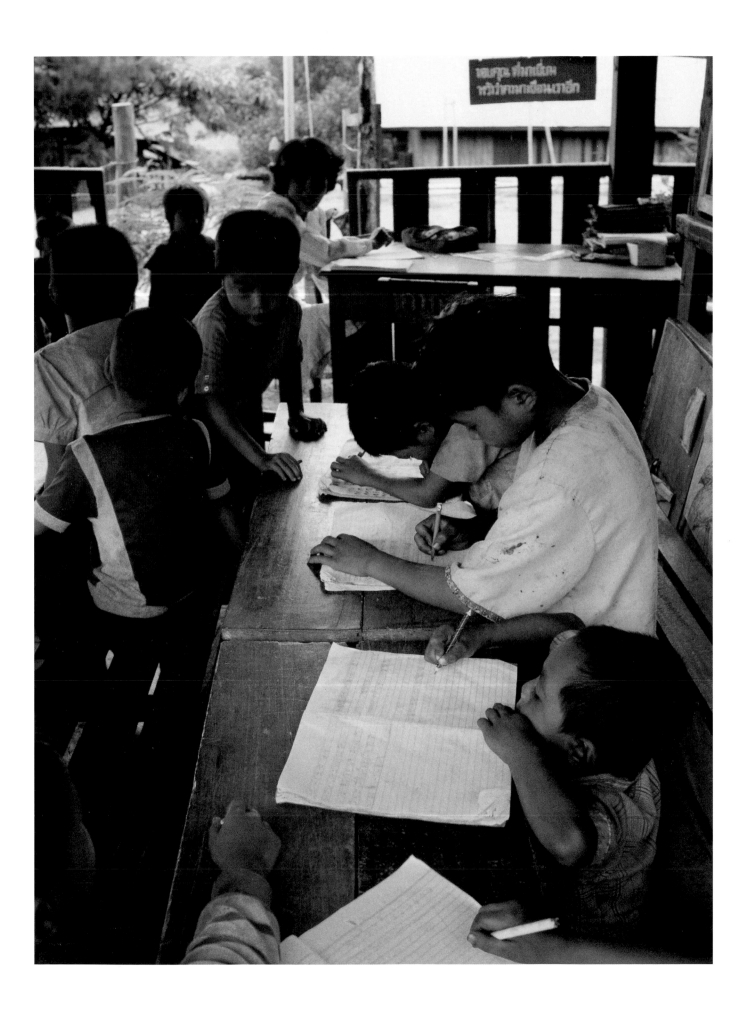

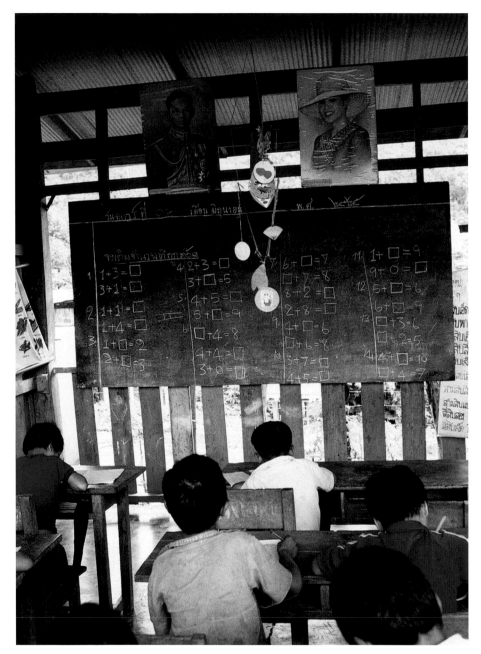

ABOVE:
Arithmetic lesson
in an open-air class
decorated with
portraits of the king
and queen. Chang
Saen region, Thailand.

OPPOSITE PAGE:
Young monk studying
the sutras from a
Tibetan manuscript.
Sacred books are
never bound. Ulan
Bator, Mongolia.

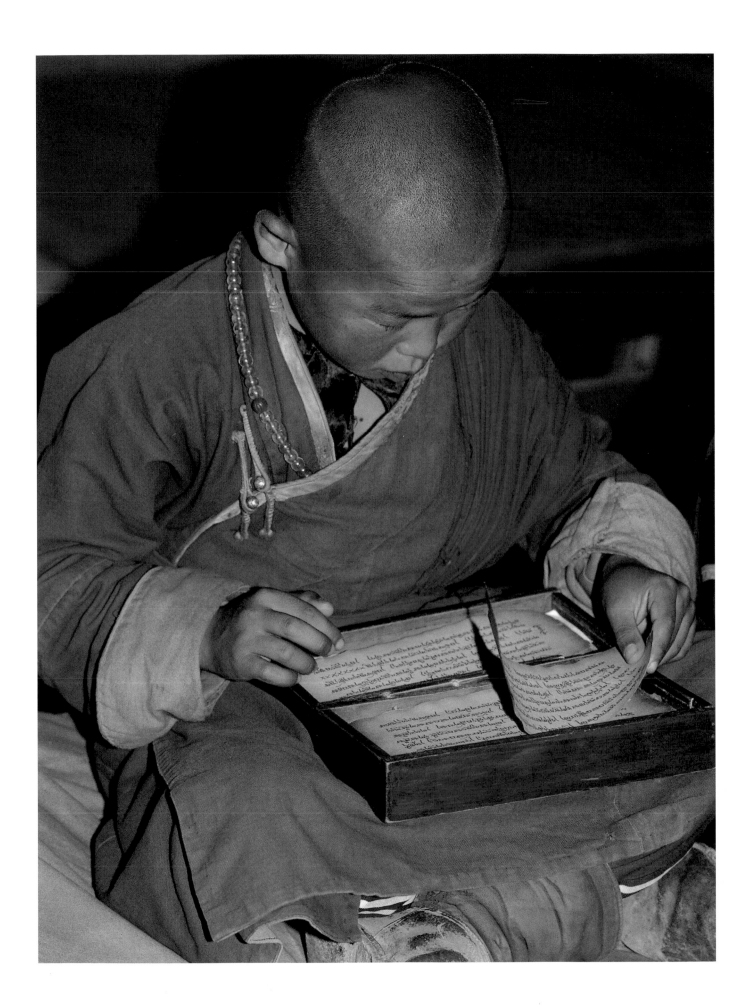

Companionship

The pampered young child has to learn to be independent. The role of its parents is to prepare it to leave them after having taught it everything it needs to know in life. Traditionally, children learn to reason at around seven years; after that they must be removed from their protected existence within the bosom of the family to widen their horizons and prepare themselves for future responsibilities. Before rubbing shoulders with other adults, young people enjoy relative freedom and, in their interactions with contemporaries, have the chance to experiment with the rules of society they have been taught. Childhood is a journey full of sudden changes. At each stage we have to turn our backs on our past life and step into the future that beckons us forward. Each rite of passage leads us on to adulthood, contributing to the pool of knowledge so essential to the man or woman who will be active and respected in the community.

BELOW:

Little gossips.

Pujili, Ecuador.

OPPOSITE PAGE:

Twins from Suzhou,

Jiangsu Province,

China.

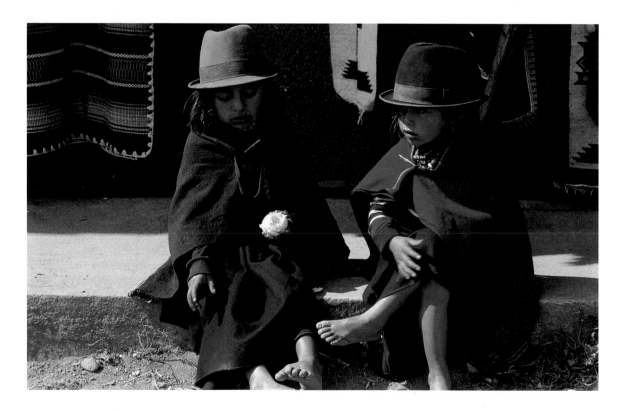

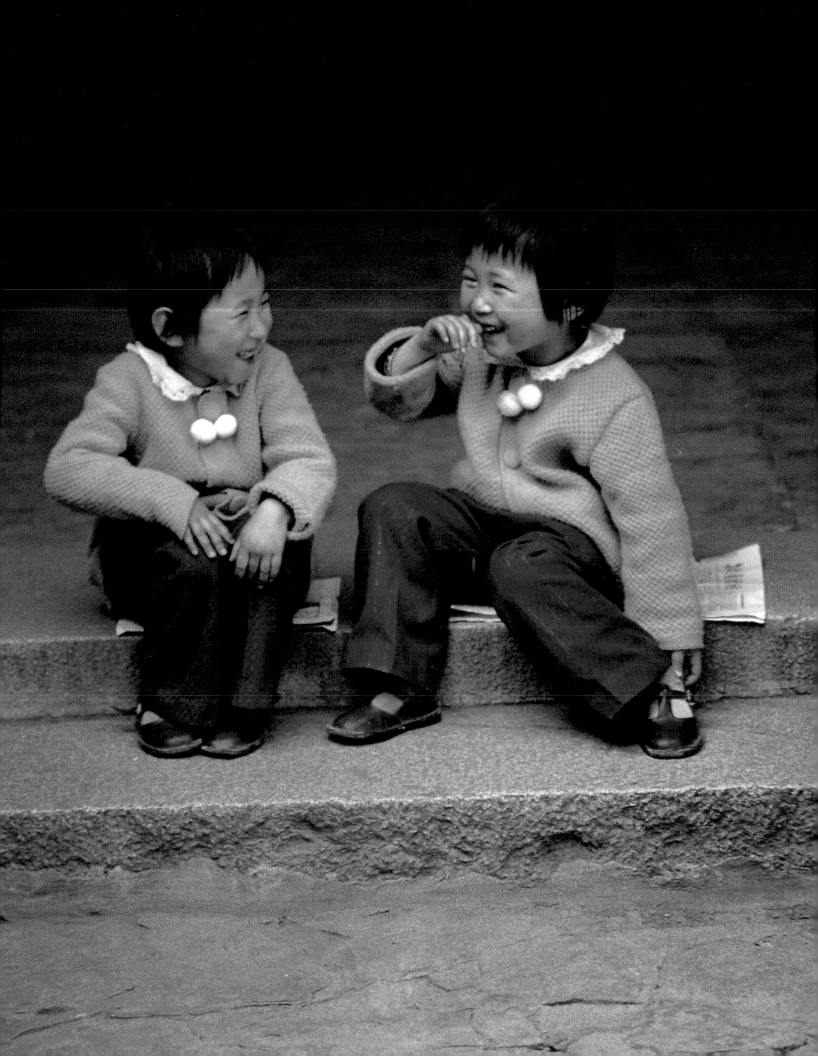

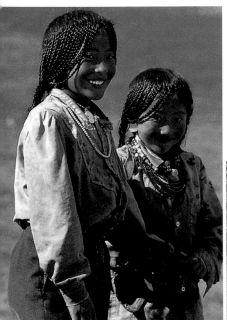

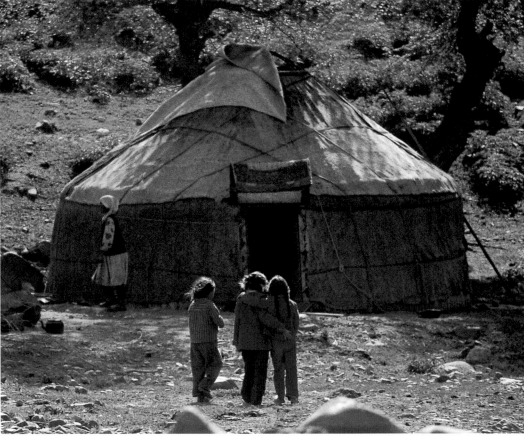

ABOVE:
Inseparable sisters.
Kham, Tibet.

RIGHT:
"Let's go and play
in my yurt".
Kazakhs from
Tian Shan, China.

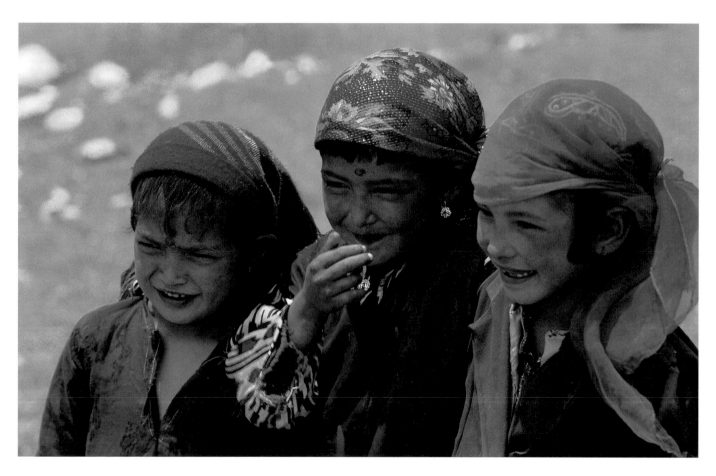

ABOVE:

A laughing group of
young Kyrgyz at the
Islamic Spring Festival.
To bring good luck, each

girl wears a drop of
sheep's blood in the
position of the "third
eye". Oytak Valley,
Pamir Mountains, China.

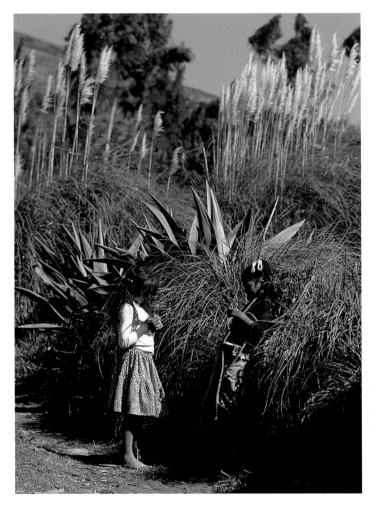

LEFT:
Swapping secrets
at the foot of the
Tungurahua volcano,
Ecuador.

OPPOSITE PAGE:
Nomad sisters
enjoying lamb cutlets
and dripping during
a picnic on the lush
green steppe.
Summer in central
Arhangai, Mongolia.

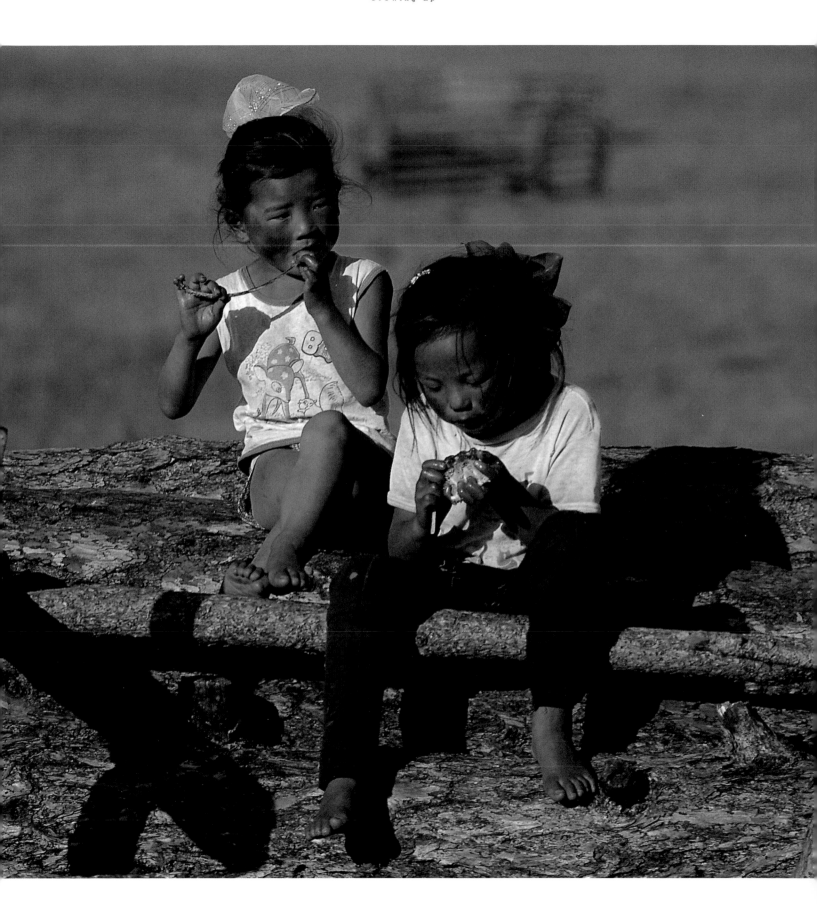

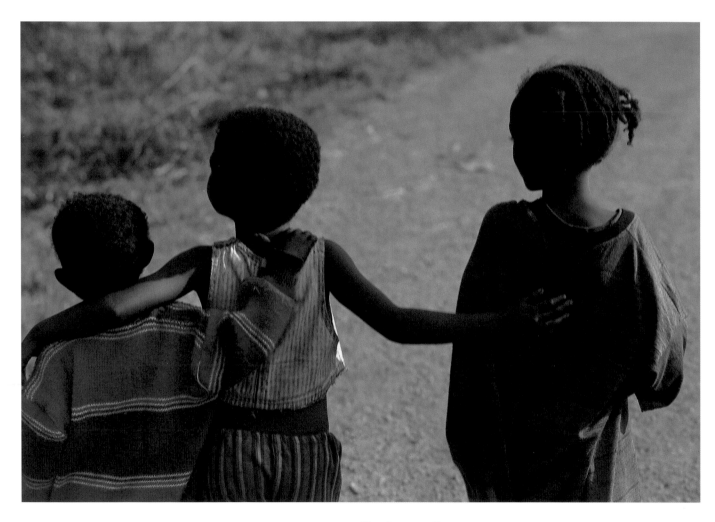

Growing up on the
coffee plantations.
Kefa Province, the
original source of
coffee, close to the
Sudanese and Kenyan
borders, South-West
Ethiopia.

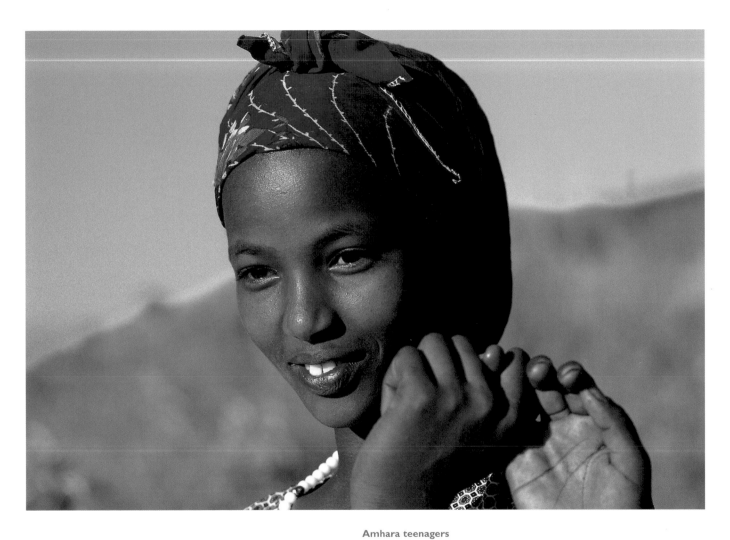

**Amhara teenagers
express their affection
by holding hands.
High plateau near
the African Rift Valley.**

ABOVE AND
OPPOSITE PAGE:
Africans of the Andes.
Several centuries ago,
populations of African

origin were settled near
the equator in arid
regions less inviting to
the Spanish. El Chota
Valley, Ecuador.

Play

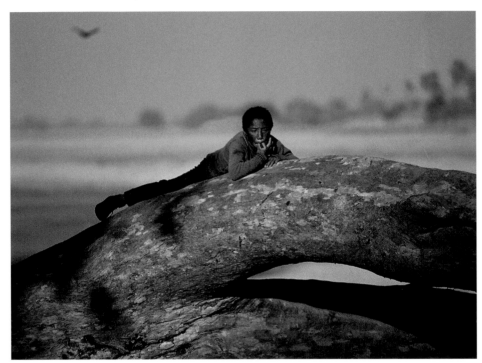

Part of the way children learn to live in a community is
through play. Their games only give the impression of being
uninhibited and spontaneous; in reality, they are part
of the socialisation process, a gentle form of apprenticeship
in the rules of society and an informal initiation into
basic economic activities.

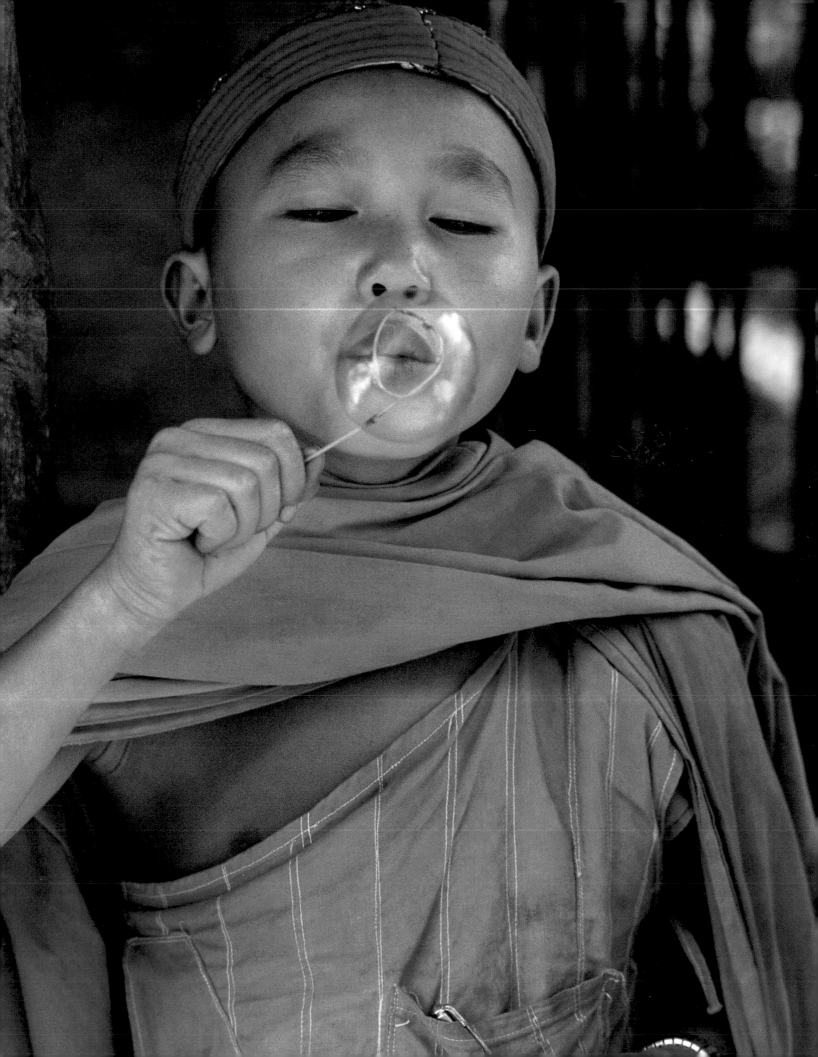

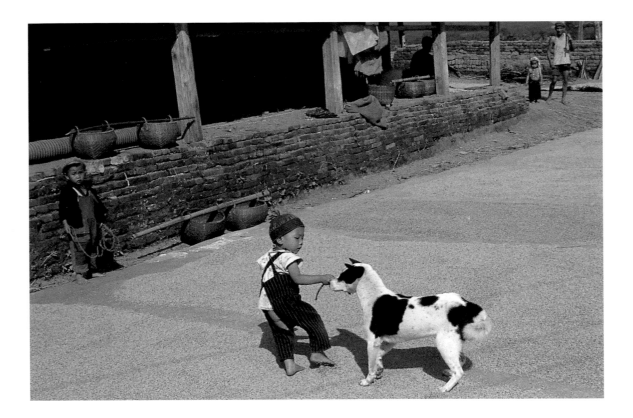

Toddler teasing a puppy among the drying grain. Southern Simao, China.

Toys are vital to the educational process: they are not merely a means of free expression for small children. The community encourages youngsters to make use of "educational toys" that prepare them for their future roles. A little girl mothers a doll, anticipating what she will become herself, dressed as a grown woman, veiled if custom demands and invariably modest. Boys are given toys that are active and involve movement, toys for the open air, as opposed to those for girls that introduce them to indoor activities.

Very often play is, in fact, a rehearsal for the family's economic activities. Thus, in poor communities, children must learn very quickly how to help the adults by sharing their work. Dolls, in particular, accustom children to behave as their parents and society expect.

In Japan, the Feast of Dolls is celebrated on 3 March and is dedicated to little girls. The dolls on parade reflect the life of the married woman, with her wardrobe, furniture and tea set. On 5 May the boys have their own festival, which reminds them of their futures as conquering warriors.

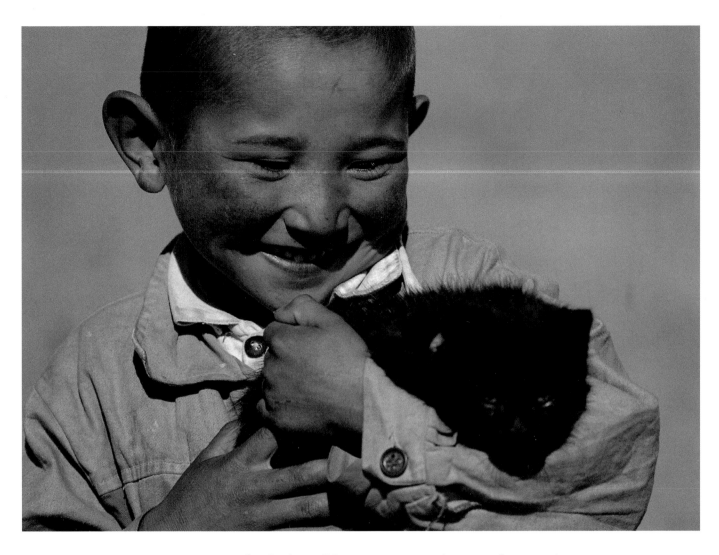

Kazakh boy and his kitten. Pets are a luxury in the high valleys of the Altai Mountains. North-West Mongolia.

On display will be weapons, complete sets of armour in miniature, helmets, wooden swords, sabres and all the equipment a fighter would need, as well as "carp fashioned out of material and flapping from tall masts: symbols of vigour and longevity".[1]

Daughters are either bought dolls by their mothers or they make them themselves. These dolls, however, are not just innocent toys – they have immense significance because they represent people. We hear how the ancient divinities collected human images of clay or rags, and how they blew into these to infuse them with life. They transformed the effigies into living beings, just as the God of the Old Testament created Woman by breathing upon a bone.

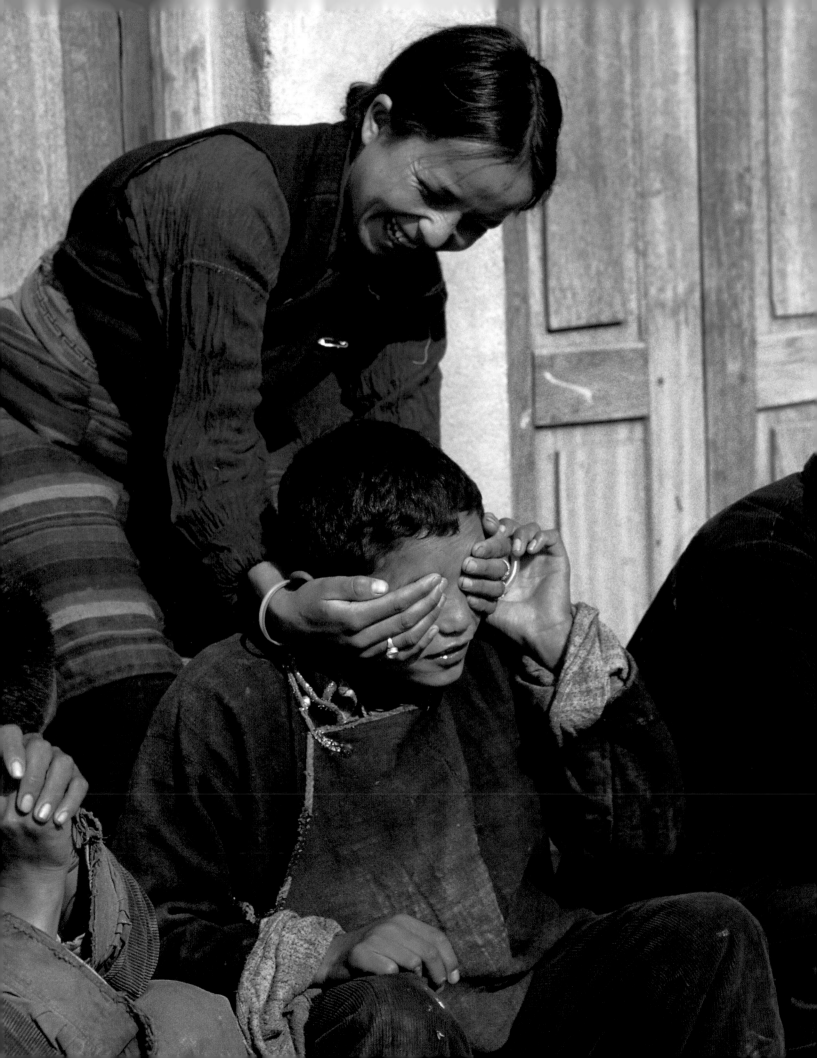

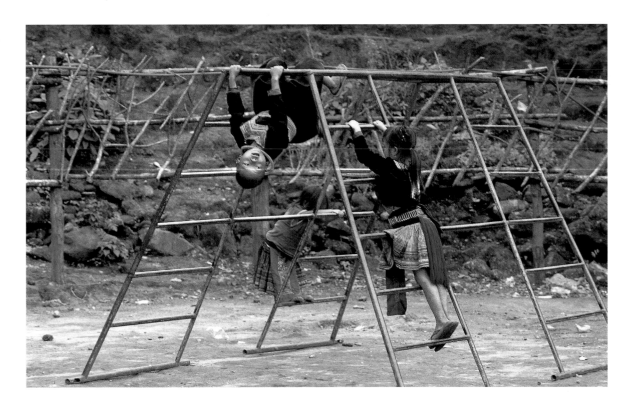

OPPOSITE PAGE:

"Guess who!"

Bodnath, Nepal.

ABOVE:

Meo children

scrambling on

the climbing-frame

in a rudimentary

playground.

Shan Plateau, Thailand.

African mothers urge their daughters to make their own dolls in order to introduce them to their future roles: assuring the prosperity and reproduction of the group. In this way playing with dolls encourages child-bearing. "Little girls treat their dolls as they would new-born babies, for which these are substitutes. Young adolescents who carry them about really do consider them as babies, lavishing maternal attentions on them. The 'mothers' bathe them, pamper them, cradle them and make them dance; when they are 'ill' they nurse them; they feed them at the breast. If the doll 'cries', they console it. It is given a name, which is the occasion for a feast with plenty of food, not to mention dancing, singing and general rejoicing".[2]

A young girl who has been accustomed to playing with dolls will be happy to be entrusted with looking after new-born babies. "Games often mimic adult activity: a little girl will, with the utmost seriousness, carry about on her back a doll made out of an ear of maize or a piece of bamboo wrapped in a rag, just as if it were a real child".[3]

We should note, too, in passing, that both the little girl playing with her doll and the small boy acting out war games are discovering a way of escaping from their parents' authority. In its play, the child makes the rules, even if they are often cruel and unreasonable ones.[4]

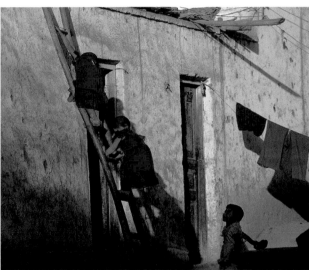

LEFT:
"The flying insect".
Children of far western
China make up for the
lack of model aircraft
with a variety of
inventive pastimes.
China.

ABOVE:
Chasing game on a
ladder. Old city of
Kashgar, Xinjiang,
China.

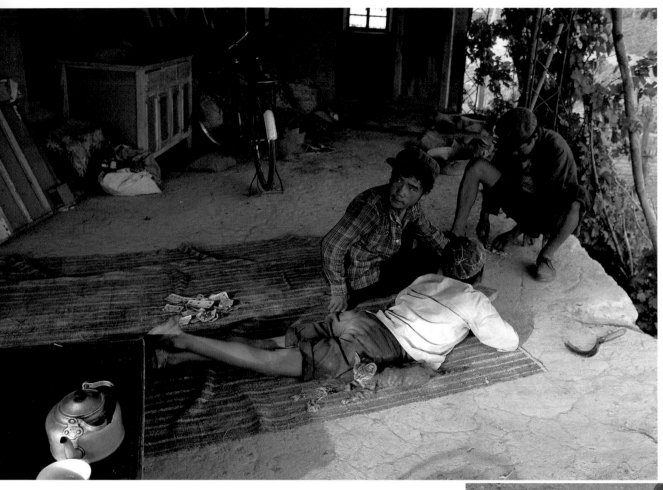

ABOVE:

Game of dominoes.

Grape Valley, Xianjiang,

China.

RIGHT:

Friendly wrestling

match between

Mongolian boys.

Gobi Desert, China.

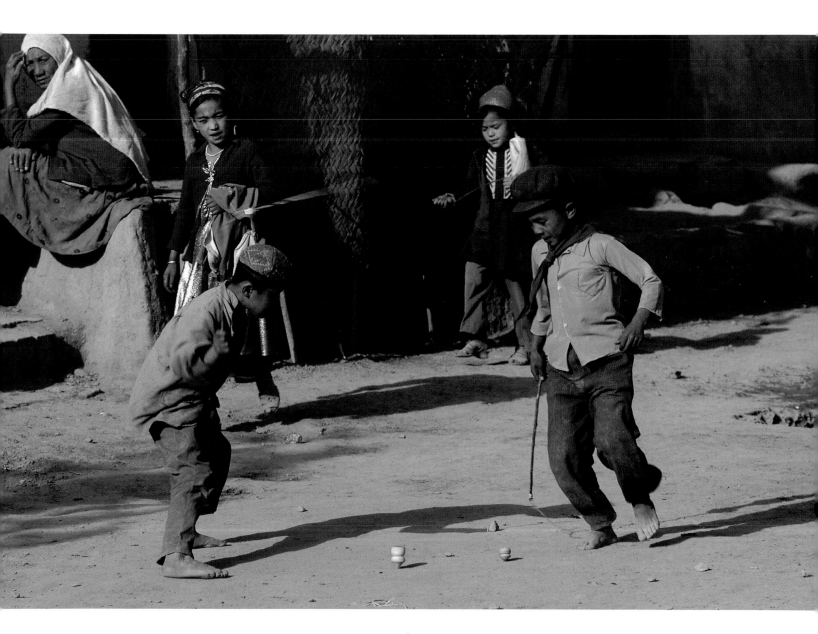

ABOVE:

Spinning game with
two tops. Kuqa,
bordering Taklamakan
Desert, China.

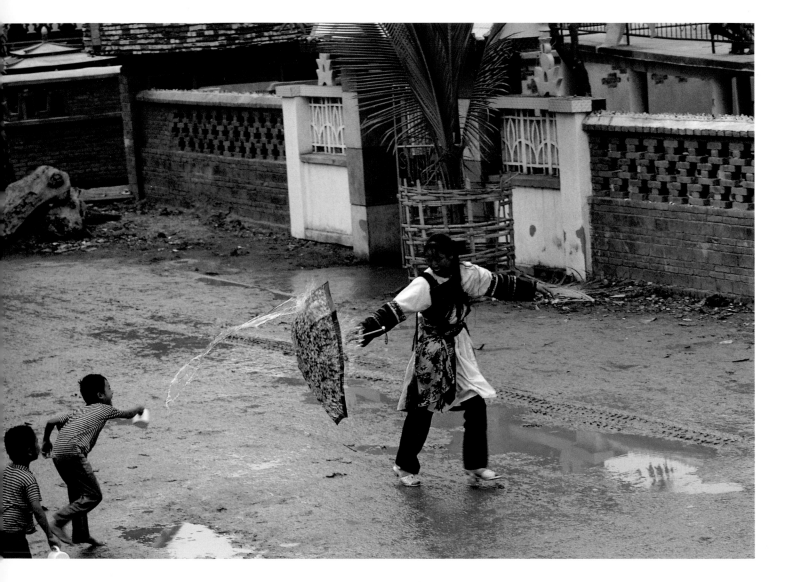

ABOVE:
Soaking passers-by
is not a naughty trick:
among the Dai of
Xishuanbanna,
it brings good luck.
Water festival,
South China.

ABOVE:
Acrobatics
in the dunes.
Tarim Desert,
China.

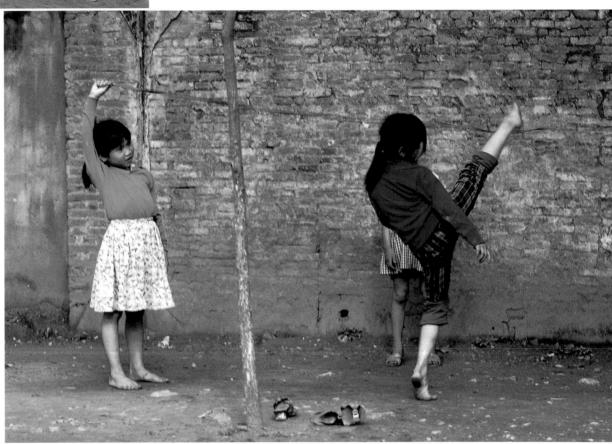

ABOVE:
"One more inch!"
Guilin, Guangxi
Province, China.

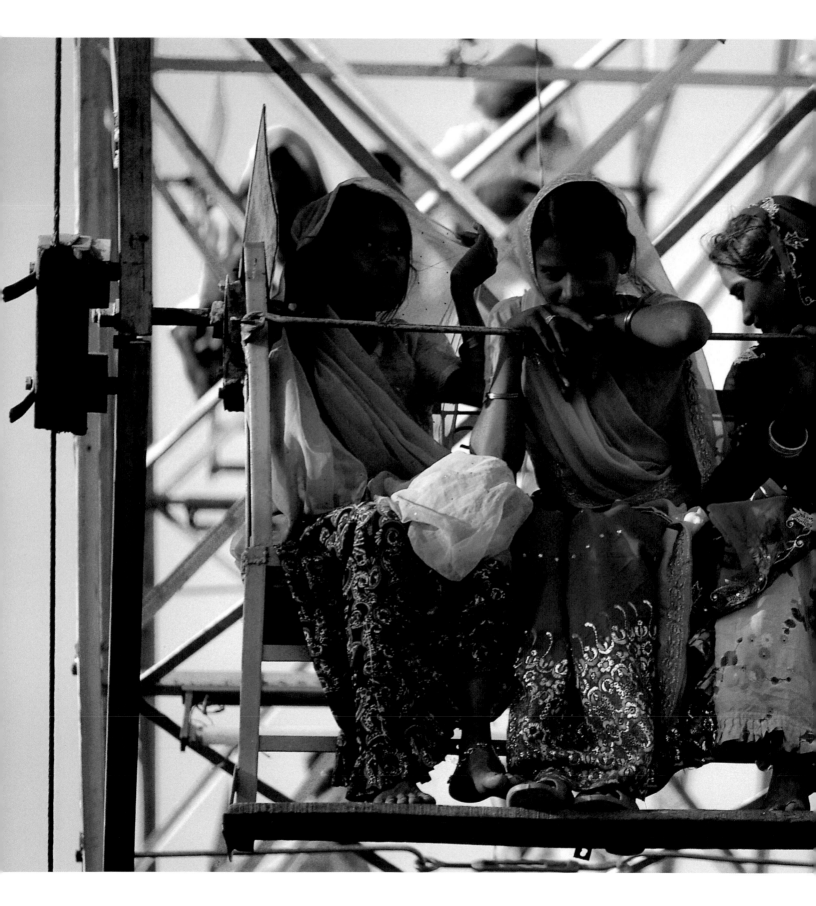

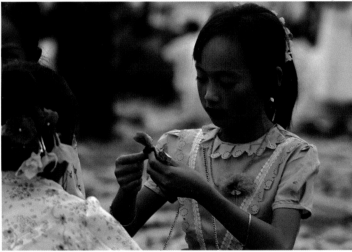

LEFT:

On the Big Wheel at the Dromedary Fair. Rajasthan, India.

ABOVE:

Swapping trinkets on the day of the great Mekong boat race. China.

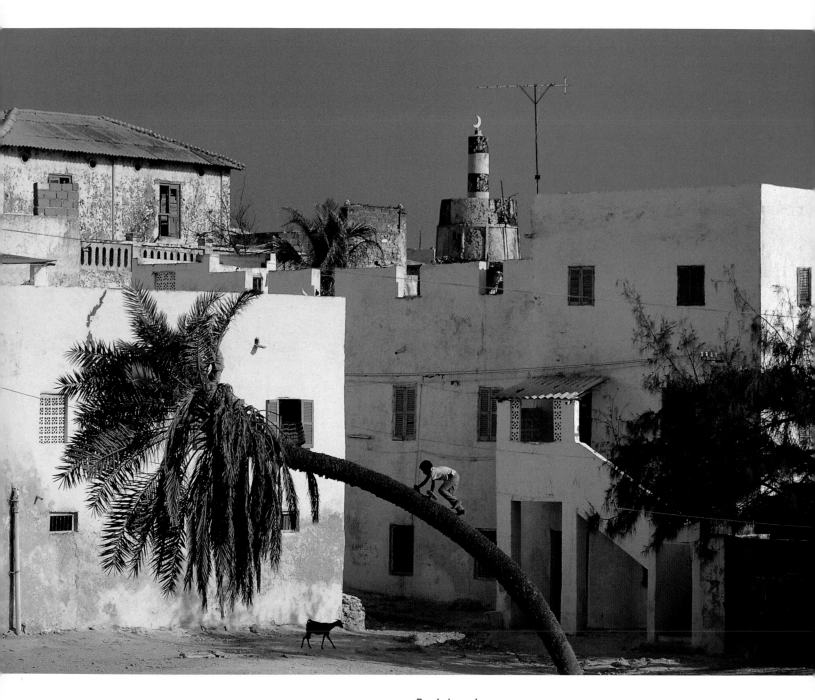

**Boy balanced on a
leaning palm trunk.
Merca, Somalia**

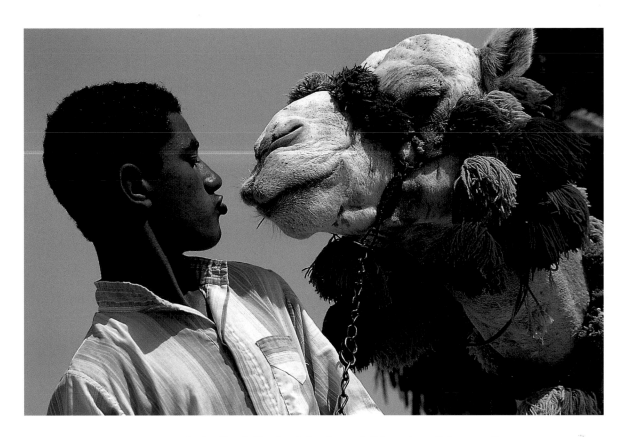

**"Ever been kissed
by a camel?"
Mt. Sinai, Egypt.**

In India, dolls also introduce children to religious cults.
"If the way a child plays with its doll always involves scenes from
adult life, certain aspects of adult rituals – curiously resembling a
game, even though structured and uniform – provide an
immediate role model. For instance, the statuette of a god is
regarded as a living person and the object of considerable care:
the temple priest (or, in the case of the family altar, the mistress of
the house) wakes it, bathes and dresses it, adorns it with jewellery,
decks it with flowers, cradles it, takes it for walks, sings to comfort
it, and puts it to bed. The god is dressed like a doll, and every
requirement necessary for its immediate comfort is met: in winter,
for example, the infant Krishna is warmly wrapped up in little
woollen garments. Again, for the family rites, a woman uses
miniature utensils identical to those in her little daughter's tea set.
Finally, for both younger girls (from five to ten) and adolescents,
play and religious ritual – or at least apprenticeship to ritual –
merge into one at special children's festivals, during which they
are expected to make dolls".[5]

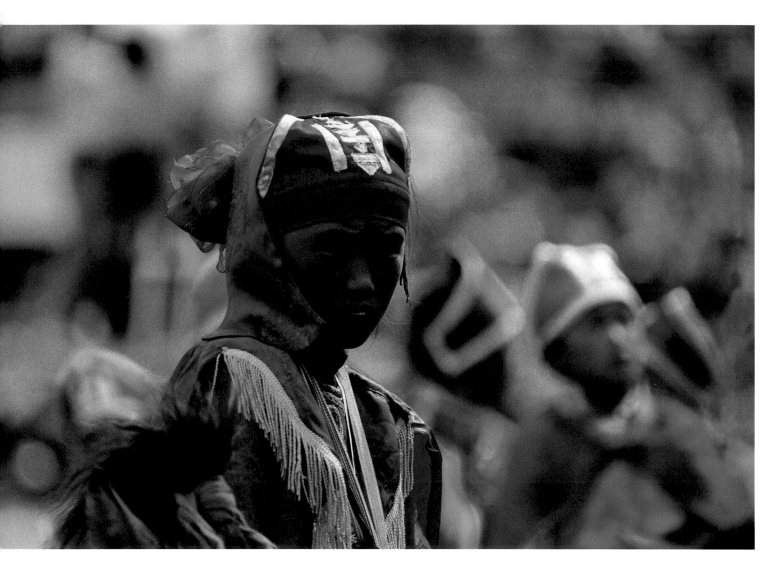

Play can also be an introduction to love. In effect, boys and girls
are destined to fall in love with each other, to marry and start
families. Young people living in villages have plenty of
opportunities to meet: on family visits, at ceremonies and festivals,
as well as during communal dancing, which is the equivalent of a
European ball. In Africa, bands of adolescent boys "hang out" with
groups of girls; in South-East Asia, both sexes can meet in so-called
"bachelor houses".

Among the Kyrgyz nomads of Central Asia, encounters take place
in an atmosphere that is both romantic and playful. "Young people
sing songs, almost invariably improvised. They form two choirs:
boys in one, girls in another. The female choir usually declares the

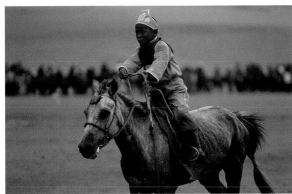

THIS PAGE AND OPPOSITE: The Nadaam Festival, on the Mongolian National Day. Only children from five to twelve can take part in this horse race, the most important of the year. Adults would be too heavy for a ride of 12–19 miles (20–30 km) across the steppe. Uverhangai Aymag, Mongolia.

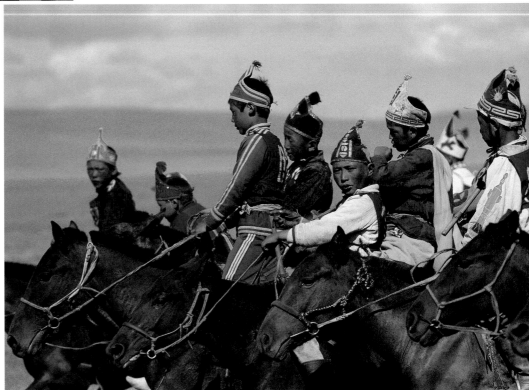

virtues and attractions of their sex and rails against the shortcomings of the males. The latter then attempt to justify themselves, singing their own praises and vocalising the joys of love. Both sides fling insults at each other, being met with witty replies, with the spectators immediately joining in the repartee. Sometimes boys and girls divide into couples, singing either all together or in pairs".[6]
A favourite winter game in encampments is played by girls and boys seated in a circle. A small mutton bone is passed from hand to hand. "One of the boys took the bone between his teeth; then each girl approached him, also trying to get her teeth on the bone. The most agile ones managed it very skilfully. Those who failed paid a forfeit by kissing the boy".

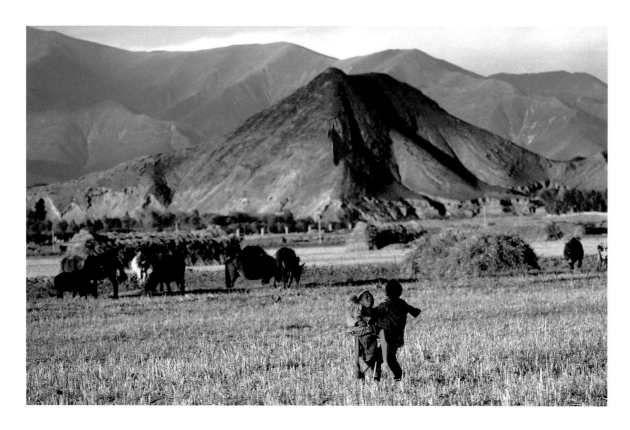

ABOVE:

Harvest-time:

kite-flying near

Gyantze, Tibet.

Ritual horseback contests give the boys a chance to prove their skills and attract the girls' attentions. A boy tries to ride his horse into the path of his favourite and touch her breast. "The Kyrgyz beauties only allow this liberty to a boy whom they favour. They use all their litheness and agility to avoid the touch of a boy they do not like, swerving aside and lashing out if necessary with their whips, the severity of the blows depending on how distasteful the girl finds find her pursuer. In this way they can easily keep the boy riders at a respectful distance, especially as it is considered fair play to leave the mark of their anger on the face of an over-enthusiastic suitor".[7]

In Laos, the tradition still exists of "love trials". Boys and girls line up opposite each other and alternately challenge each other with songs and verses accompanied by mouth-organ music. Boys can also make their feelings known by throwing a ball at the object of their passion. This game, which is accompanied by amorous repartee, is in fact a mime based on the Sun's course around the Earth.

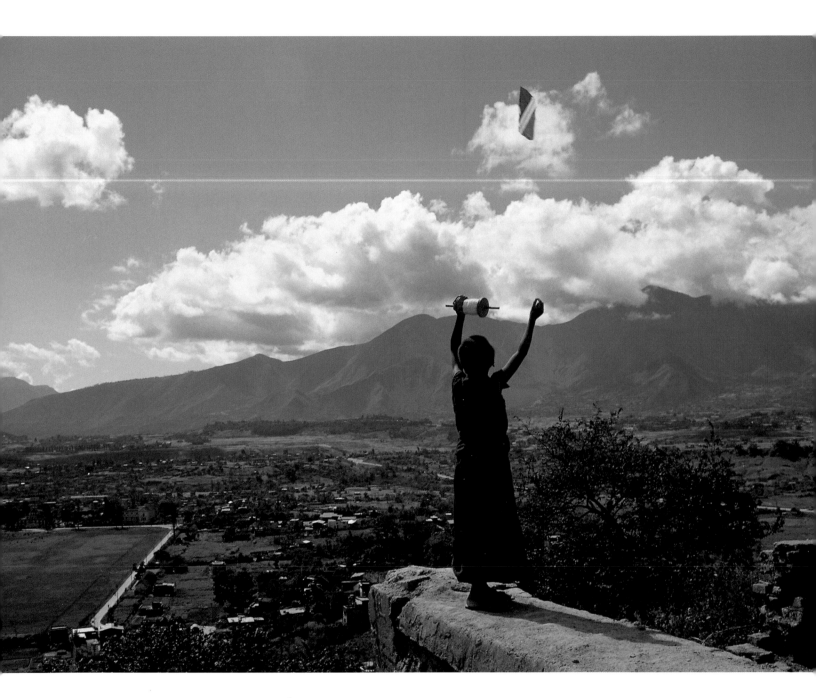

ABOVE:

Young monk launching

kite. Overlooking the

Katmandu Valley,

Nepal.

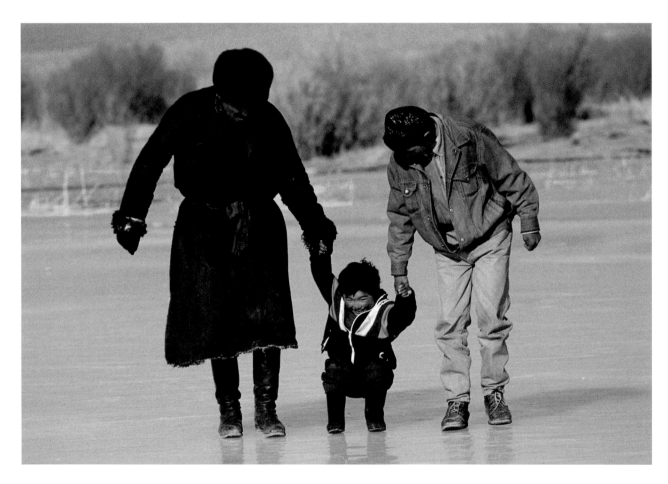

ABOVE:
Sliding on the
frozen River
Khovd in spring.
North-West Mongolia.

OPPOSITE PAGE:
Kazakh teaching
his son to hunt with
an eagle. Altai
Mountains, Mongolia.

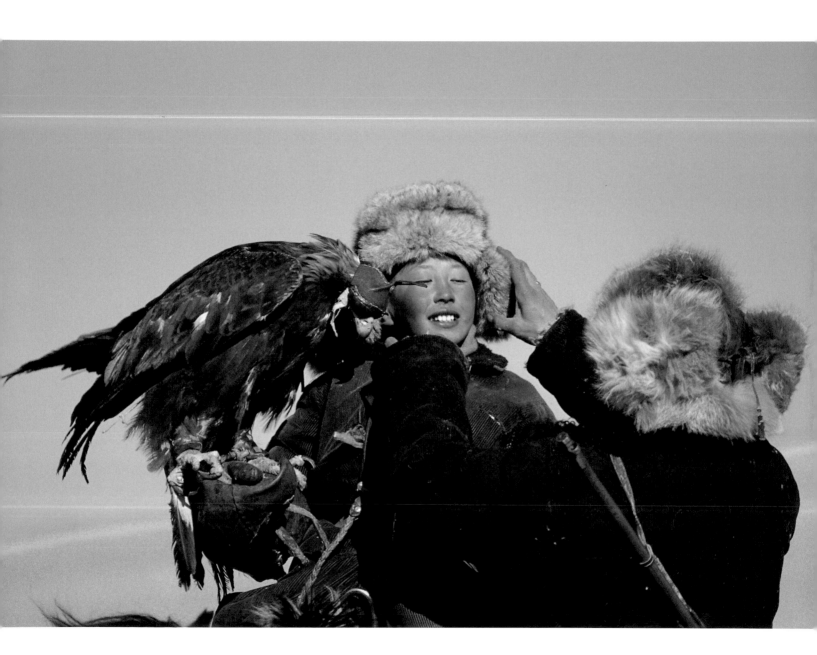

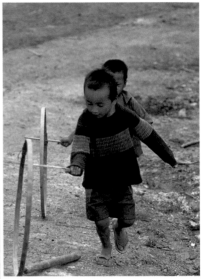

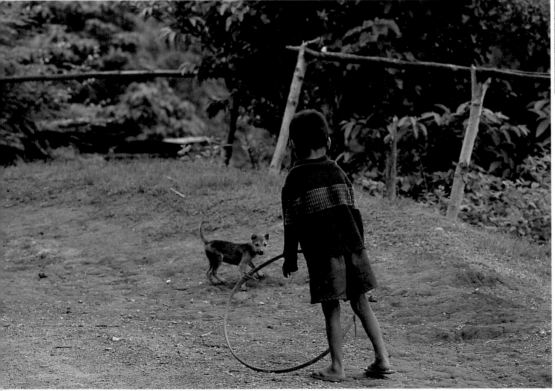

ABOVE:
Yao pals playing with
hoop. Northern Thailand.

LEFT:
Yao lad and puppy
having fun. Unlike
their neighbours,
the Yao never eat dogs.
Northern Thailand.

OPPOSITE PAGE:
"The one to climb
highest wins".
Meo children, Thailand,
near border with Laos.

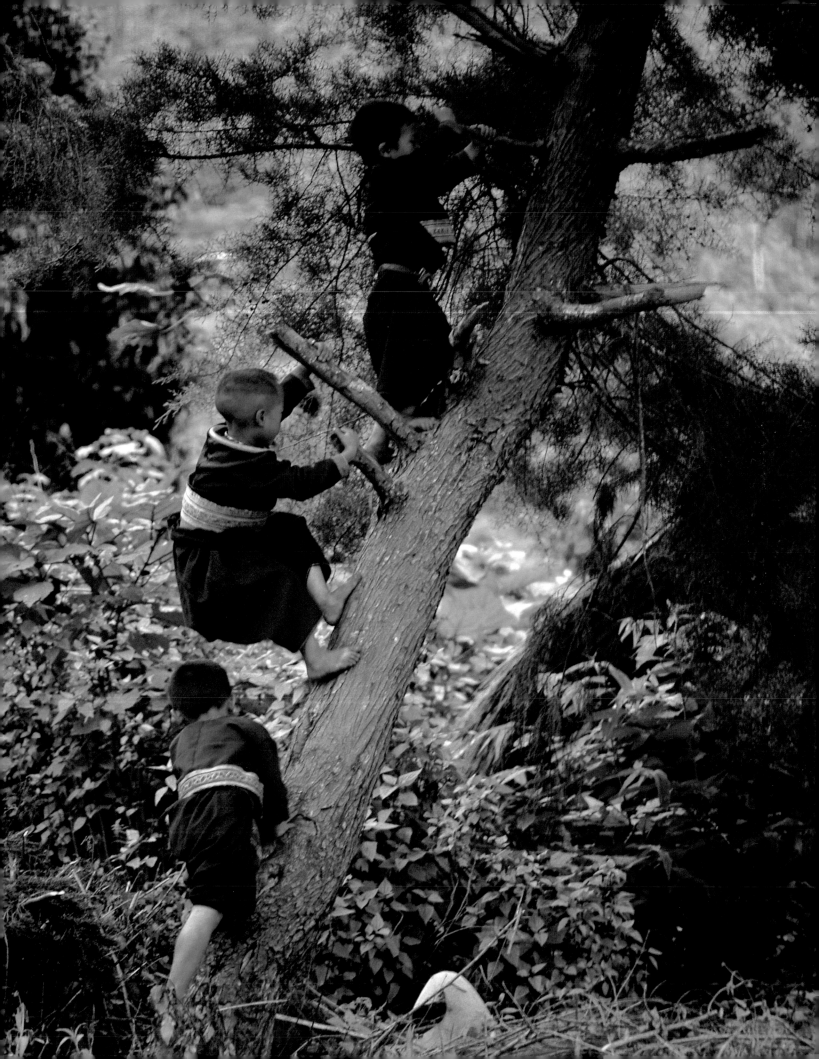

OPPOSITE PAGE:

Romping in a pool
to cool off: the
temperature is a
clammy 104°F (40°C)
just before the
monsoon. Near the
Mingoun *stupas*, Burma.

ABOVE:

In Burma, girls
bathe fully clothed,
wrapped in their
sarongs. Lake
Taungthamen.

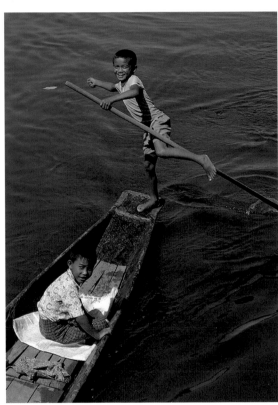

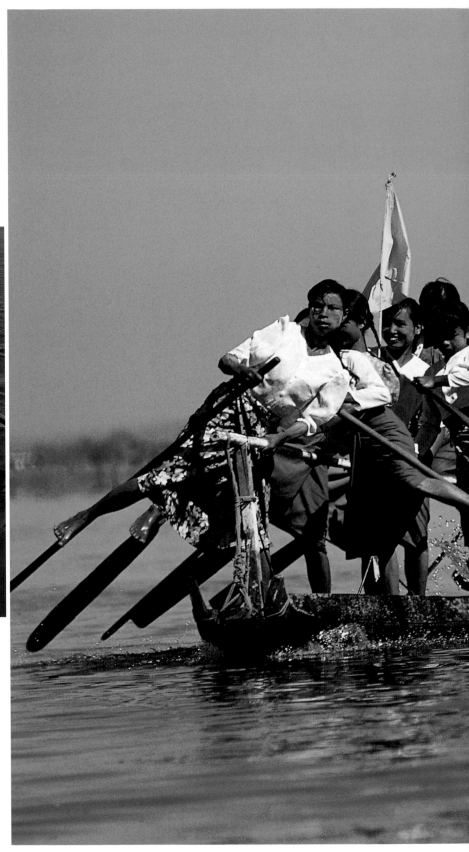

ABOVE:
Skilful boatmen, the
Intha balance on the
stern of their frail
canoes, rowing with a
leg round the oar. Lake
Inle, Burma.

OPPOSITE PAGE:
A canoe race
reserved for girls,
on the occasion
of the Buddhist
"Lent". Lake Inle,
Burma.

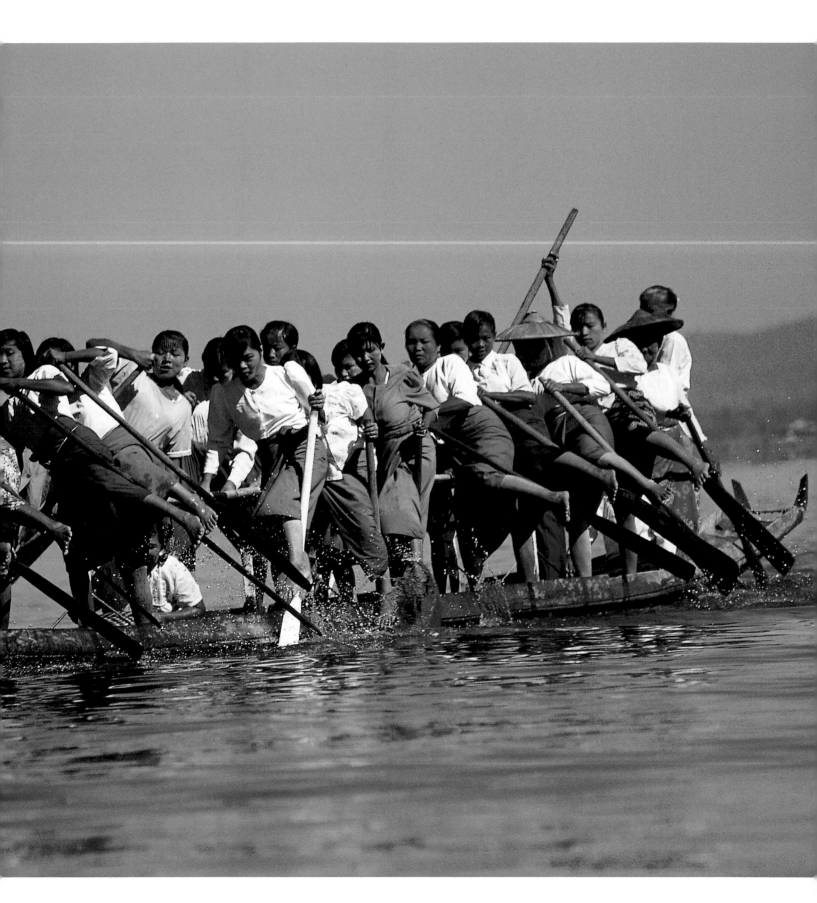

Apprenticeships

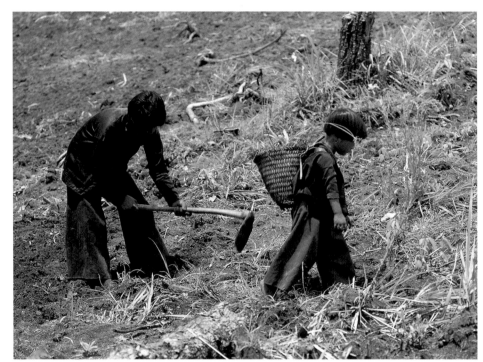

A young child is forgiven all its shortcomings; it has not yet been shaped by its culture. A series of "apprenticeships" will transform the child into a social being who has assimilated the community's customs and values. "The son should follow in his father's footsteps", says the African proverb. Children grow up surrounded by adults whom they constantly observe – it is through imitation that they learn.

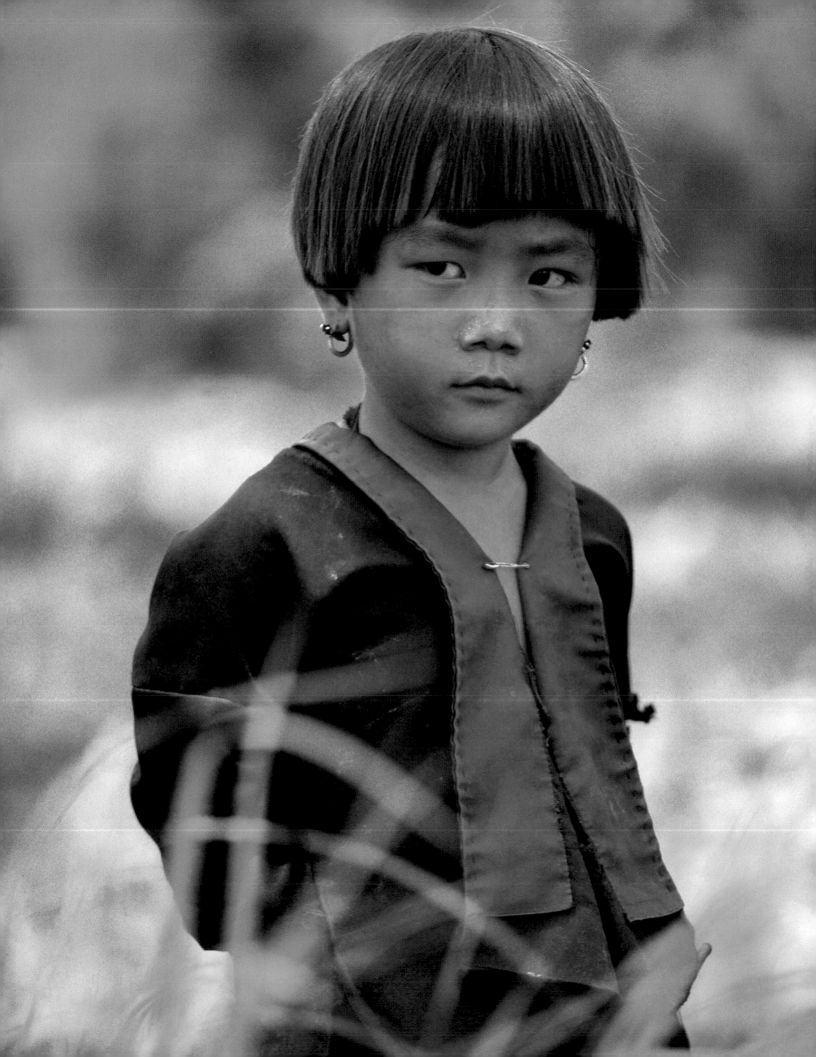

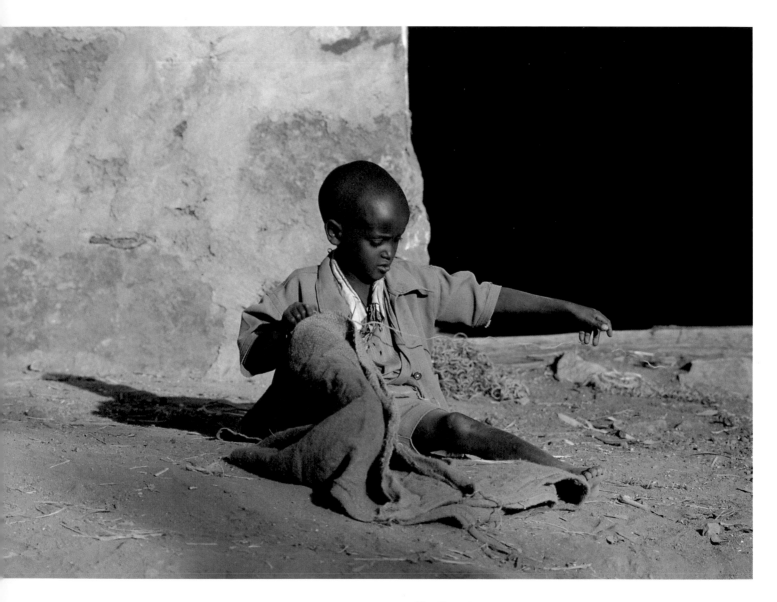

Mending a torn
grain sack.
Aksum, region
of Tigray,
Ethiopia.

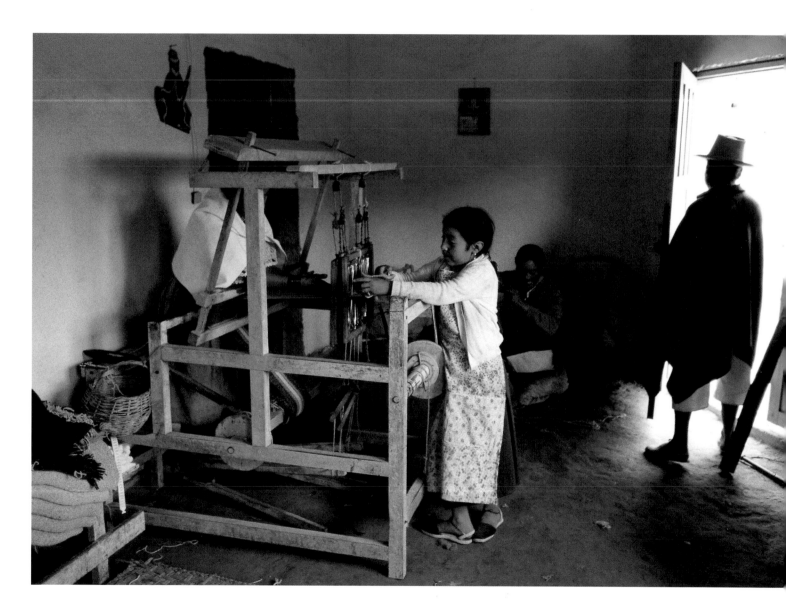

Otovalo girl, aged nine, at work on the family loom. Children's small fingers are particularly adept at forming the tiny knots in ponchos. Peguche, Ecuador.

In pre-modern societies, children progressively lose the privileges that are enjoyed by being small, sexually neutral and undifferentiated. Little by little, they have to accept the role their gender demands: for the girls, a future mother and housewife, for the boys, a provider of food. "In Africa, a girl is often taught not by her 'mothers' [female relatives] but by a slightly older friend. By the age of twelve or thirteen, she is capable of preparing all the usual meals. Housekeeping also requires familiarity with rules of hospitality and the rights of the various blood relations and kin by marriage. From the age of seven or eight ... a son is despatched to the fields after sowing to scare the birds off the seeds; the daughter will frequently be placed in charge of a younger child".[1]

Among the Aztecs, the education of boys aged three to fifteen "was entrusted to the father, and that of the girls to the mother. Learning was practical and discipline ferocious. Punishments rained down on the idle: parents would scratch them with agave thorns or force them to breathe the acrid smoke from burning peppers. Child-rearers in Mexico appear to have fervently embraced strong-arm methods".[2]

ABOVE: Young Buddhist nun holding a traditional oil-paper sunshade. Amarapura, Burma.

RIGHT: First prostration. A Golok family on pilgrimage to the monastery of Kunbum, the cradle of Tibetan Buddhism. Qinghai, China.

OPPOSITE PAGE: A father points out the fourteenth Dalai Lama during a Kalachakra (initiation ceremony). Gandan, Ulan Bator, Mongolia.

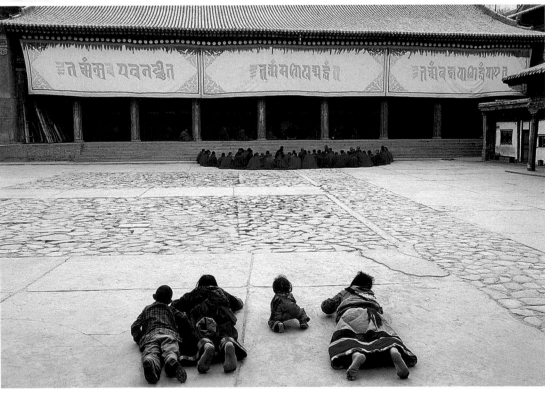

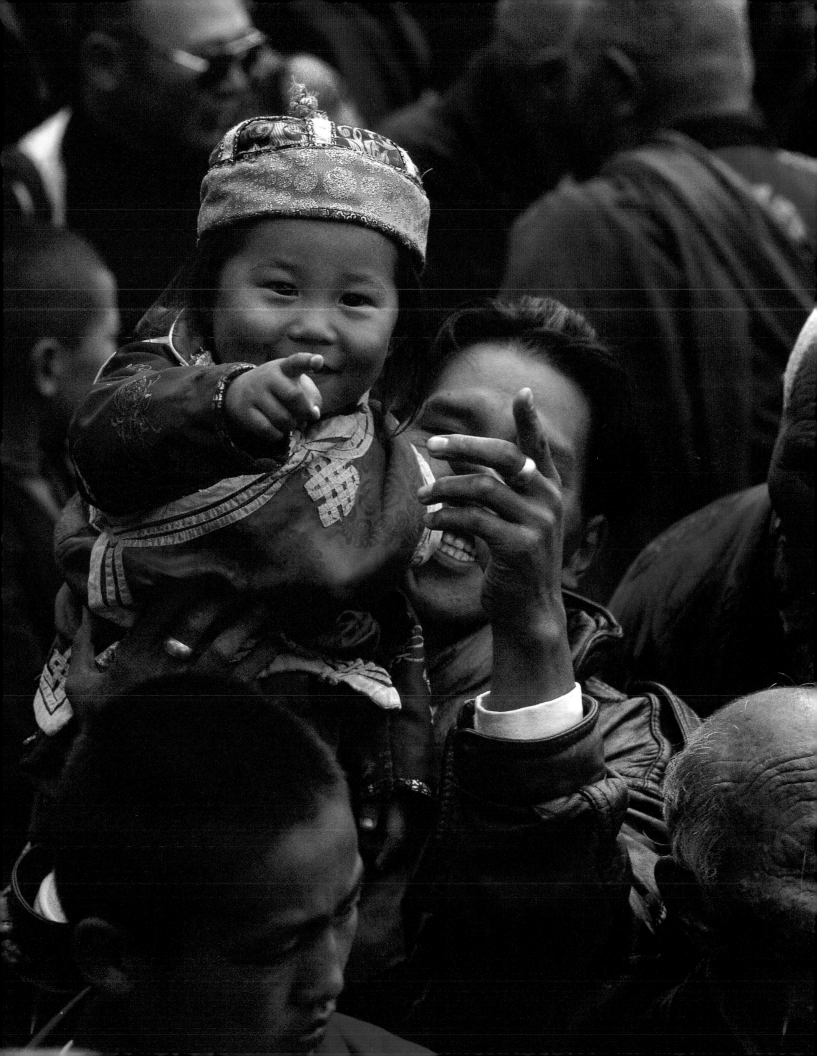

THIS PAGE AND OPPOSITE: Young monks engaged in ritual (top left), reciting prayers (above) or taking their siesta (opposite page) during the teaching and initiation of the Kalachakra ceremony. Bodh Gaya, the "Mecca" of Buddhism, India.

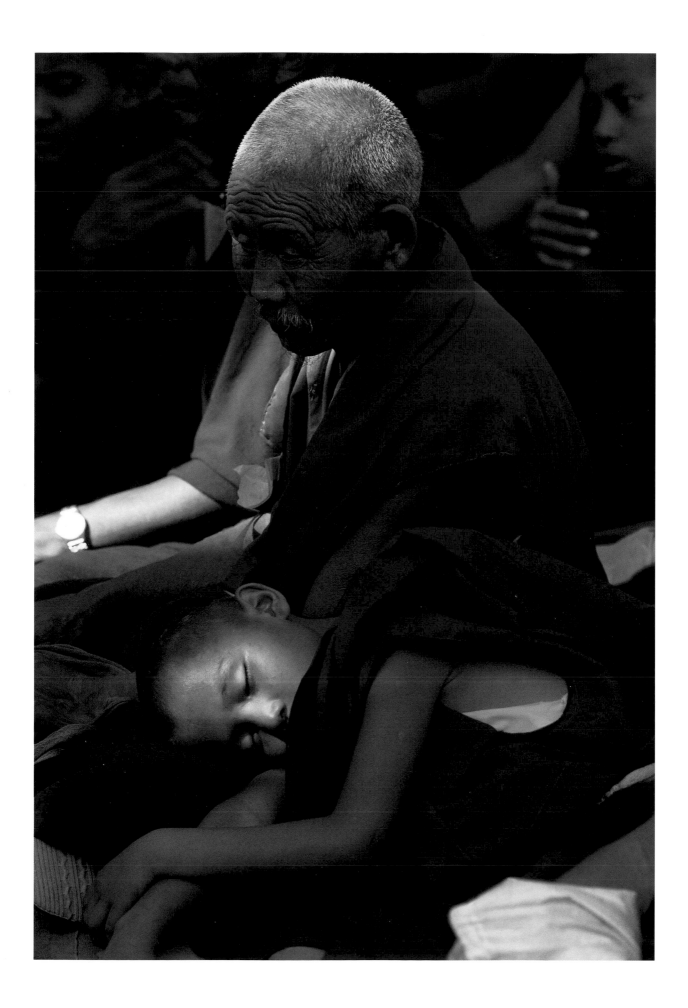

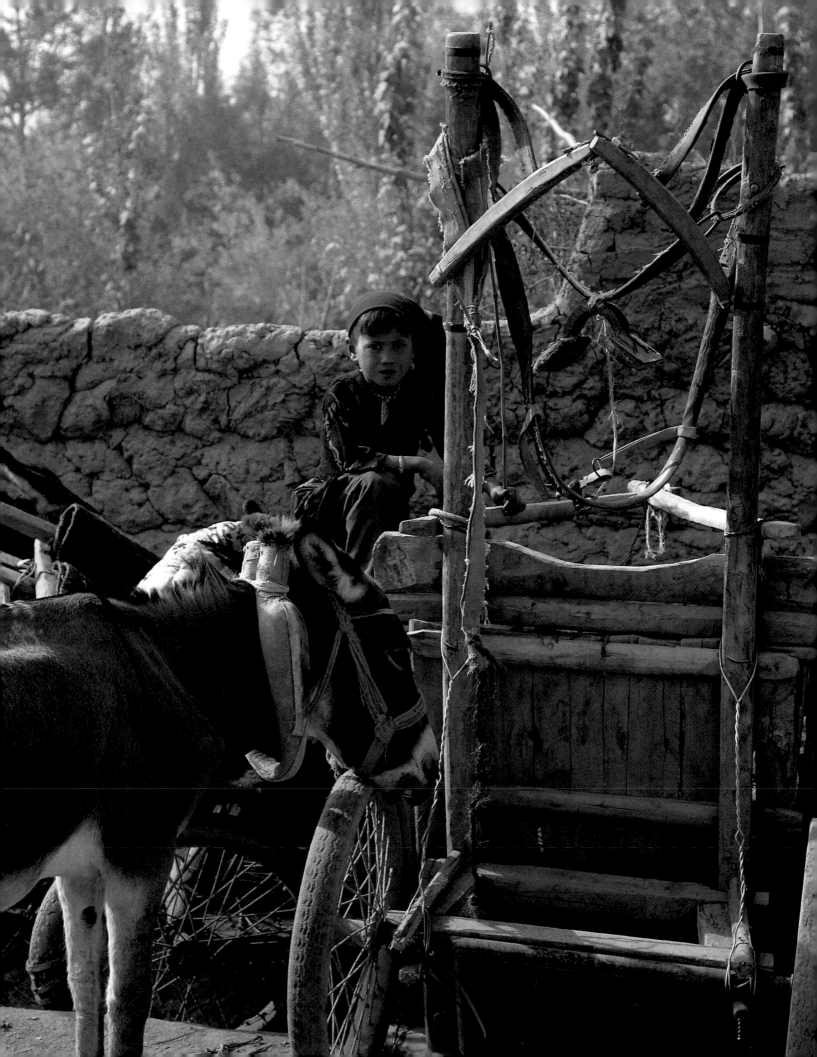

In European society, too, "education for adolescents was formerly conducted on purely sexist lines, with aims differing according to gender. The responsibility for rearing female offspring was exclusively that of the mother, teaching them first a daughter's duties, and eventually preparing them for marriage. The time came to put together the girl's trousseau; its preparation symbolised the link between mother and daughter and underlined the relationship, both cultural and emotional, binding the two. The ultimate purpose of the trousseau was to make it easier for the girl to leave the family

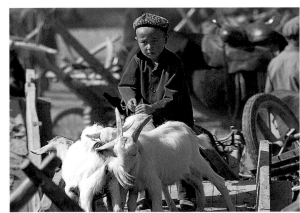

home. She was groomed to assume her 'natural' role of wife, mother and housekeeper. On the other hand, the boy was trained to safeguard the material wellbeing of the family and, above all, to act as master to his wife and children. Generally speaking, boys are brought up to be superior to women through their physical strength and courage, while girls are encouraged to submit to male demands. Modesty, gentleness and restraint in word, movement and gesture are qualities expected of girls".[3]

THIS PAGE AND OPPOSITE: In central Asia, parents send their children to market with mule-carts carrying melons, grapes, chickens, goats and sheep. North of Silk Route, China.

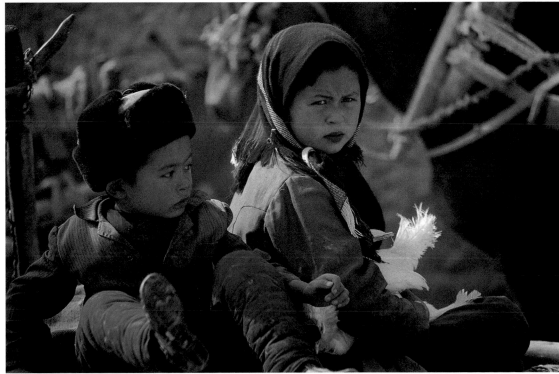

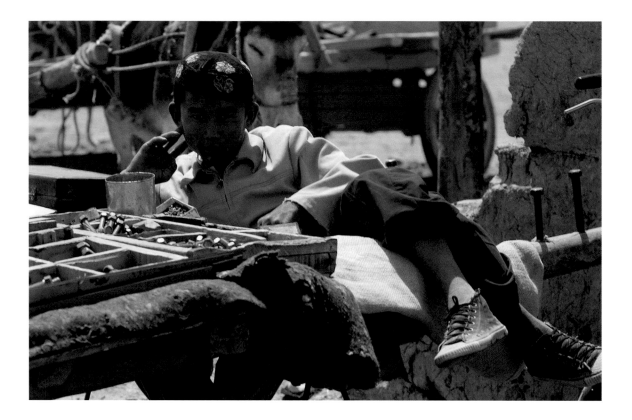

ABOVE:
Mobile ironmongers.
Uighur boy minding
the family "shop".
Sunday market,
Turfan, China.

OPPOSITE PAGE:
Young girl resting
on cotton bales,
which will be sold
at the market.
Kuqa, bordering
Tarim Desert, China.

Children can enjoy imitating adults. Their sense of self-worth is increased when they feel useful and when they manage to accomplish certain activities as if they were adults; their "apprenticeship" consists in persuading them little by little to carry out these adult tasks voluntarily. In Eastern Europe, little girls learn from the age of six to handle a distaff. They watch their grandmothers as they spin the wool, preparing tufts of animal hair for them and picking up the distaff as it falls on the ground. At home, the grandparents look after the children, teach them what they need to know about life, how to behave, how to recognise plants and how to dry berries. "My teacher was my grandmother", recalls a woman from Belorussia.[4]

In Europe, this learning process is often the responsibility of grandparents; in Africa, uncles tend to assume this role, while the parents are out working in the fields and return exhausted at night. Informal learning is also passed on outside the sphere of daily work. At festivals and gatherings, people recount the stories of their clans and past generations, as well as myths explaining the origins of mankind and of the various groups of people that the children come into contact with.

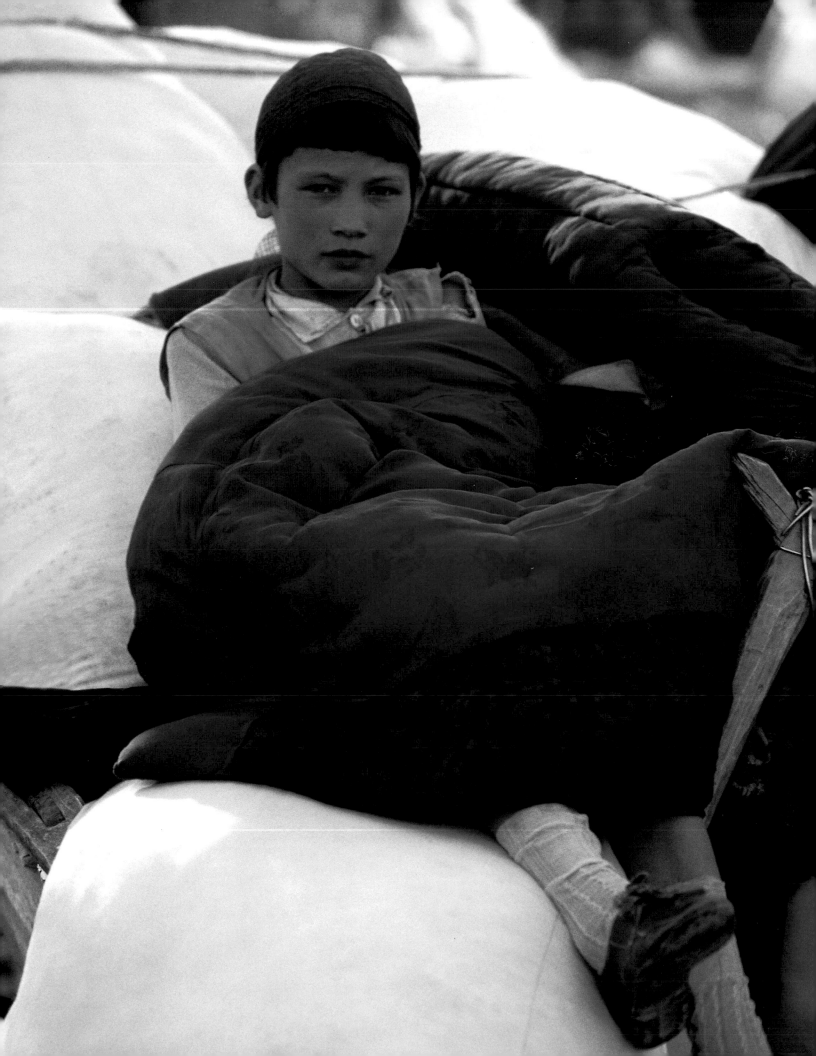

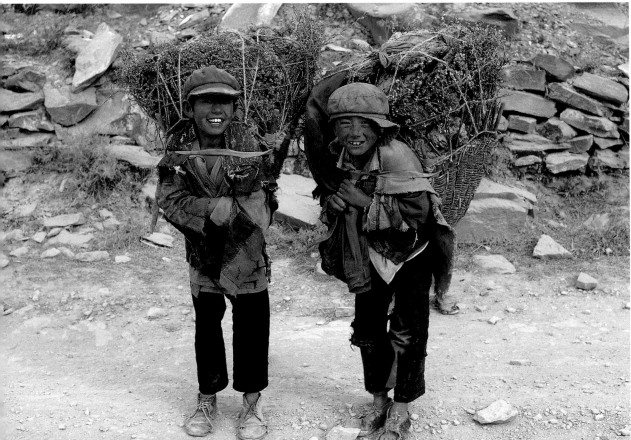

ABOVE:
Kazakh nomads fetching firewood for their evening halt. Autumn transhumance, Kayirti, Altai Mountains, China.

LEFT:
The heavy baskets on the backs of these two boys are overflowing with yak dung. Trees will not grow on these high plateaux – over 13,000 ft (4,000 m) – and yak dung is the only fuel. Tibet.

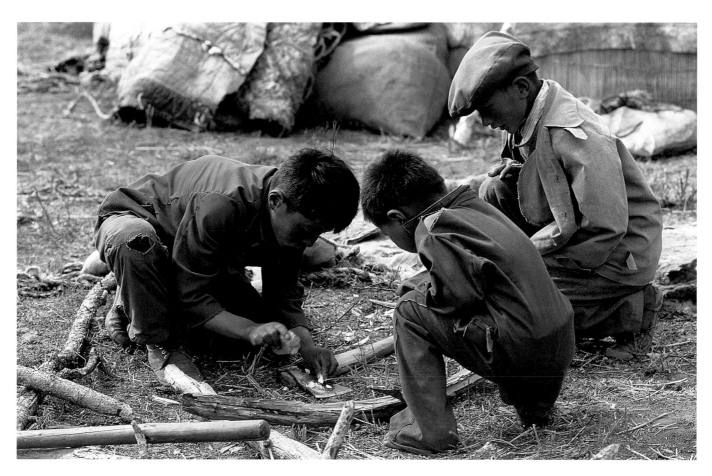

ABOVE:
Treasure-hunting.
Young Kazakhs
breaking stones
from the mountain to
extract aquamarines;

they exchange these
at the market for
vital necessities,
such as a Bactrian
camel. Black Irtysh,
China.

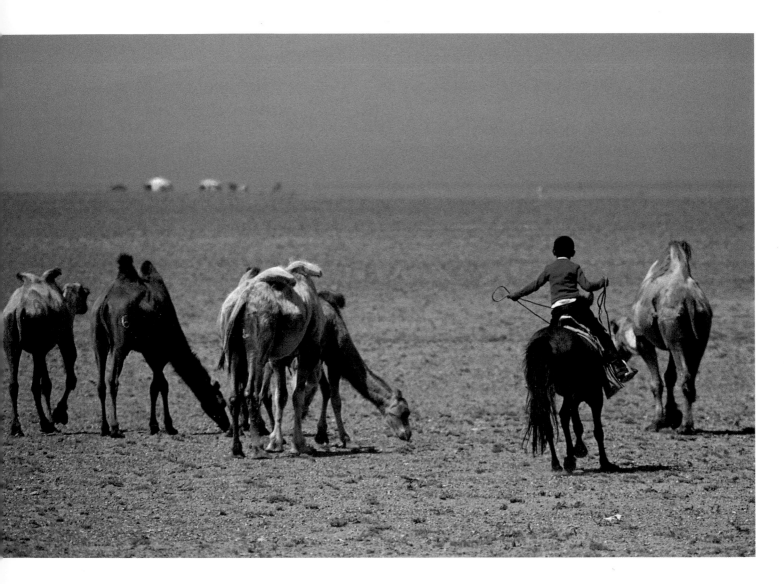

**Young boy minding
Bactrian camels.
Gobi Altai Aymag,
Mongolia.**

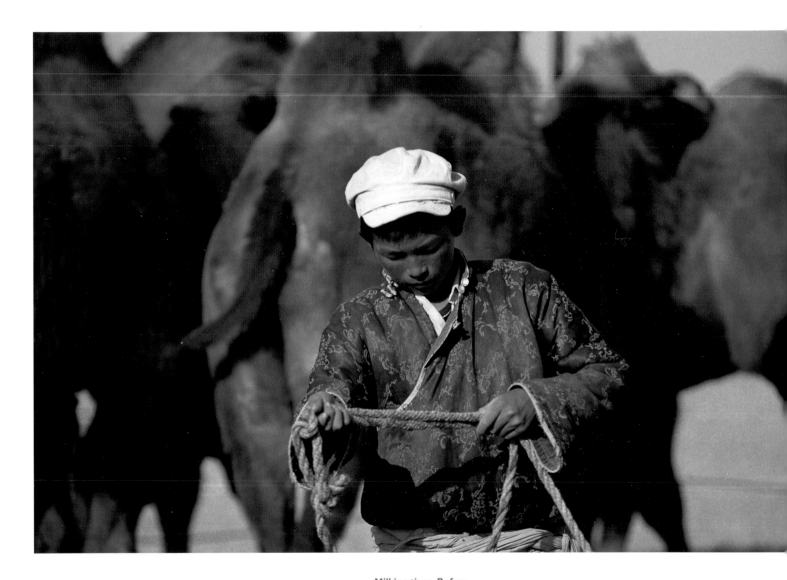

Milking time. Before
starting, a Mongolian
shepherd-boy prepares
a muzzle from a stout
camel-hair rope. Gobi
Desert, Mongolia.

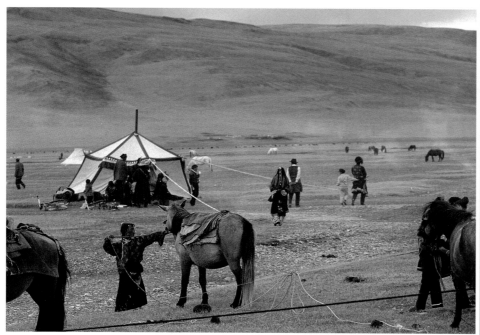

ABOVE:
A girl unsaddles
her mount at evening
camp. The Khampa use
horses more than any
of the other peoples
of Tibet. Near Yushu,
Kham, Tibet.

OPPOSITE PAGE:
On the wings
of the wind.
Mongolian girl
riding bareback
on the steppe.
Beyond Tsetserleg,
Mongolia.

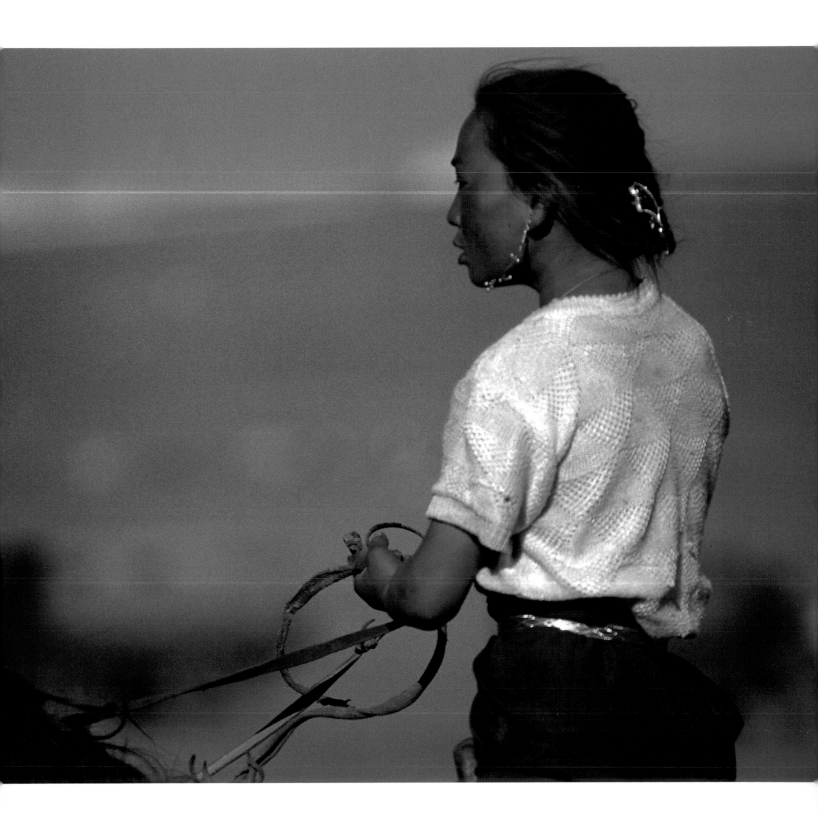

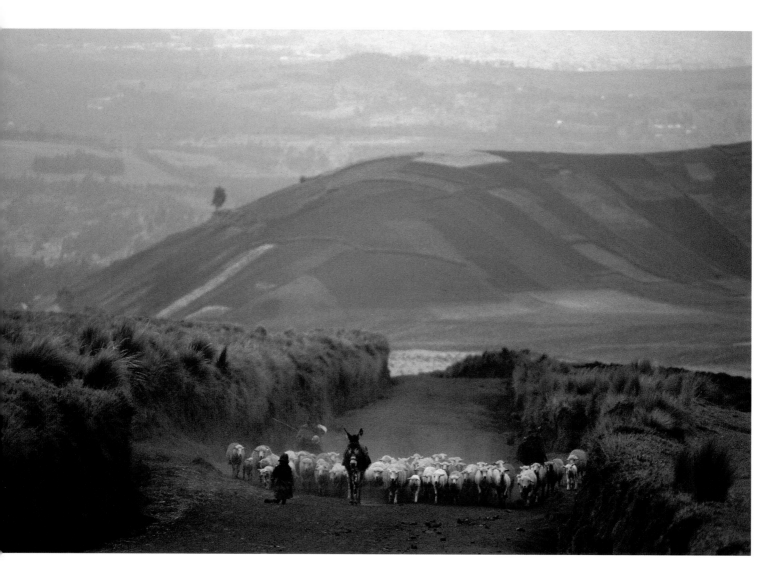

Through the cold wind and dust, a Puruha shepherdess races the onset of darkness to return her flock to the fold. Chimborazo Province, Ecuador.

Childhood is also a time for learning the numerous subtleties of ritual – what the rules are and what conditions are necessary to make the act effective. It is vital to memorise the details of religious observances, the obligations to the gods, and their names, along with their habits and characteristics.

Whether teaching practical rules and morals for everyday use or passing on age-old memories of the past, the tales told by older people at festivals and gatherings play a fundamental role in socialising youngsters and integrating them into the community. Children are thrilled by adults' story-telling. Unconsciously, they begin to unravel the mysteries of the world that surrounds them and acquire a feeling of belonging to the eternal continuity of

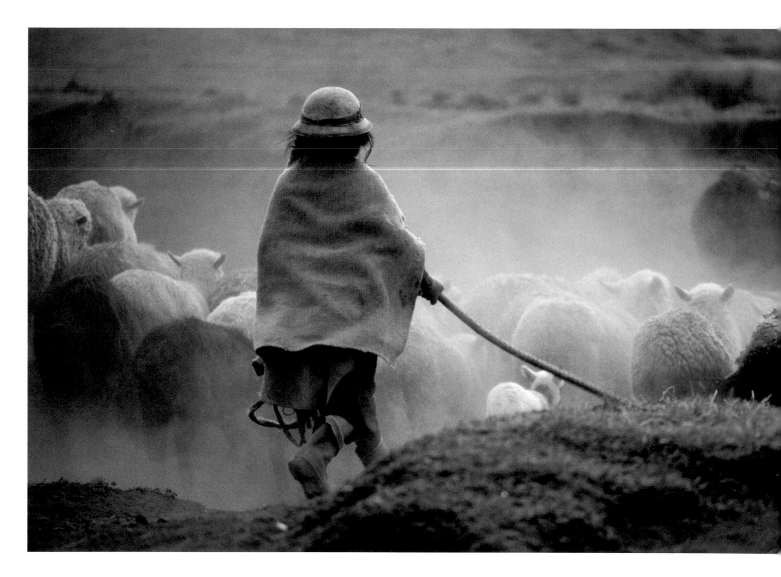

In the Andes, youngsters' duties are no child's play. Everyone helps mind the flock. Chimborazo Province, Ecuador.

human life. They are transported back to a time, both mythical and historical, where everything had a place – men, gods, animals, fairies and other creatures from paradise. They experience a world where life is not always the same as on earth, a world where the strange is normal, where the unusual is the rule, and where the gods of Nature can help a man, or, conversely, heap obstacles in his path.

As soon as they are old enough and have fulfilled their obligations to their mothers and fathers, young Peul boys escape from the adult group, forming "gangs" with their peers, roaming the countryside, hunting, picking berries and fruits, or fishing: this is their way of finding the necessary food to supplement their diets.

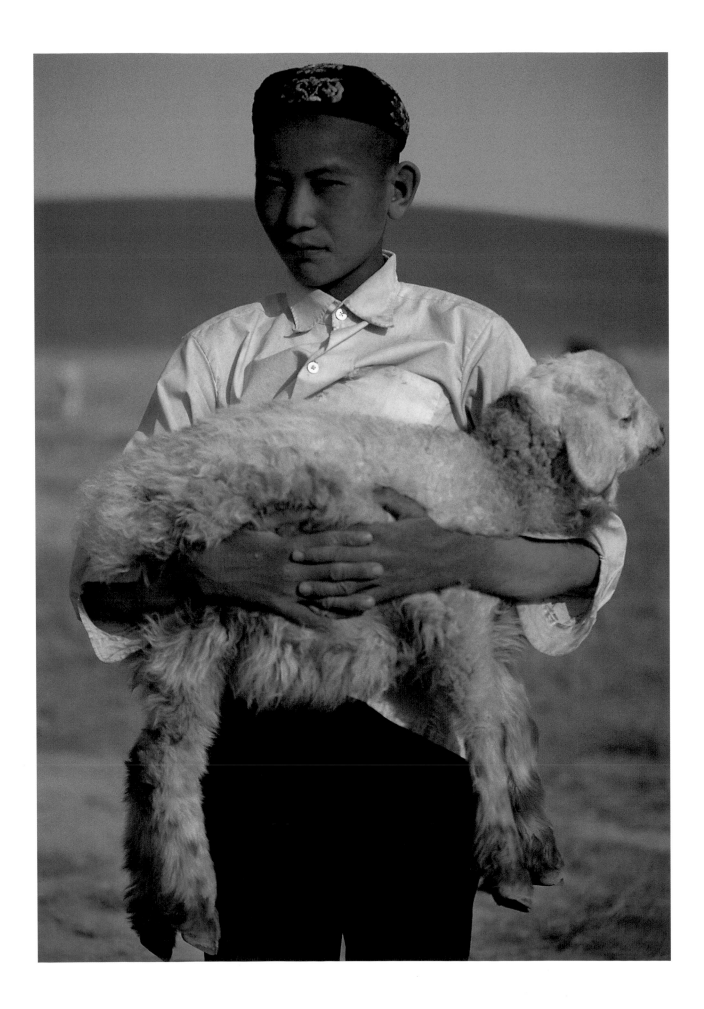

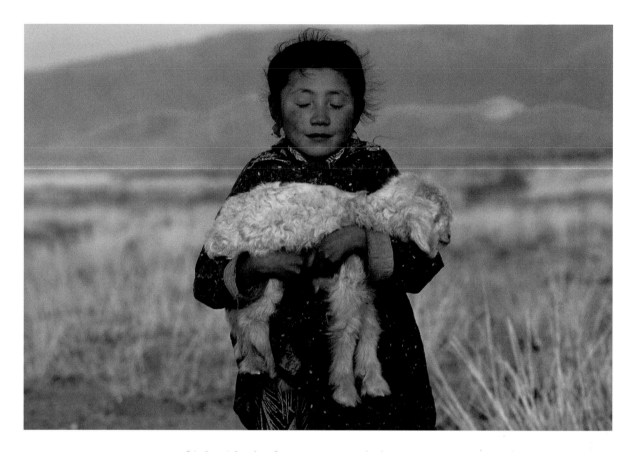

Opposite page:
Uighur shepherd
carrying an ailing sheep.
Turfan Oasis,
Xinjiang, China.

Above:
A treasure to cherish:
young Kazakh girl
with new-born lamb.
Bayan Olgey Aymag,
Mongolia.

Little girls also form groups with their peers as soon as their mothers allow them. Sometimes male and female groups meet up in the evenings "to chat, sing or dance in the moonlight". Custom approved of "a kind of symbolic marriage", which brought together boys and girls for evening amusements.[5] The life of adolescents also develops through a series of initiations, each one more demanding than the last, and sometimes painful. Such trials imbue young people with a sense of pride in progressing from one step to another, forge their characters by presenting them with challenges and reinforce the sense of belonging to a specific group. Obedience to the rules of the group, formerly imposed, now becomes a matter of choice. Initiations can take a violent form. From that moment, young people can no longer submit passively to the rituals imposed on them by adults. It is not enough to be mere spectators at the rites of passage. The participants are confronted with fear and pain; adults lay hands on them and thrust them by force from one milestone to the next.

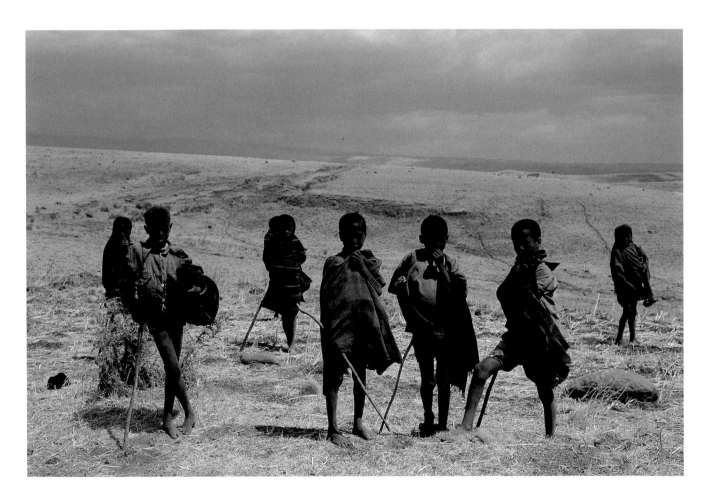

ABOVE:

A group of shepherd-
boys lean on their sticks
against the wind
sweeping the high
plateau. Simien
Mountains, Ethiopia.

OPPSITE PAGE:

As proud as a prince:
Amhara shepherd.
Tisisat, at the sources
of the Blue Nile.
Ethiopia.

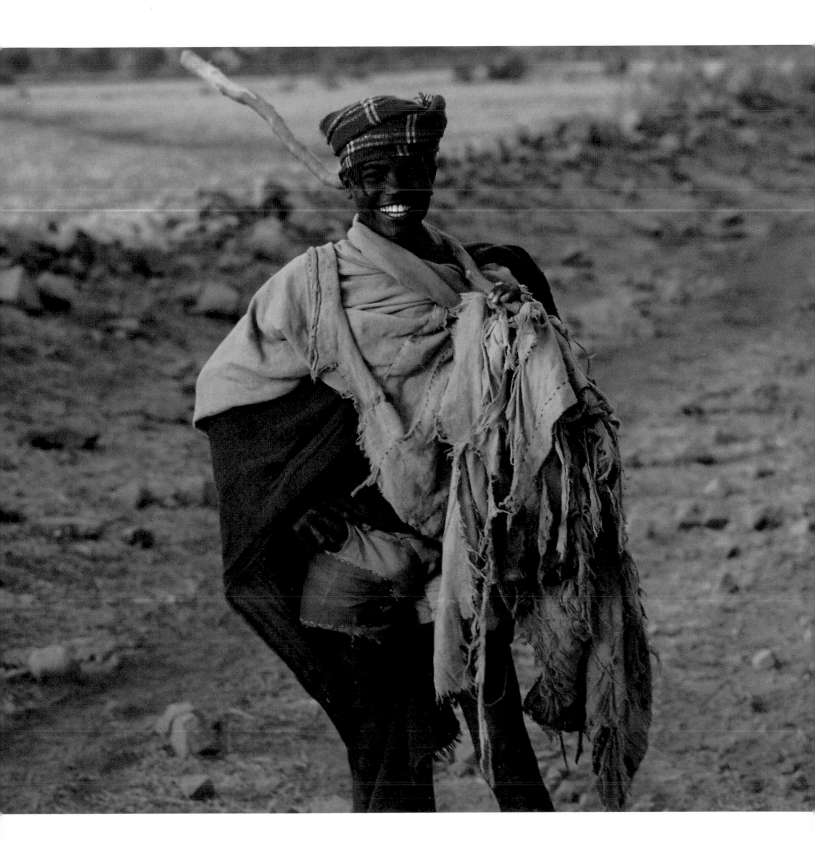

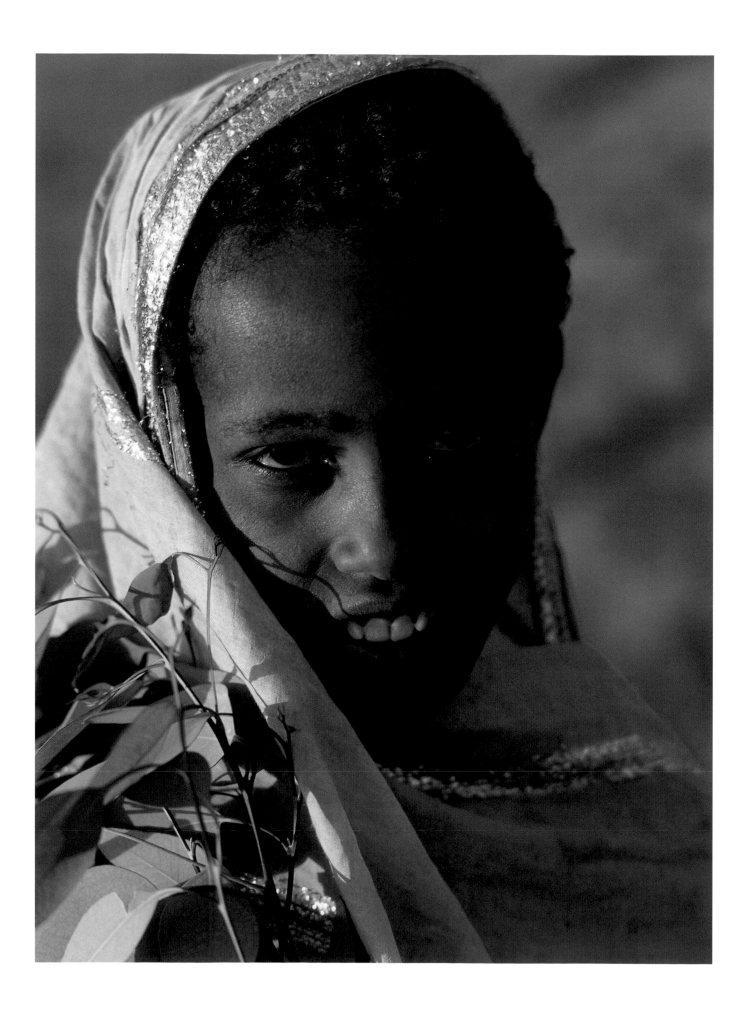

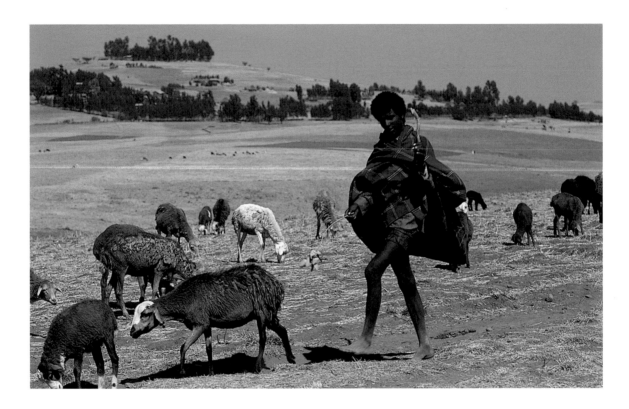

OPPOSITE PAGE:
An Amhara
shepherdess,
almost straight
from the Bible.
Lalibela, Ethiopia.

ABOVE:
Bare-footed shepherd
and flock. The branch
he uses to drive
the animals is
from the eucalyptus,
an Australian tree
that has colonised
the Ethiopian plateau.
Near Debarek, Simien
Mountains, Ethiopia.

The adolescent must survive these trials without flinching, weeping, or showing distress. At the end, he or she will have attained manhood or womanhood and be admitted to the society of adults, progressively acquiring all their rights.

The initiation of a boy is a major event in traditional societies where the individual has no validity except in relation to the group; where his role is not to lead a personal existence but to immerse himself in the community and perpetuate its rituals. The youths, in their peer-groups, take part together in the same violent tests. United in their battle with pain and exhaustion, they will learn the same things at the same moment: the secrets of life and the gods, revealed only to the initiated – who alone are capable of understanding them and then only at a given instant. Initiation is not the result of mere mental reflection, but also of physical effort that will transform and mature the youth, leaving him ready to assume fresh responsibilities and obligations.

The physical effort and pain involved in the initiation can be extreme in certain societies, from the North American Indians to the Papuans of New Guinea. The Apaches say that "breaking a boy

is like breaking a colt. They force him to make holes in the ice and bathe, run with water in his mouth, humiliate him on his trial war parties, and generally bully him".[6] In non-Islamic Africa, boys must undergo a series of challenges to acquire the status of young men. After three cycles of seven years, they can marry and join the male societies of their community. An initiatory retreat in the forest – "to all intents and purposes a social birth" – marks the coming of age, with all the responsibilities this new status entails. "The initiation is always accompanied by bodily mutilations: for the boy, circumcision or scarification; for the girls, excision. The period of retreat is variable, from a few weeks to a few months; formerly it lasted several years".[7]

Among the Kissi of Guinea, as Denise Paulme has observed, the girls, during the months preceding their initiatory retreat, care for nothing but "their appearances and amorous intrigues ... It is their period of sexual liberty, and they make the most of it. They are merciless to their contracted fiancés, who are obliged to submit with forbearance to the capricious moods of their future wives".

ABOVE:
Back from the fields; Oromo boy making for his *tulku* (hut) with a sack of grain. Bale Mountains, Ethiopia.

RIGHT:
Harvesting *teff*, a cereal of the high plateaux, used to make *injira*, a soft Ethiopian pancake. Modjo.

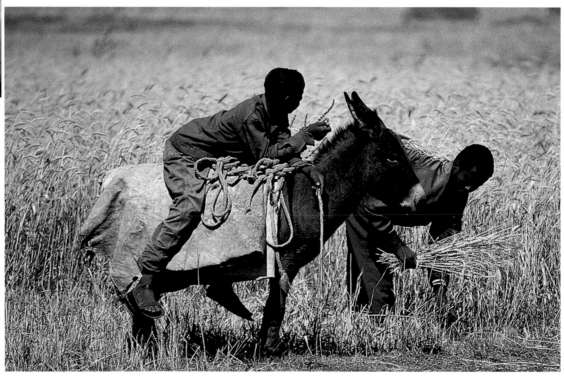

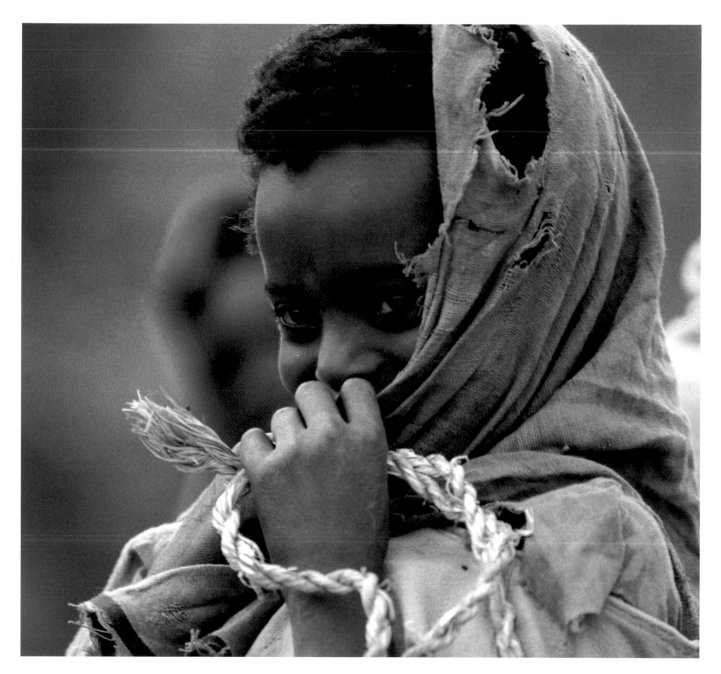

ABOVE:

**Coy smile of an Amhara
girl. She is bundling up
firewood sawn by her
elder brothers. African
Rift Valley, Ethiopia.**

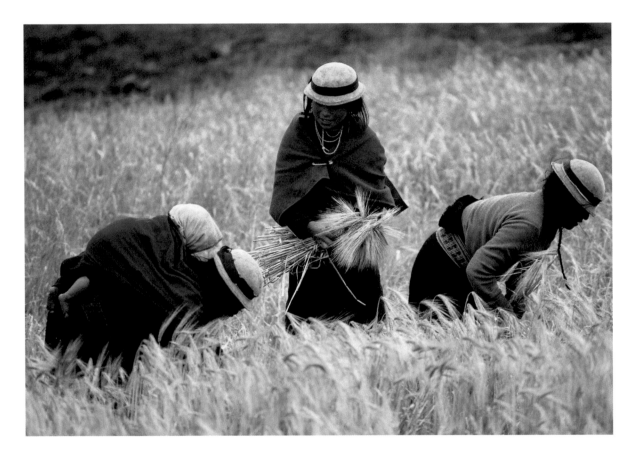

ABOVE:
The Puruha ,
descendants of the Incas
of the Tawantinsuyo
kingdom, harvest corn
in the traditional way,
13,000 ft (4,000 m) up,
some with babies on
their backs. Chimborazo
Province, Ecuador.

OPPOSITE PAGE:
A break from
sowing. Cañari child.
Ecuador.

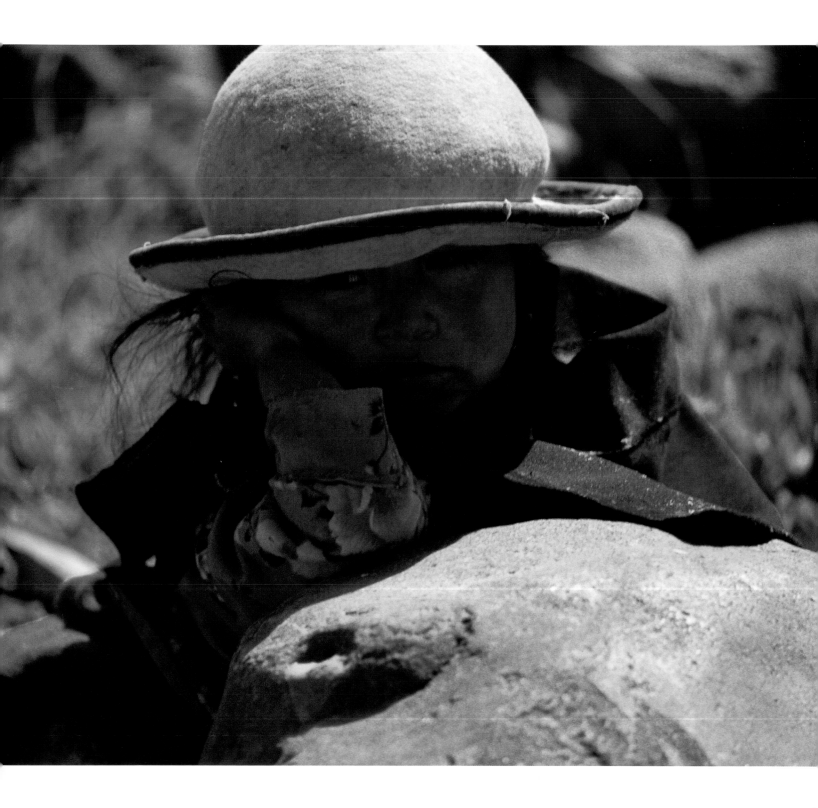

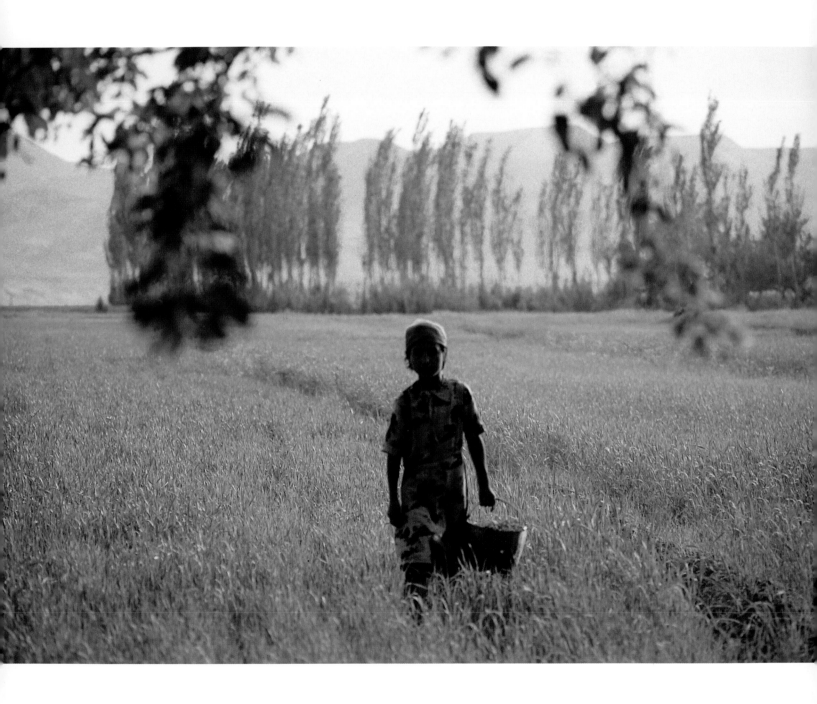

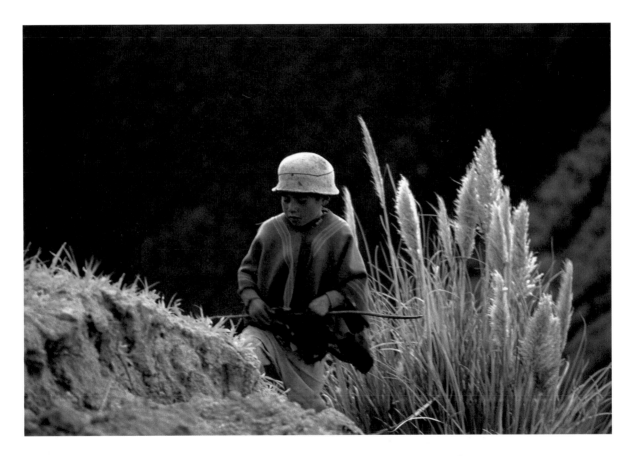

OPPOSITE PAGE:
A breezy day: Uighur
girl among the rippling
corn and swaying
curtains of poplars.
Foot of Tian Shan
("Celestial Mountains"),
China.

ABOVE:
Diminutive Puruha
shepherd on the slope
of a volcano. Ecuador.

OPPOSITE PAGE:

Dai girl carrying

heavy pails of water

with the aid

of a bamboo yoke.

Mekong Valley,

Southern China.

BELOW:

Harvesting the

lotus in autumn.

The Sani consider the

roots a tremendous

delicacy. Yunnan, China.

During their forest retreat, they receive instruction that is meant to teach them how to manage their homes – even though they already possess this practical knowledge. "Later, they will remember the retreat as a happy holiday period; on festive days, women will recall snatches of songs they learnt at the time".[8]

In most African societies, a girl of fourteen "is supposed to have acquired sufficient knowledge to be a future wife and eventually a mother. Finally, she will indeed marry and have her own children".

Tattoos are another way of expressing belonging. Magical designs scratched into the skin protect the individual, who is thus marked out as a lifelong member of a unique and immediately identifiable group. Tattooing is definite proof that the person can withstand pain, and opens the door to a new world.

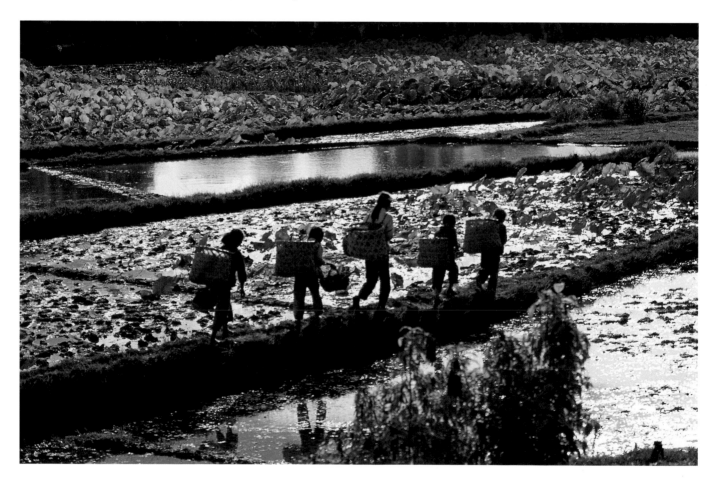

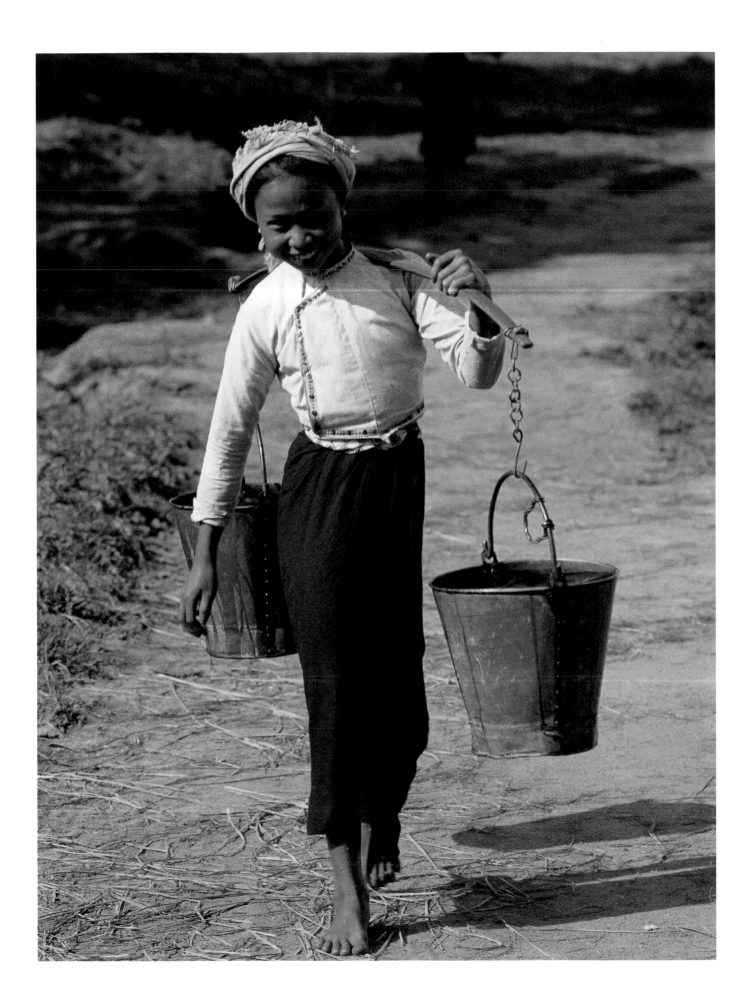

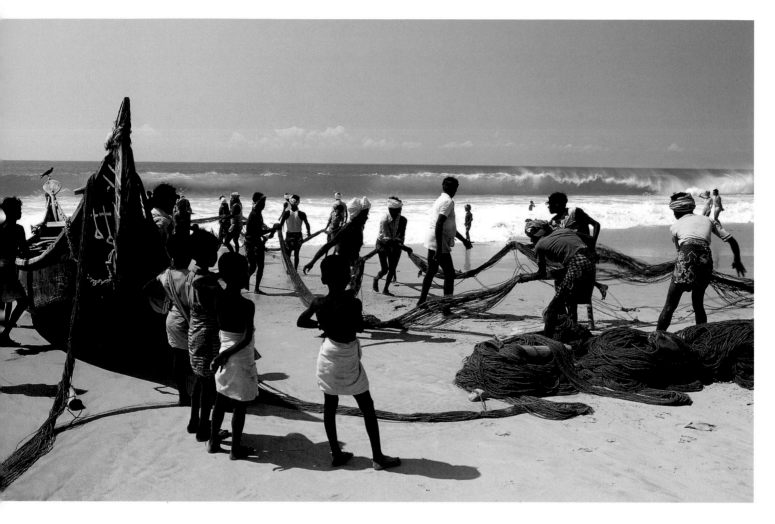

Rolling up nets after fishing. Kerala, Arabian Sea, Southern India.

Initiation, for boys as well as girls, marks the end of the carefree period of childhood and entry into the world of duty – and, in the case of women, submission.

Membership of a group strengthens an individual's self-assurance and his or her capacity to confront hardships. Pain shared forges a link between group members, adding extra significance to the bonding process because acceptance was achieved at a cost. In the West, young people no longer undergo painful rites of passage; like a stream flowing peacefully on its course, childhood is expected to progress without any problems. Everything is organised so that youngsters can avoid facing life's difficulties: no challenges, no hurdles, no setbacks and no taboos. Even compulsory military service, the symbol of boys' initiation and integration into society, has been abandoned.

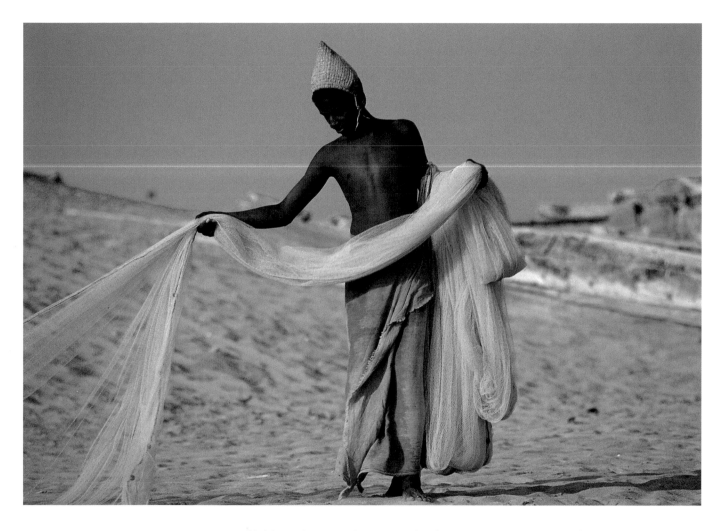

Nets being laid out to dry. Coast of Orissa, Bay of Bengal, India.

Children desperately want to be the same as their peers. Western fashions in clothes, food, and leisure activities are the same in every country; soon they will be identical the world over. The fact that young people go about in groups and gangs denotes a need for socialisation, but in this case between peers, away from the presence and control of adults, and equally without their assistance or well-meaning attentions. For a brief moment adolescents rebel, but finally accept the inevitable, having, in fact, little choice. A few intractable characters persist in making their mark by being different, but in traditional societies, the general aim is to become accepted by being indistinguishable from others. Scarification, mutilation and body-piercing are all tests expressing the need to demonstrate strength of character: they prove an individual's capacity to withstand pain.

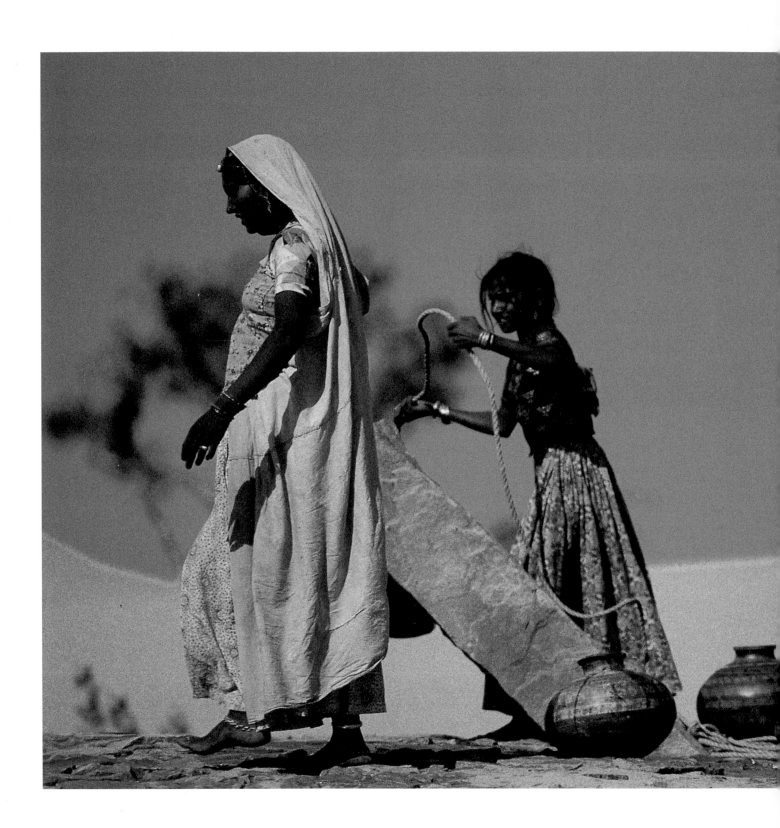

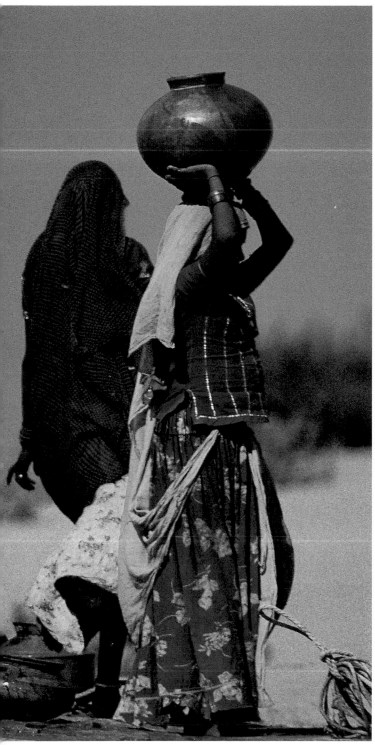

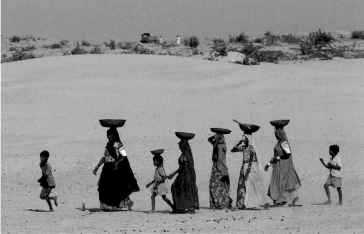

LEFT: Fetching water from desert wells is the daily task of mothers and daughters. Shekhawati, India.

ABOVE: Under a burning sun, containers balanced on their heads, women and children bring back stones and sand from the desert to make mortar. Rajasthan, India.

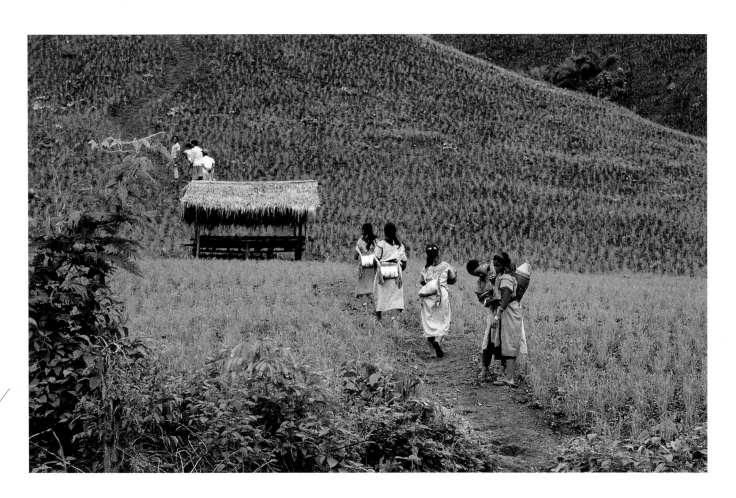

ABOVE:
Lisu girls setting
out on their long
trek to fields in
the mountains.
Slash-and-burn
cultivation exhausts the
soil in three years; thus
each new field is further
from the villages.
Northern Thailand.

OPPOSITE PAGE:
Doing the washing. Lisu
teenager in traditional
costume at the water
pump. North of Chiang
Rai, Thailand.

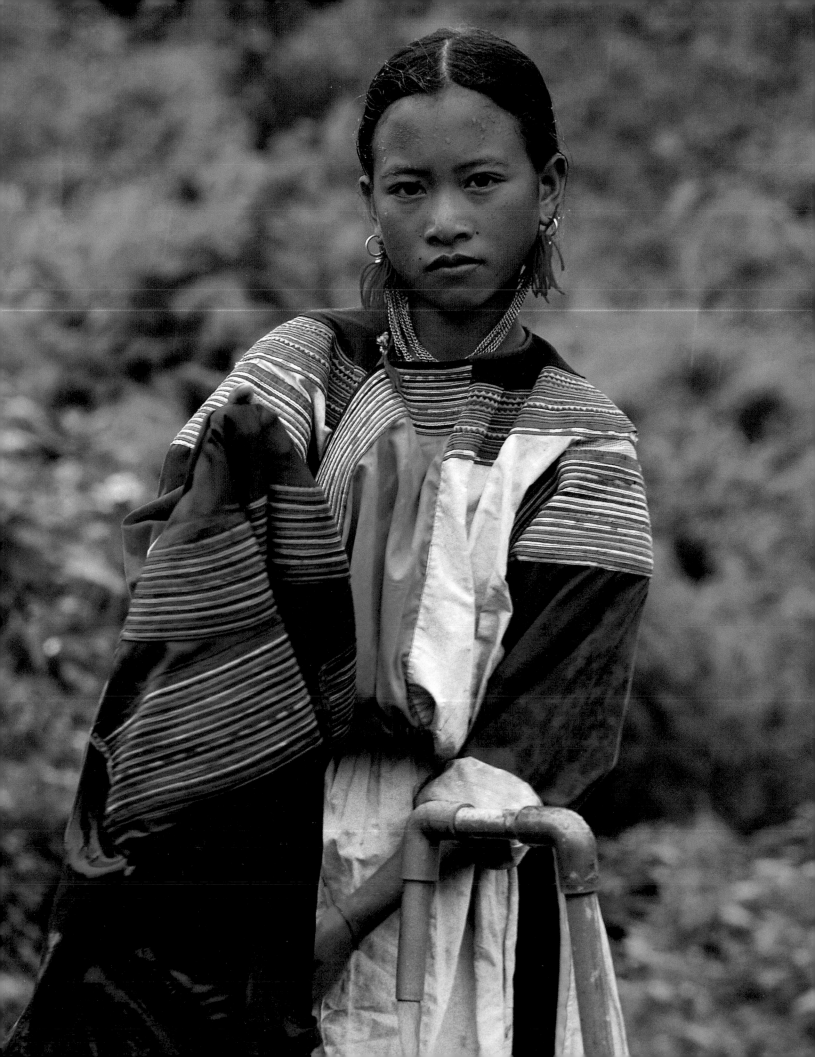

Family Portraits

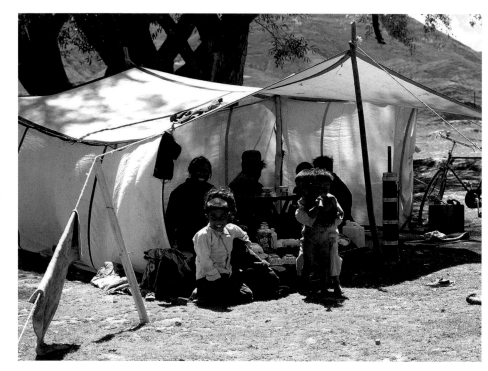

LEFT: Music and laughter on the "Roof of the World". The family are sharing dried yak meat, *tsampa* (barley flour, tea and rancid butter) and home-brewed *chang* (beer from fermented barley). Near Tacchukha, Tibet.

OPPOSITE PAGE: Brother and sister. The dry air and tropical sun redden the cheeks. Lhasa, Tibet.

In a traditional society, procreation takes place not only to fulfil
that society's needs, and to perpetuate and reinforce it, but also to
supply help with household and agricultural work and provide
a form of insurance for old age, when grown-up children will look
after their aged parents. When the parents die, the children will
see that their funerals are conducted with the proper rites
so that their souls will leave this world content and not return to haunt
the living because they have been neglected.

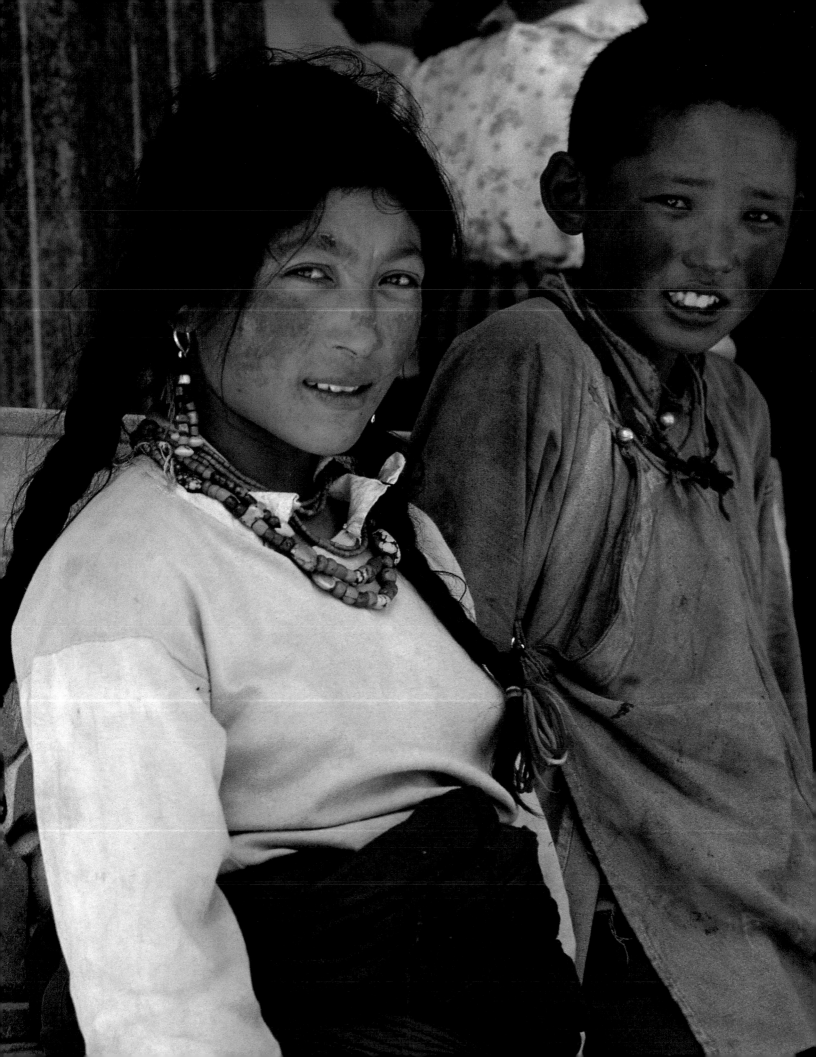

In "starting a family", to use the time-honoured expression, the young adult completes his formative period by reproducing the role model presented by his parents. The son finally becomes the equal of his father; now, in turn, he is responsible for a family – the "head of the family", in fact. The young man expresses his new status by playing the part expected of him. It brings him pleasure, as well as his parents and uncles.

In our Western world, couples produce children for themselves, for the joy and satisfaction of beginning a family. The child legitimises

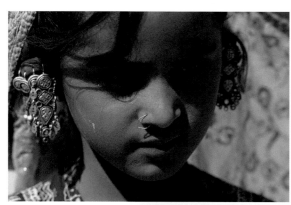

the parents' status, guaranteeing them a respectable position in society. A trendy phrase today is "making a baby": and yet one does not "make" a baby – one creates a child that will grow up to be an adult. Adults hope, consciously or otherwise, that the child will achieve what they failed to do in their own youth. "In Africa, the individual is inseparable from the family line, which continues to live on through that person, who is merely its extension".[1]

ABOVE:
Young girl with sparkling earrings. Family riches are passed from generation to generation in the form of jewellery. Gujerat, India.

RIGHT:
Afternoon shadow in the desert. Three sisters play with their dog in the women's quarters. Near Bhuj, India.

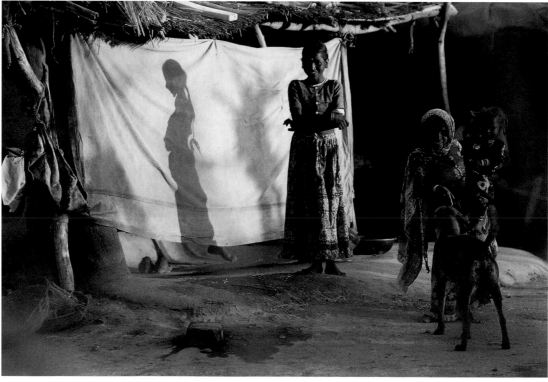

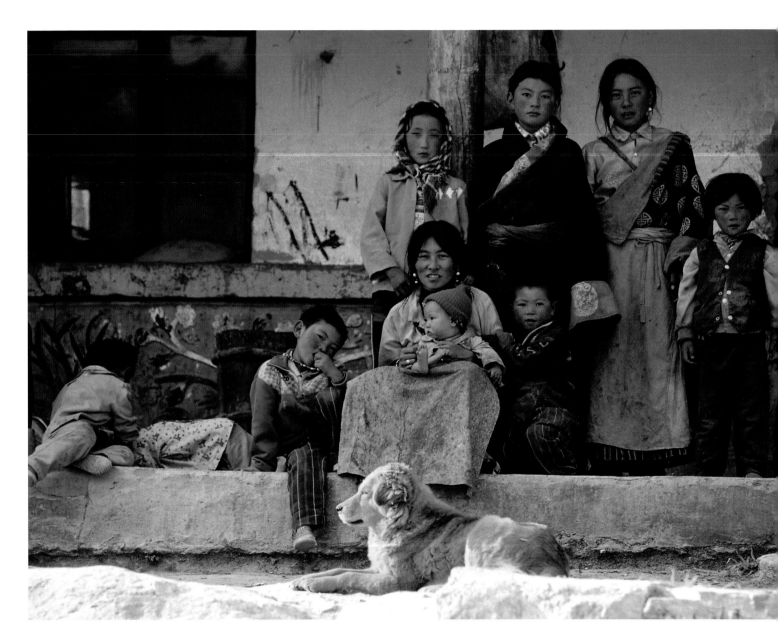

ABOVE:

Family portrait.
At the foot of the
Anye Machin, highest
peaks of the Kunlun
Mountains, Eastern
Tibet.

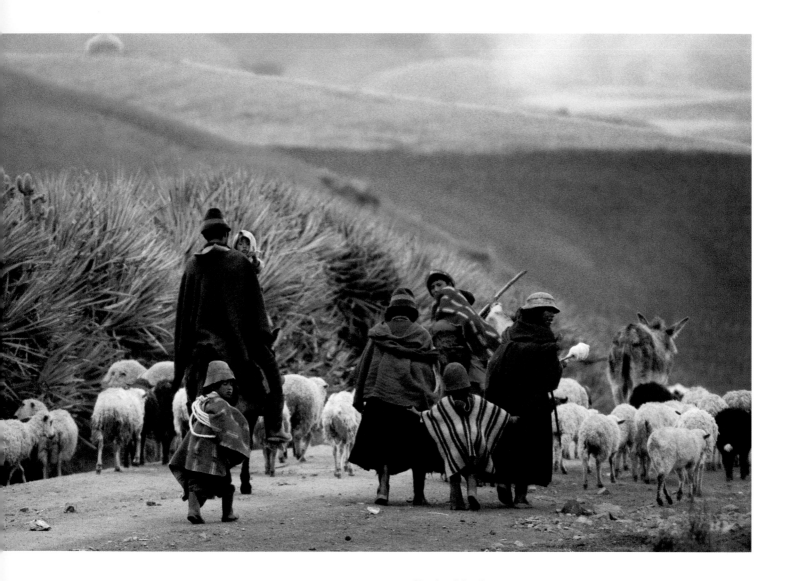

Shepherd family
returning from *taita*
("Father") Chimborazo,
highest peak of the
Ecuadorean Andes.
Twilight in the
"Valley of the
Volcanoes", Ecuador.

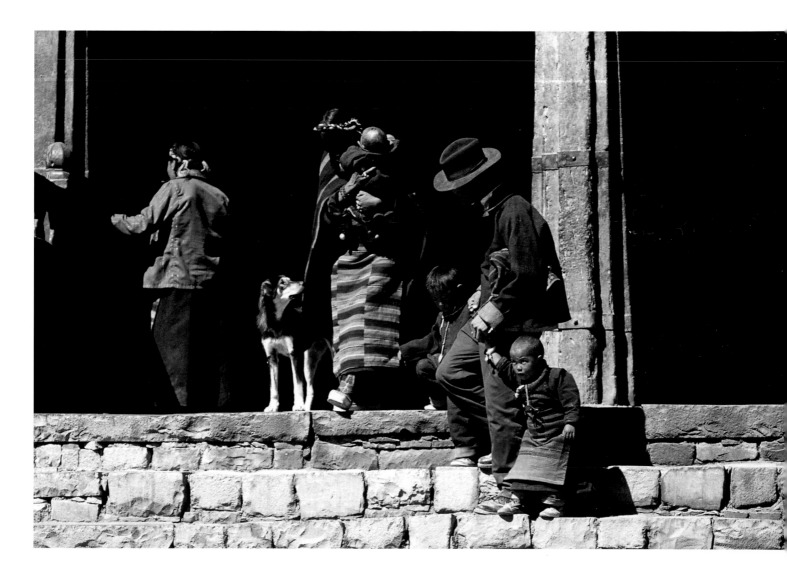

Grown-ups helping
toddlers descend the
steep steps. Tashilunpo
Monastery, former
residence of the
Panchen Lamas,
Zhikatse, Tibet.

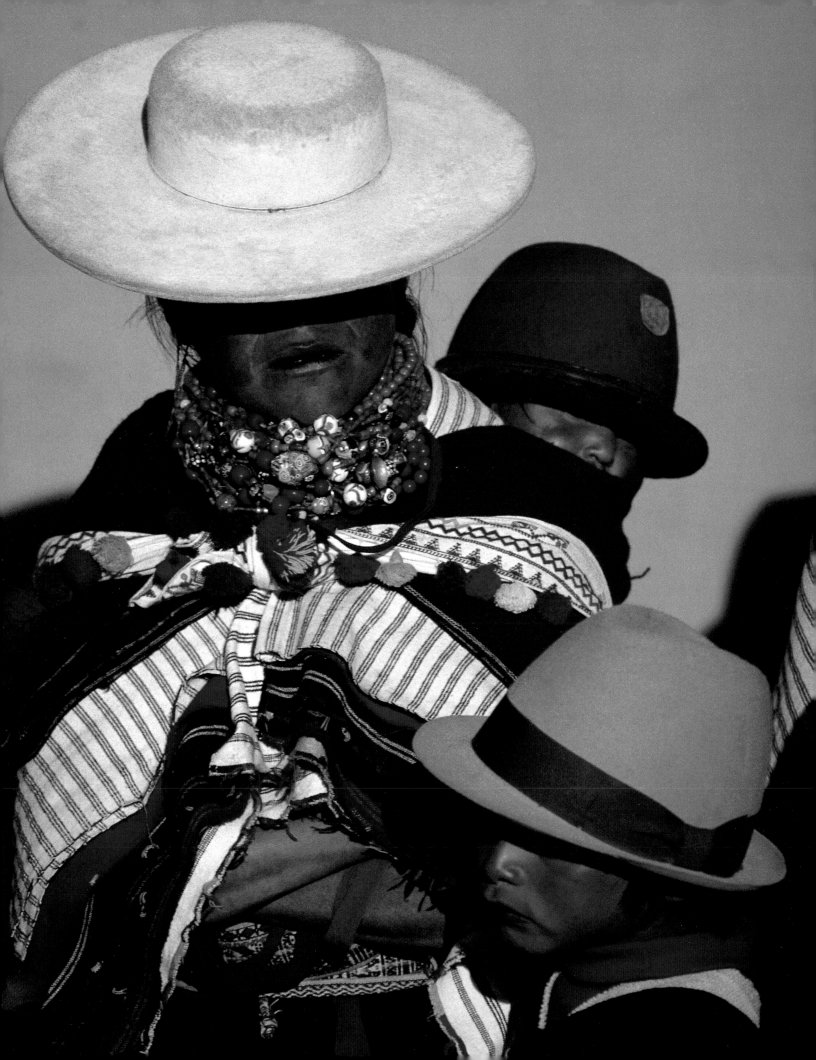

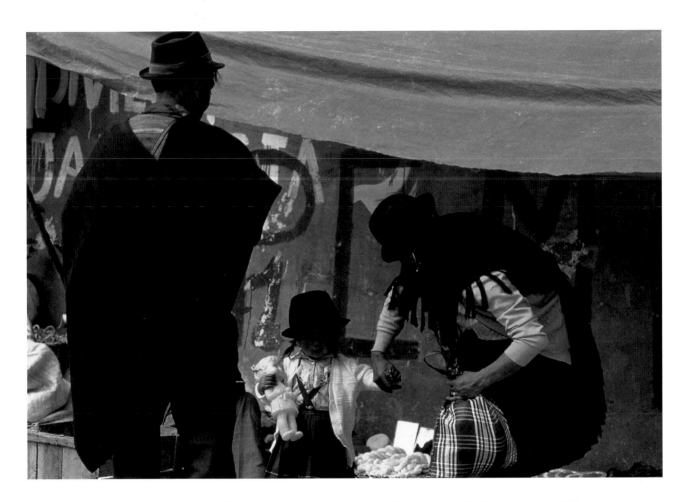

OPPOSITE PAGE:
Salasaca mother and
her two sons. Feast of
St John, Ecuador.

ABOVE:
A bit of family
shopping. Saraguro,
Southern Sierra,
Ecuador.

This is why it is so important for a man to father a son, and if his wife does not give him one, he will take a second spouse. "Marriage is more than the creation of a new family in the village: it is the one, single way to perpetuate the family line. Only a recognised union will allow the couple's children legitimate status; they will be the ones to feed their parents when they can no longer look after themselves, give them a proper funeral and honour them after their death. Of the children's children, the first-born will assume the grandfather's name, thus ensuring its survival and prolonging it beyond the grave".[2]

African fathers, in principle, exercise limitless authority. Children owe their father obedience and respect. They are expected to work for him, support him in any dispute, even against their mother. The relationship between grandparents and grandchildren is one of trust and intimacy tempered by the respect due to all elderly persons.

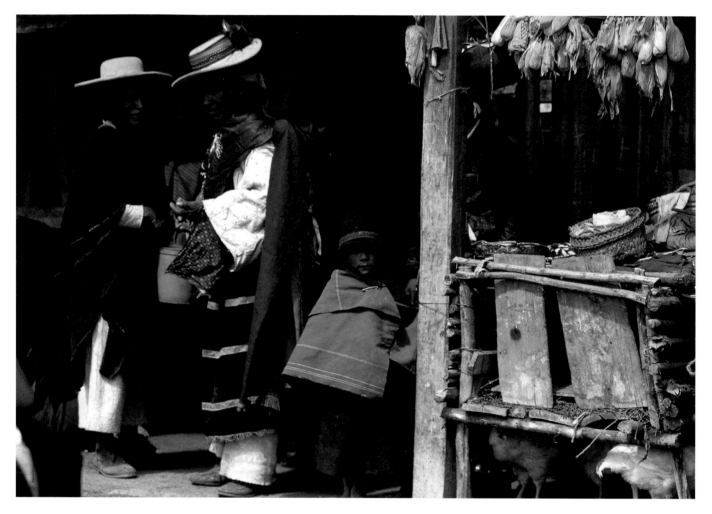

Growing up in the chief's house. Salasaca, Andes Mountains, Ecuador.

Mother love

"The mother has the right to her children's obedience and respect, but the basis of their relationship remains, in her case, entirely an emotional one. Even after the child's earliest years, she is still the source of all material comfort, the symbol of absolute security, as well as the housewife who will appease her offspring's hunger. As a boy grows up, he escapes from his mother's control. A girl remains longer at her mother's side; she can identify with her and strives to imitate her. An elderly mother, in return, has the right to be looked after by any of her sons capable of working".[3]

On the Melanesian island of Trobriand, "the totem, name and possessions are handed down to the children through the mother's line. It is to a mother's brother that the rights and

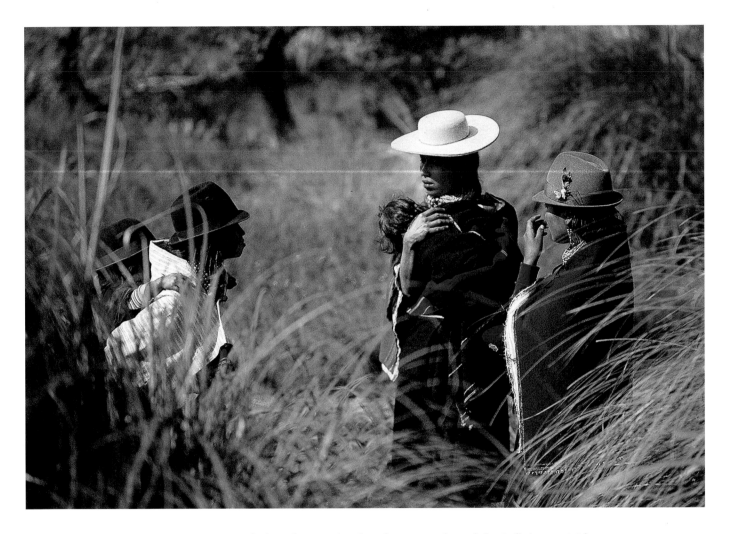

Salasaca mother and children in the long grass. She wears a black mourning poncho in homage to Atahualpa, the last Inca emperor. Summer solstice, Northern Sierra, Ecuador.

duties of paternity devolve, even though he is living outside the family. He is the one who feeds his sister and educates her children.

Thus, each child has two fathers: the true one, who lives with the child and is loved without being feared, and the maternal uncle, living apart, but exercising the authority of a father and considered and feared as such".[4]

In Cambodia, "the ideal husband will treat his wife as his equal, never despising or mistreating her. He must be faithful to her and allow her complete freedom in the running of the home. For her part, the spouse must be faithful to her husband and amenable to her in-laws; she it is who must make the most out of what the family owns, and usually, when her husband earns a little money, he entrusts it to her.

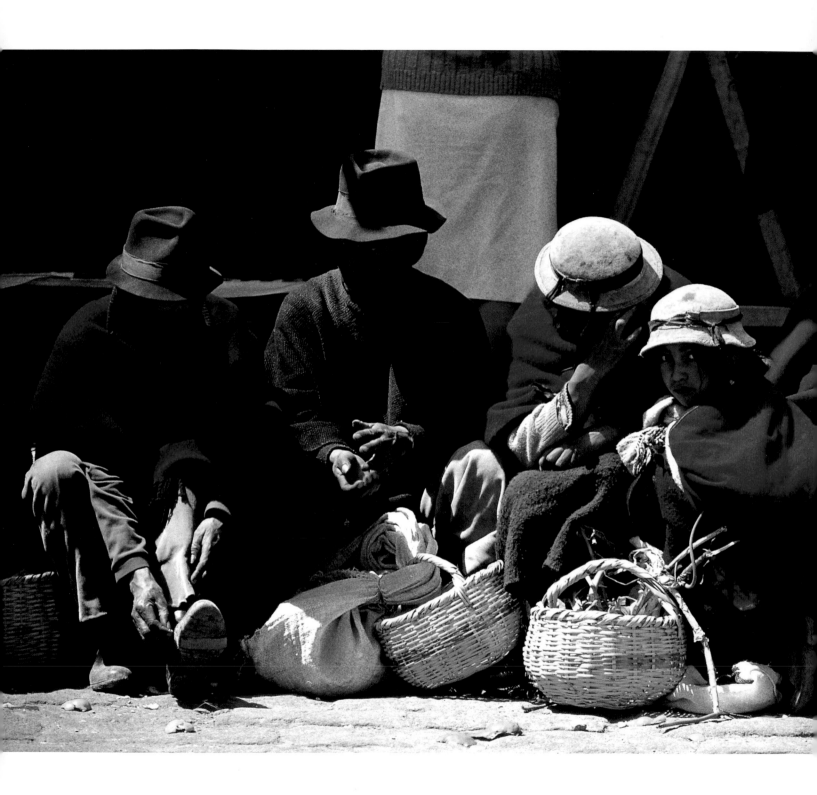

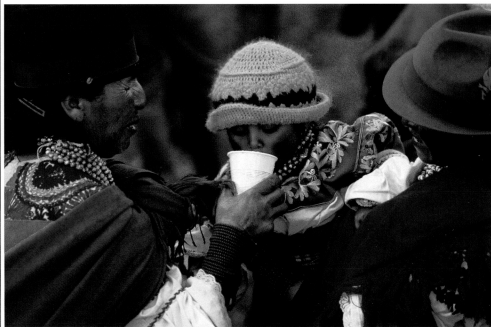

LEFT:
These Indians have
come down from the
mountains for the
Sunday market.
Riobamba, Ecuador.

ABOVE:
Even the children try
cactus beer (*chicha*) on
St John's Day. Zuleta,
near Mt. Imbabura, a
volcano in Ecuador.

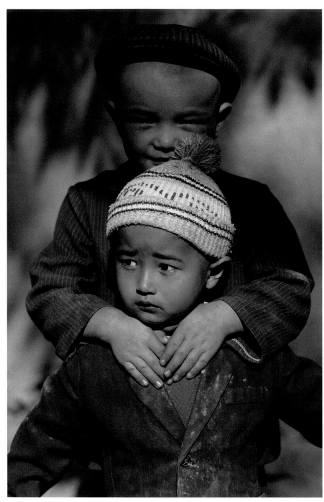

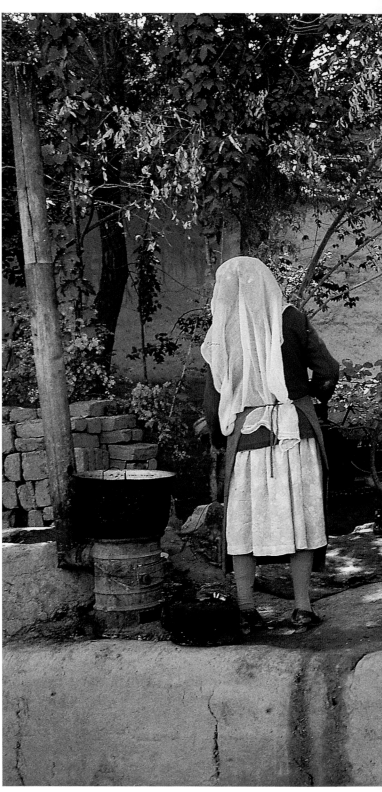

ABOVE: "My kid brother". Chinese Turkestan.

RIGHT: This open-air restaurant is the Uighur version of a fast-food diner.

On the menu are spiced kebabs (skewered meat and mutton fat) served on round, flat biscuit-loaves straight from the oven. Abakh Hoja Tomb, Xianjiang, China.

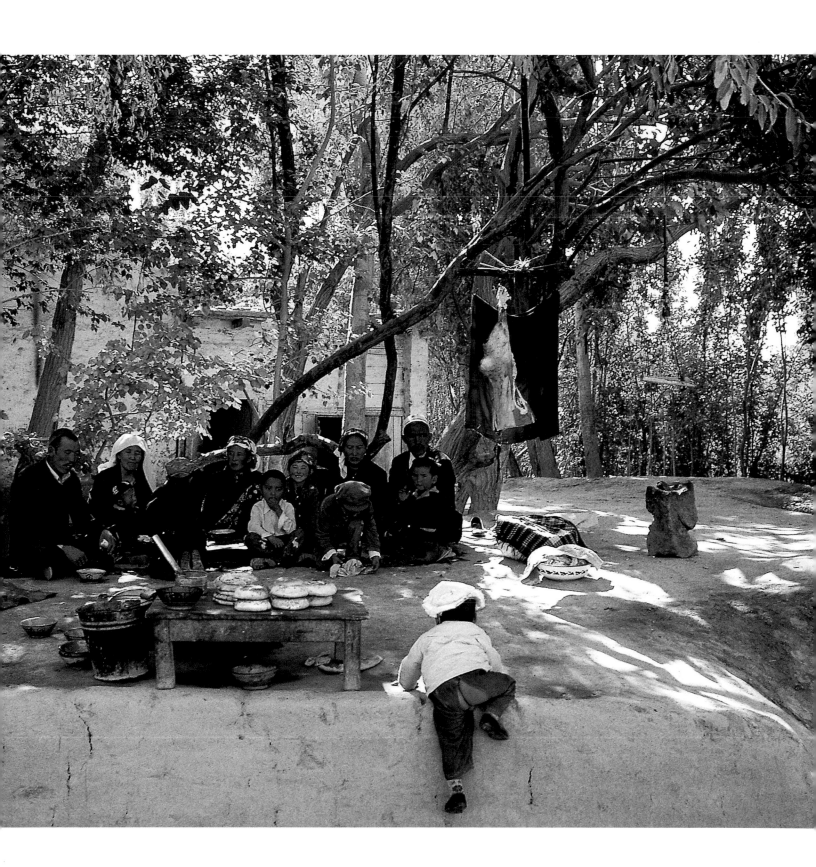

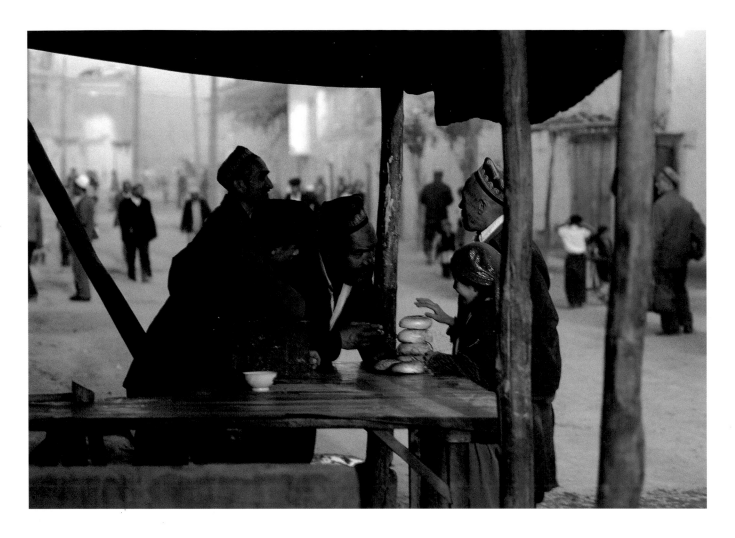

Early morning treat: choosing bagels with granddad at the crack of dawn. Old city of Kashgar, far western China.

She is mistress in her own house, but principally in the sense of seeing to the welfare of its occupants. She will, for instance, be the last to go to bed, having made sure everything is in order".[5]

In Maghreb as in Black Africa, new-born boys belong exclusively to the mother until the birth of the next child. It is only when the youngster has reached his seventh year that he will be taken in hand by his father and his father's brothers. From another viewpoint, we might agree with Germaine Tillion that "in Maghreb, the mother belongs to the new-born boy; he is her absolute and undisputed master, day and night. If Algerian mothers consider it their duty to beat their daughters to teach them submission, they never contradict their sons".[6]

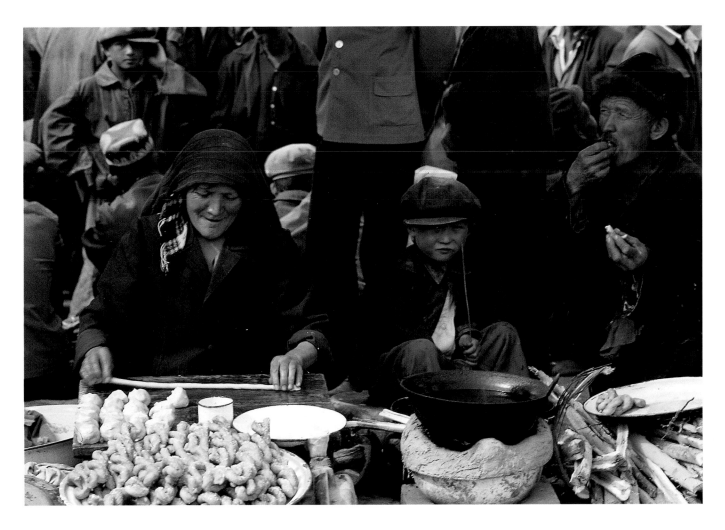

Making Uighur fritters. Aksu, northern oasis of the Silk Route. China.

The father's authority

In Maghreb, a boy's relationship with his father and the eldest of his brothers is "distant, respectful and constrained".[7] A child owes obedience and respect to his elders, always maintaining an attitude of reserve. He never confides his innermost feelings, his doubts, regrets or feelings of rebellion to his father or elder brothers, only to his mother. In China, "the family remains the fundamental unit. Formerly, the father was the unquestioned master; whatever their age, nothing released the sons from the obedience they owed him".[8]

The young Chinese wife was subservient to both her husband and his mother. "I carried out scrupulously all the tasks of a dutiful daughter-in-law", recalls a woman of good birth, now in her twilight years. "Every morning, I respectfully attended my mother-in-law when she woke up, pouring her dish of tea and warming the bowl of her opium pipe".[9]

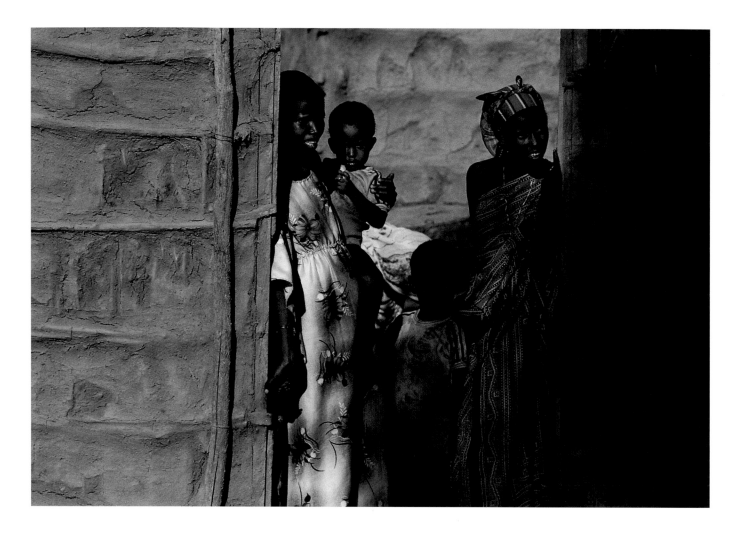

Young sisters and their sons on the doorstep. Merca, Somalia.

Heavily influenced by the old Chinese traditions, in Vietnam the father had full rights over his children. "The authority of the head of the family can be exercised over his wives, his children, his daughters-in-law (in certain cases the sons-in-law) and his servants. It is not, however, totally unlimited. According to the old notables, if a father put his child to death, and he escaped the punishment of the ancient penal code on the grounds of justification, the council of elders would nonetheless sit in judgement on him, demanding he give proof".[10]

"The slaying of a child by its father is punished, if the outcome of a justified chastisement, with a hundred strokes of the rod, to which is added a year's hard labour if the killing lacks legitimate motive. When the child in question has shown persistent insubordination, the father is excused by the law and incurs no penalty".[11]

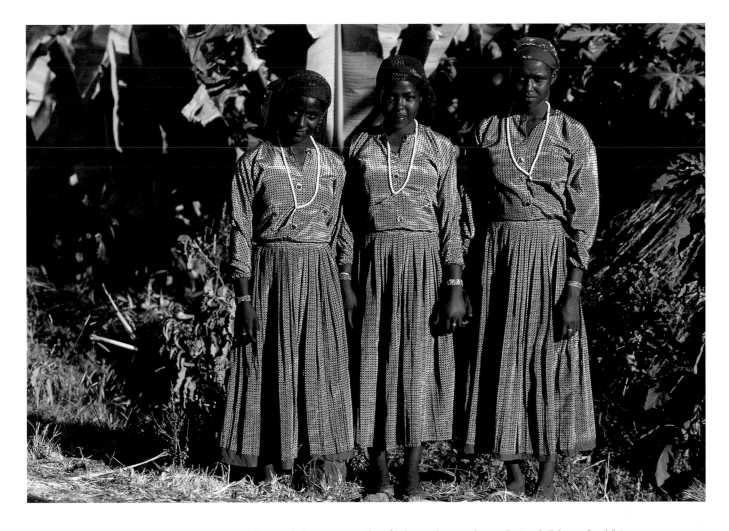

Sisters: three headscarves, three necklaces, three violet dresses. Near Kimba, African Rift Valley, Ethiopia.

None of this means that fathers do not love their children. In Africa, children are "the joy of life". Everywhere, they bring happiness to the family home, dispelling life's monotony with their innocence and eagerness to learn. Adults wish them every success. That is why a father is severe with his son: the latter will succeed him one day, so he must be worthy of his father and be proud to represent him. The child must be perfect – he will perpetuate his father's name, continue his heritage and maintain his memory, as well as that of his ancestors. Parents imagine their children will extend their existence – in some way defending them against the anguish of death. We bring up our children so they can leave us one day. All the same, we hope for a little pleasure and satisfaction from their brief stay with us. We hope too that they will remember us in the years to come and keep our memory alive when we have departed.

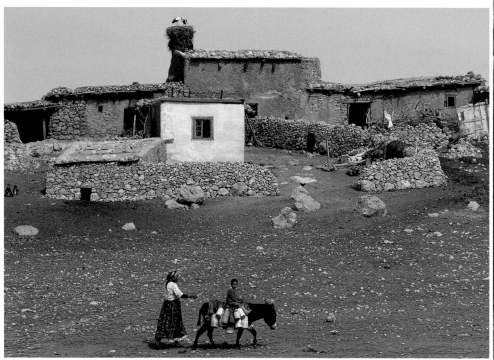

ABOVE:
Expectant mother,
with son on a
donkey. The two
storks nesting on
the roof of this
Berber house are
omens of a male birth.
Atlas Mountains,
Morocco.

RIGHT:
Berber women and
children, awaiting the
arrival of King
Hassan II, intone a
wailing chant to the
accompaniment of
drums and clapping
hands. Todra Gorges,
Morocco.

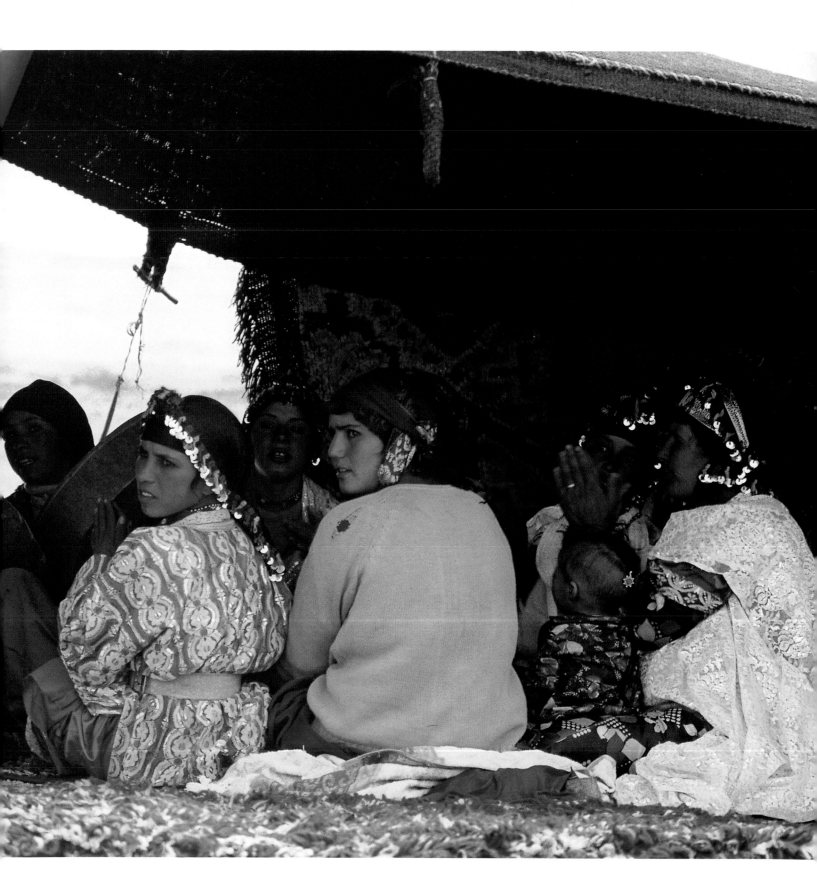

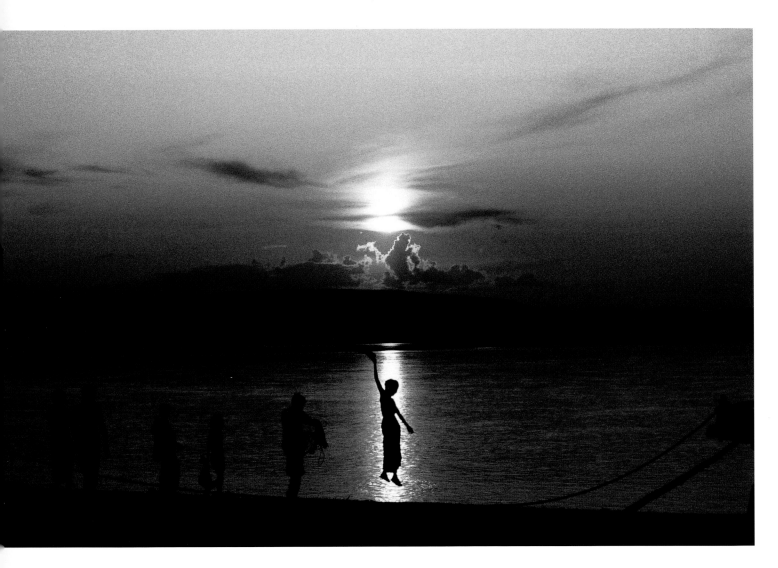

A leap in the sunset.
River Irrawaddy,
Burma.

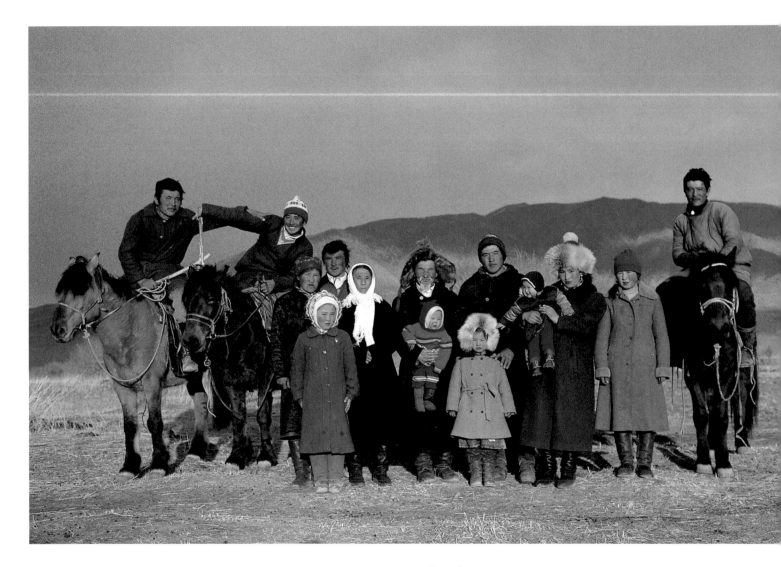

**Four generations of
Kazakhs from the
Altai Mountains.
Springtime in Mongolia,
near the republic of
Tannu-Tuva.**

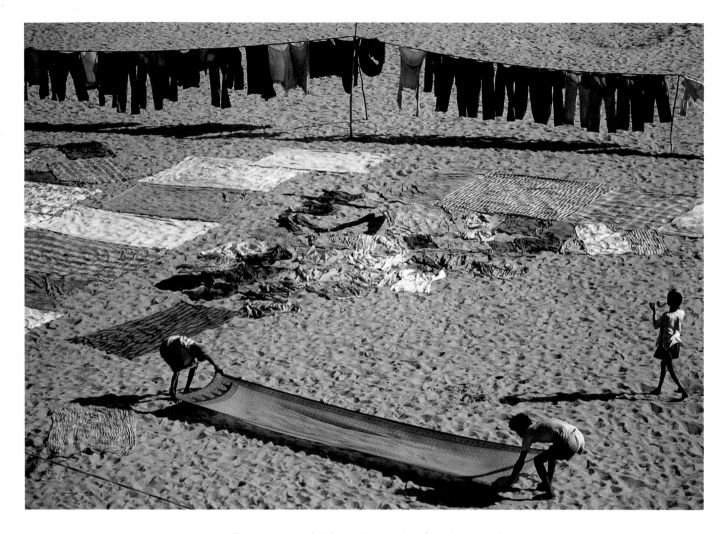

A family spreading saris and trousers to dry in the sun. Bihar, Eastern India.

Bringing up children demands a fine balance between encouragement and constraint, between too much or too little supervision, and between respect for another's personality and repression. We have to know when to guide, when to lead and when to correct. Every society has its own ways of tackling the dilemma, from a benevolent form of laissez-faire to the strict enforcement of rules and codes. Adults have an uncomfortable role. They see the child of their own bodies growing ever more incomprehensible and distant, refusing to be another version of themselves or follow in their footsteps.

The father has to be both stern and affectionate, close and distant, a guide and role model rather than a foil. The mother has to accept

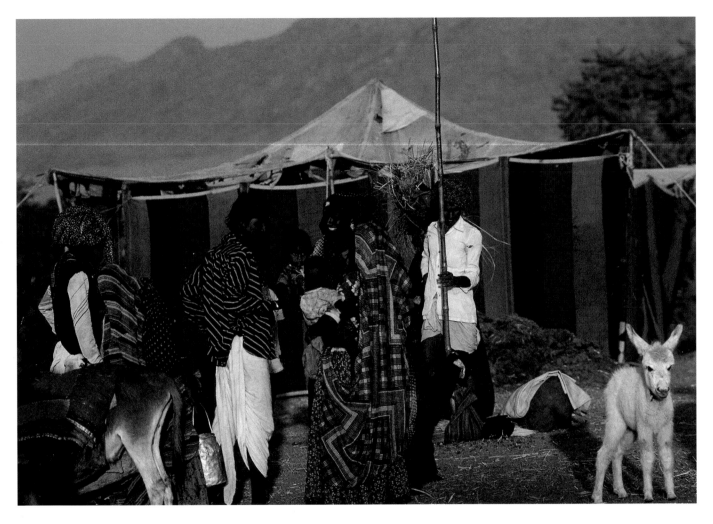

**Family gathering.
Thar Desert,
Rajasthan, India.**

that her "baby" is growing up, no longer needs her, and does not regard her with the same veneration.

Parents need to provide love and attention and be available, but at the same time they must point children on the right road and correct them. They must be there when needed, but also know when to take a back seat and let their offspring grow up in their own time – show them the way while still allowing them to discover it. For us in the West, adolescence means following the route traced by our parents or proclaiming our individuality by taking a different path, building our own image by turning our back on theirs. Conversely, in more traditional cultures, conformity with adult values – and thus integration with adult society – is the natural outcome of adolescence.

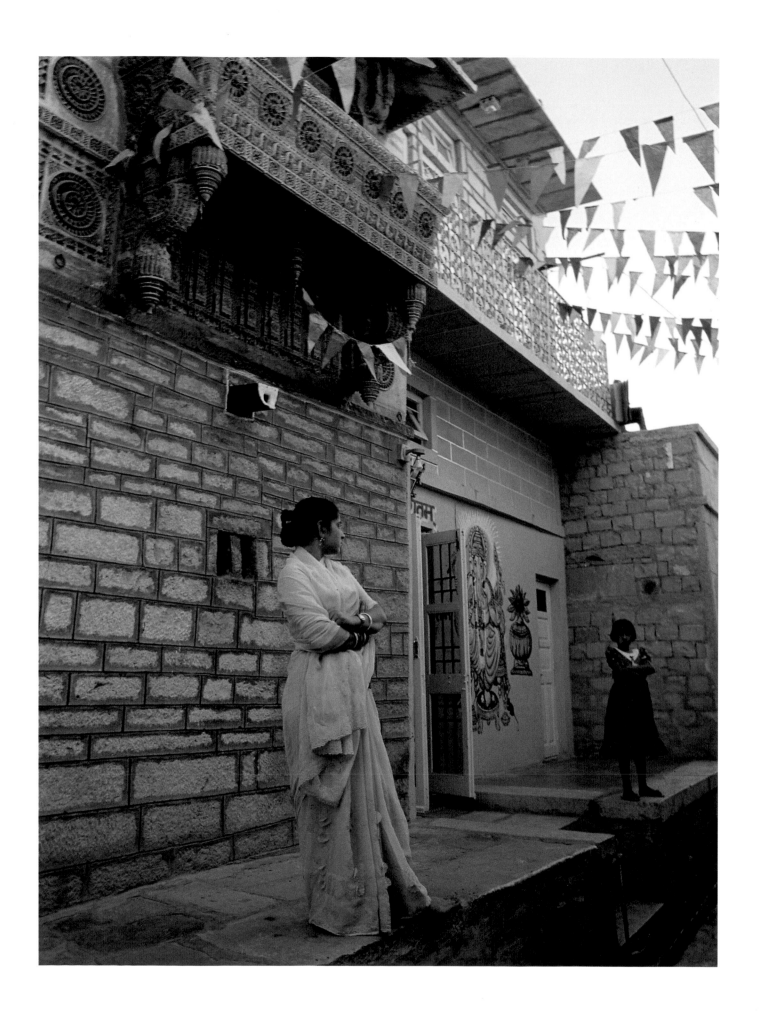

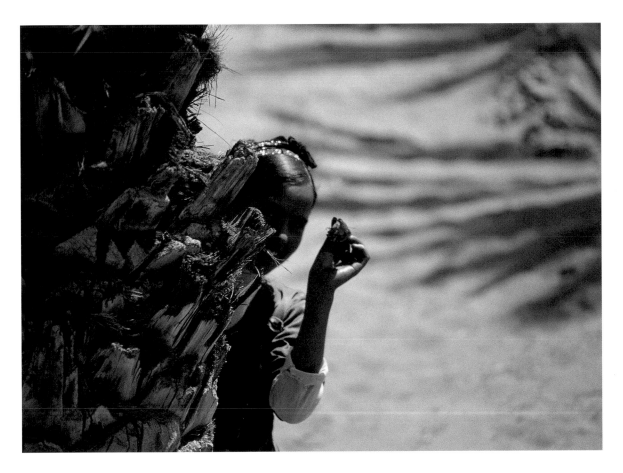

LEFT:

Mother scolding her
daughter on the patio
of a *haveli* (villa).
Jaisalmer, India.

ABOVE:

A Berber flower. Valley
of the Dadès, Morocco.

Notes

Chapter I: Babies and Toddlers

1. J. Cuisinier, *Les Muong. Géographie humaine et sociologie* (Paris, Institut d'Ethnologie, 1948).
2. J. Soustelle, *La Vie quotidienne des Aztèques* (Paris, Hachette, 1995).
3. D. Paulme, *Les Gens du riz. Kissi de Haute Guinée française* (Paris, Plon, 1954).
4. C. Alhassane, "Les Manding de Guinée sont structurés par la parole", unpublished thesis (Université de Paris VII, October 2001).
5. Y. Broutin, *Vêtements et Sociétés* (Paris, Musée de l'Homme, Laboratoire d'Ethnologie, 1981).
6. M. S. Stevenson, *The Rites of the Twice-Born* (New Delhi, Oriental Books Reprint Corporation, 1971).
7. J. Cuisinier, *op. cit.*
8. B. Milcent, "Cheminements. Écrits offerts à Georges Condominas", *ASEMI*, XI, 1–4 (1980).
9. J. Cuisinier, *op. cit.*
10. R. Benedict, *Patterns of Culture* (London, Routledge and Kegan Paul Ltd, 1935, repr. 1971).

Chapter II: Growing Up

1. Commandant Baudesson, *Au pays des superstitions et des rites. Chez les Moïs et les Chams* (Paris, Plon, 1932).
2. J. Cuisinier, *Les Muong. Géographie humaine et sociologie* (Paris, Institut d'Ethnologie, 1940).
3. Commandant Baudesson, *op. cit.*
4. *L'Univers pittoresque. Tartarie* (Paris, Firmin-Didot, 1848).
5. Commandant Baudesson, *op. cit.*
6. D. Paulme, *op. cit.*
7. F. Bebey, *Le Fils d'Agatha Moudio* (Yaoundé, Éditions Clé, 1967).
8. D. Paulme, *op. cit.*
9. M.-C and E. Ortigues, *Oedipe africain* (Paris, Plon, 10/18, 1973).
10. *La Vie du paysan Khmer* (Phnom-Penh, Institut bouddhique, 1969).
11. Commandant Baudesson, *op. cit.*
12. D. Fernandez, *Mère Méditerranée* (Paris, Grasset, 1965).
13. A. H. Bâ, *Amkouliel, l'enfant Peul* (Aries, Actes Sud, 1991).
14. M.-C. and E. Ortigues, *op. cit.*
15. A. H. Bâ, *op. cit.*
16. *La Vie du paysan Khmer, op. cit.*.
17. M. and E. Ortigues, *op. cit.*

Chapter III: Play

1. S. Thierry, in *Poupées-jouets, poupées-reflets* (Paris, Musée de l'Homme, Laboratoire d'Ethnologie, 1983).
2. J.-P. Leboeuf in *Poupées-jouets*.
3. D. Paulme, *op. cit.*
4. J. Guiart, in *Poupées-jouets*.
5. J.-B Faivre, in *Poupées-jouets*, preface.
6. *L'Univers pittoresque. Tartarie* (Firmin-Didot, 1848).
7. Levchine, in *L'Univers pittoresque*.

Chapter IV: Apprenticeship

1. D. Paulme, *op. cit.*
2. J. Soustelle, *op. cit.*
3. Y. de Sike, *Mariages d'ailleurs* (Paris, Musée de l'Homme, Laboratoire d'Ethnologie, 1995).
4. N. Abramtchik, July 2001.
5. A. H. Bâ, *op. cit.*
6. R. Benedict, *op. cit.*
7. D. Paulme, *op. cit.*
8. D. Paulme, *op. cit.*
9. C. Alhassane, *op. cit.*

Chapter V: Family portraits

1. A. H. Bâ, *op. cit.*
2. D. Paulme, *op. cit.*
3. D. Paulme, *op. cit.*
4. B. Malinowski, cited by R. Bastide, in *Ethnologie générale* (Paris, Encyclopédie de la Pléiade).
5. *La Vie du paysan Khmer*.
6. G. Tillion, *Le Harem et les Cousins* (Paris, Le Seuil, 1966).
7. G. Tillion, *op. cit.*
8. *Manuel à l'usage des troupes employées outre-mer* (Paris, Imprimerie Nationale, 1925).
9. Père R. Dulucq, *Nuage d'automne* (Paris, Librairie Vincentienne et Missionaire, 1935).
10. J. Cuisinier, *op. cit.*
11. E. Luro, *Le Pays d'Annam*.

First published by Hazan, an imprint of Hachette-Livre
43 Quai de Grenelle, Paris 75905, Cedex 15, France
© 2001, Hazan, Paris
Under the title Enfances Lointaines
All rights reserved

Editorial supervision: Catherine Bray and Hélène de Bettignies, with the collaboration of Isabelle Chain
Design: Sylvie Milliet
Photo-engraving: Arts Graphiques du Centre, Saint-Avertin

Language translation produced by Translate-A-Book
© 2003 English translation, Octopus Publishing Group Ltd, London
This edition published by Hachette Illustrated UK, Octopus Publishing Group,
2–4 Heron Quays, London, E14 4JP

Printed by Tien Wah, Singapore
ISBN: 1-84430-014-5